S·MARIA DELLA MINERVA.

PP·ALESSANDRO VII. 3 Tempio della Rotonda.

Iacomo Rossi in Roma alla pace cõ priu. del S. Pont.

The Artist
and the
Eternal City

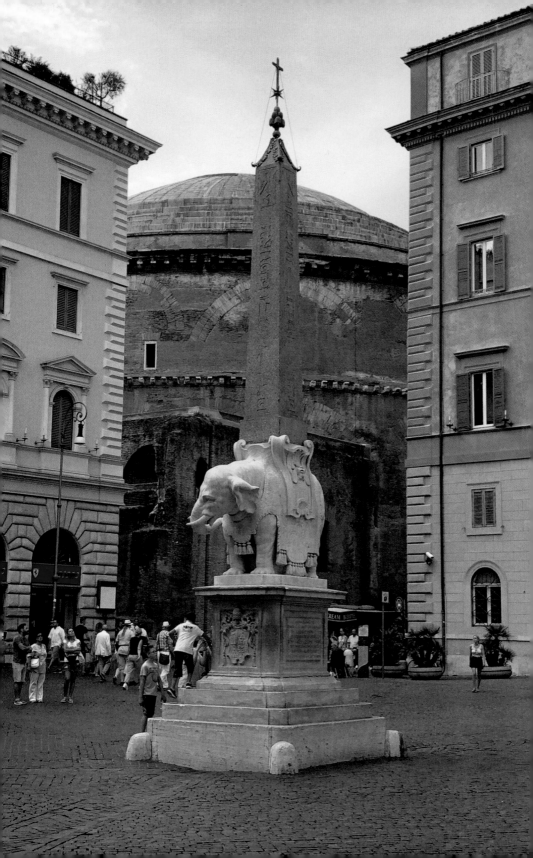

The ARTIST
and the
ETERNAL CITY

Bernini, Pope Alexander VII,
and the Making of Rome

LOYD GROSSMAN

PEGASUS BOOKS
NEW YORK LONDON

THE ARTIST AND THE ETERNAL CITY

Pegasus Books, Ltd.
148 West 37th Street, 13th Floor
New York, NY 10018

First Pegasus Books cloth edition August 2021

ISBN: 978-1-64313-740-7

10 9 8 7 6 5 4 3 2 1

Printed in the United States of America
Distributed by Simon & Schuster
www.pegasusbooks.com

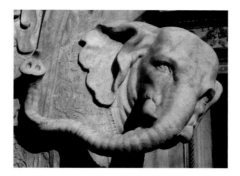

*Imagine a population, one fourth of which consists of
priests, one fourth of statues, one fourth of people who
hardly do anything, and the remaining fourth
who do nothing at all.*
Charles de Brosses

*As in Rome there is, apart from the Romans, a population
of statues, so apart from this real world there is a world of
illusion, almost more potent, in which most men live.*
Goethe

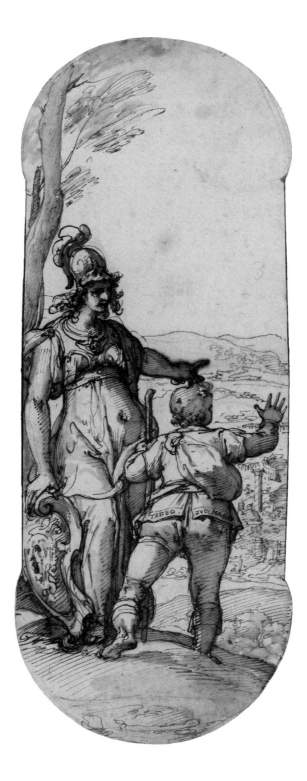

ROME is a city of statues. Statues of saints, popes, emperors, angels, gods, and heroes. There is even, in the little Piazza della Minerva, a statue of an elephant carrying an obelisk on its back.

Rome is a place of chance and depth. Whatever your itinerary, it will be derailed by something unexpected and profound around a corner that you never even planned on turning. On my first trip to Rome in the mid-70s, I was booked into a very studenty pensione by the Pantheon, up three flights of narrow stairs. As I climbed up to the reception desk, I was pressed against a wall by two stretcher bearers bringing a stiff down the stairway: a suicide who chose a dramatic check out. I soon learned he was the previous occupant of my room. Rather than wait for the housekeeper to 'prepare' things, I went out for a walk aiming to go from one tourist honeypot—Piazza della Rotonda, the square of the Pantheon —to the next—Piazza Navona—by way of Ditta Gammarelli, the papal tailors who sold (and still sell) beautiful socks in the appropriate colours for bishops, cardinals and popes.

First stop, the Pantheon itself, ancient Rome's most complete surviving building, saved for future generations thanks to the Emperor Phocas' decision in 609 AD to give it to Pope Boniface V for conversion to a Christian church. Two nineteenth-century kings of Italy are buried there. More interestingly, so are the artists Raphael, Annibale Carracci and Taddeo Zuccaro, whose resting places testify to the high esteem in which

Opposite: The young Taddeo Zuccaro, guided by Pallas Athene (Minerva), has his first glimpse of Rome. The Colosseum, Trajan's Column and the Pantheon can all be seen

artists were held by Italian culture. No artist could wish for a better epitaph than (in Thomas Hardy's translation):

> Here's one in whom Nature feared—faint at such vying—
> Eclipse while he lived, and decease at his dying.

The lives of all three artists also testify to the magnetic lure of Rome. Carracci came there from Bologna while Raphael and Zuccaro made the journey from Urbino. For centuries, Rome was where artists made their reputations and fortunes.

As interesting as both artists' tombs are, the overwhelming fact of the Pantheon is its great dome—the largest concrete dome in the world until the twentieth century, made even more remarkable by its open top or oculus which let the smoke from ancient Roman sacrifices rise to the heavens. On subsequent visits I've been lucky enough to watch rain fall through it, and once, magically, snow. On my first visit, and indeed on almost every later one, there was a huge crowd of tourists and a scattering of guardian flunkeys trying to preserve the decorum of the place, which after all is still a working church. There was a lot of official shouting 'silenzio' and a battle to ensure that no wearing of tank tops and short shorts be allowed.

After enough dome, it was time to wander. And that's when I walked through Piazza della Minerva and saw a three hundred-year-old elephant carrying a three-thousand-year-old obelisk in front of the mediæval church of Santa Maria sopra Minerva.

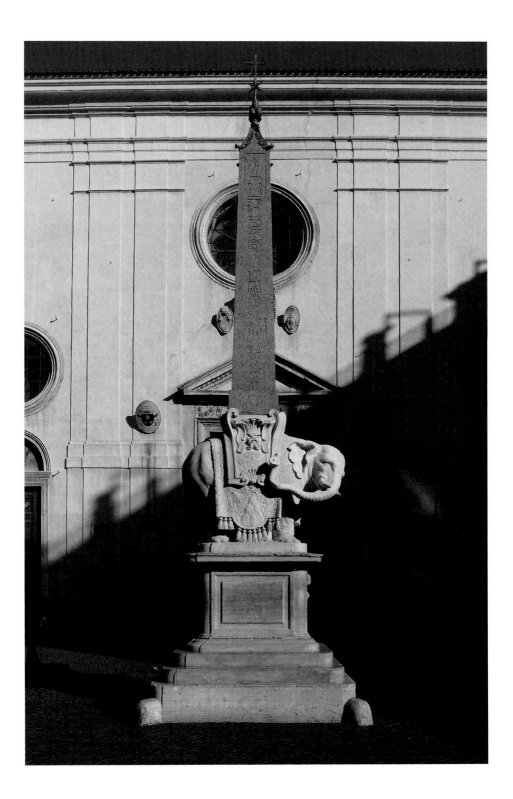

That was the moment—a dreamlike convergence of Egyptian, Baroque, Gothic, pagan and Christian—that Rome had me: what I later decided was my 'Goethe moment'. In his *Italian Journey,* Goethe, the most penetrating and subtle of all Grand Tourists, wrote how he was bewildered and intoxicated by Rome, 'an entity which has suffered so many drastic changes in the course of two thousand years, yet is still the same soil, the same hill, often even the same column or the same wall'. This constant rubbing up against the past makes the observer into 'a contemporary of the great decrees of yesterday', as Goethe put it. In Rome, history is more than a spectator sport.

Because history is part of everyday Roman life, it is, while much appreciated, not always taken so seriously. The Minerva elephant is hardly anatomically correct. Its squat body, extended trunk, high domed forehead and quizzical expression have a lot in common with Bernini's celebrated caricatures of contemporary bigwigs. Indeed the elephant's cartoon-like qualities apparently led Romans to give it an affectionate nickname—'Il pulcino della Minerva' or 'Minerva's chick' although I must confess that while I have read that, I have never heard anyone refer to it as such. Some have speculated that 'pulcino' should really be 'porcino', or piglet. I don't think it looks like either a chick or a piglet: it is freighted with far too much grand symbolism.

Over its back is a richly carved saddle blanket adorned with the coat of arms of Fabio Chigi, who reigned as Pope Alexander VII from 1655 until 1667. The elephant stands on

a high plinth carved with arcane Latin inscriptions roughly translated as:

LET ANY BEHOLDER

OF THE CARVED IMAGES OF THE WISDOM OF EGYPT

ON THE OBELISK CARRIED BY THE ELEPHANT,

THE STRONGEST OF BEASTS,

REALISE THAT IT TAKES A ROBUST MIND

TO CARRY SOLID WISDOM

and

IN THE YEAR OF SALVATION 1667,

ALEXANDER VII

DEDICATED TO DIVINE SAPIENCE

THIS ANCIENT EGYPTIAN OBELISK,

A MONUMENT TO EGYPTIAN PALLAS,

BROUGHT FROM THE EARTH AND ERECTED

IN WHAT WAS FORMERLY THE SQUARE OF MINERVA,

NOW THAT OF THE VIRGIN WHO GAVE BIRTH TO GOD.

The elephant turns his head sharply backwards, with eyes up to heaven and the hint of a sly smile. And he swishes his tail to the side as if about to defecate. The first time I saw it, I was impressed by the beauty and vivacity of its carving, and entertained by its humour, but also puzzled by its downright weirdness. Why the elephant? Why the obelisk? The answers took me into the heart of Baroque Rome.

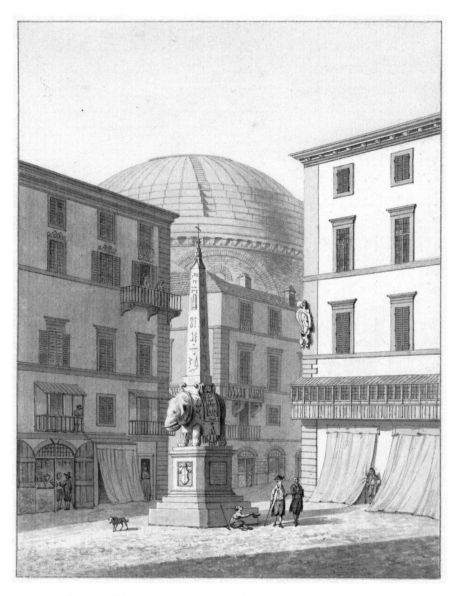

*The view of the Piazza della Minerva from the Grand Hotel de la Minerve
in 1790, much as Stendhal would see it twenty years later. S Maria sopra
Minerva is out of the picture to the right*

Piazza della Minerva is not among the grandest squares in Rome. It doesn't attract the throngs that crowd Piazza Navona or Piazza della Rotonda, the square of the Pantheon. There are no cafés and no fountain. There is Santa Maria sopra Minerva, the only Gothic church in Rome, and a dignified hotel, the Grand Hotel de la Minerve. The latter was much favoured by nineteenth-century celebrities, not least Stendhal. The novelist was celebrated for his description of 'hyperkulturemia', or Stendhal's Syndrome: a symptomatic bundle of heart palpitations, nausea, dizziness and confusion caused by too much exposure to too much great art. It's still a not uncommon reaction of first-time visitors to Italy. Stendhal keenly recorded his impressions of the Colosseum, Saint Peter's and a host of other Roman landmarks, but he found the view from his hotel window less arresting. In his list of eighty-six minor Roman churches he describes Santa Maria sopra Minerva as 'having a dreadful look' and 'located opposite an elephant carrying an obelisk.'

It seems a rare failure of imagination. Perhaps he was already feeling the Syndrome, exposed to excessive obelisks? For while an elephant is a rare sight in the streets of Rome, obelisks are not. In fact erecting them is a Roman habit dating as far back as the time of the first emperor. After Augustus' conquest of Cleopatra's Egypt in 30 BCE, obelisks began arriving as potent reminders that Romans had subjugated the world's most long-established civilisation. The very transportation and re-erection of these great stones—the obelisk in Saint Peter's Square, for example, is twenty-five

metres high and weighs over 300 tonnes—was also a symbol of Roman willpower and technical skill. Before long, obelisks proliferated, marking the sports stadia, places of worship and imperial tombs of ancient Rome. After the empire fell, the obelisks started falling too, victims of neglect; just one remained standing. Succeeding centuries heaped up builder's rubble and common rubbish over all the rest.

Not until the end of the sixteenth century was the custom of raising obelisks revived. Beginning in 1584, the uncouth and violent Pope Sixtus V re-erected four, using them as exclamation points in the Roman cityscape. They defined a network of roads linking the Piazza del Popolo—the traditional grand entrance to Rome—with Saint Peter's and the great basilicas of Saint John Lateran and Santa Maria Maggiore, imposing a new order on Rome and making it easier for pilgrims and other visitors to navigate the city. These obelisks had massive propaganda value as well. Transformed into Christian monuments, they embodied the triumph of the Church over the pagan Roman Empire and, in the face of the trauma of the Reformation and the rise of Protestantism, proclaimed that Rome was still in business as the Holy City.

Today there are thirteen standing obelisks in Rome, eight dating back to the temples of ancient Egypt and five made to order in Egypt for the ancient Romans: more than any other city in the world, more even than remain in Egypt herself. But even with all this competition – not to mention that of such curious monuments as the Pyramid of Cestius or the

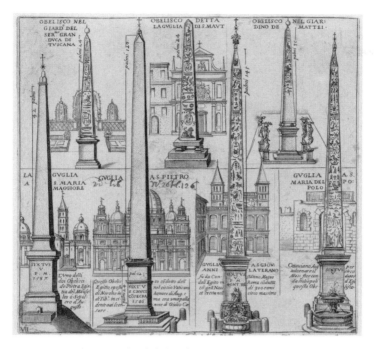

The obelisks of Rome in 1618

Bocca della Verità – the elephant and obelisk of the Piazza della Minerva is still among Rome's most captivating sights.

More than that, to me it is also a key that helps unlock the complexities of papal intrigues, European power politics and the artistic and intellectual life of seventeenth-century Rome. Above all, it also helps to explain why Rome looks the way it does.

Overleaf: Rome as reorganized by Sixtus V. A star-like grid of roads connects the main churches of Rome, most clearly Santa Maria del Popolo (bottom left) to the Lateran (top right), passing Santa Maria Maggiore in the centre of the picture, all of them signposted by obelisks. The inscription reads: 'When he opened the direct paths to the holiest churches, Sixtus himself opened the way to the stars'

15

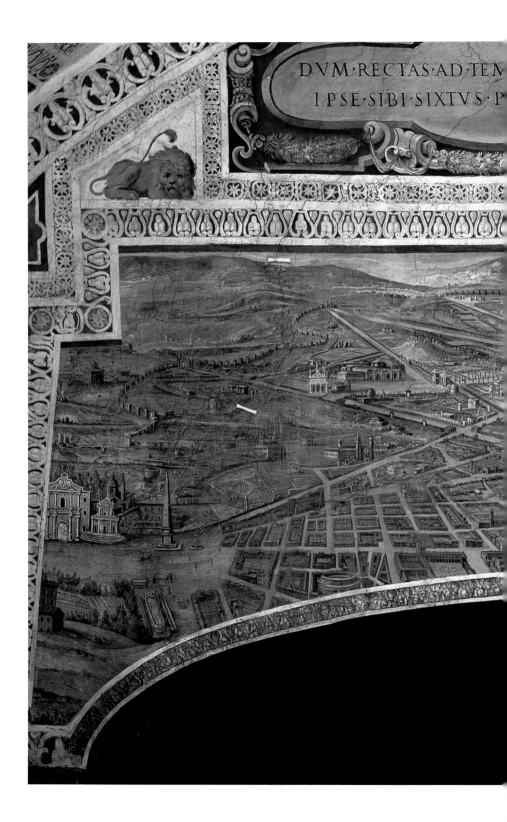

DVM·RECTAS·AD·TEM

IPSE·SIBI·SIXTVS·P

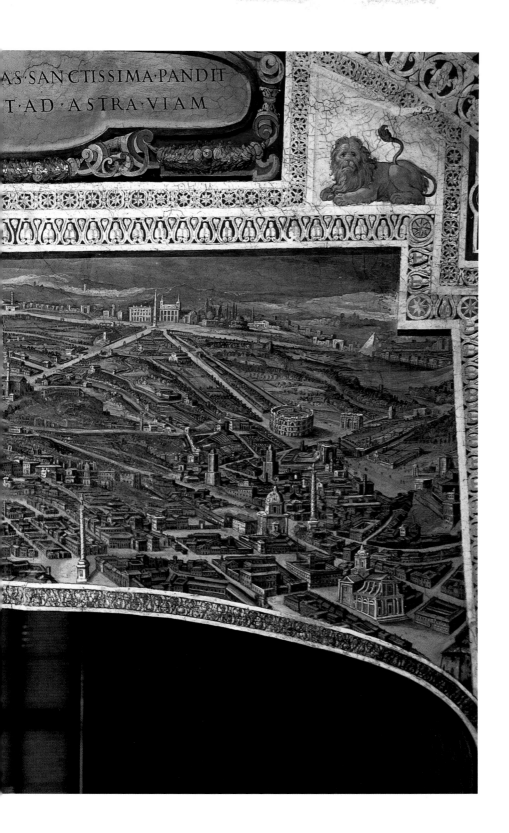

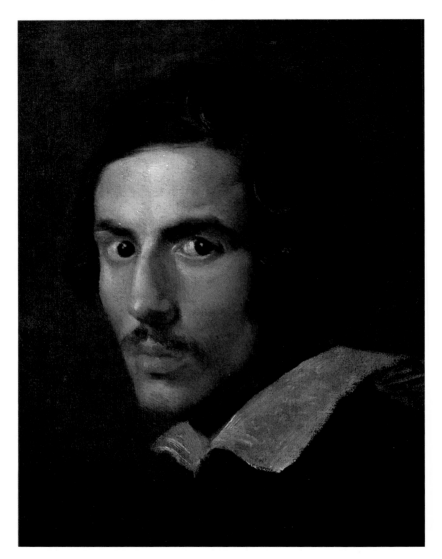

Gian Lorenzo Bernini, Self-portrait painted c. 1621, the year he was knighted by Pope Gregory XV at the age of only twenty-three

THE ELEPHANT of the Piazza Minerva is the creation of Gian Lorenzo Bernini (1598–1680), an artist who dominated Europe like no other of his time (no mean feat in the age of Rubens, Rembrandt and Velázquez). The sheer volume and variety of Bernini's work in Rome are dizzying, ranging from monuments and statues to fountains, chapels and churches, palaces and piazzas. He is synonymous with the Rome of Baroque drama, highly emotional piety, thrilling vistas, and the feeling, though no longer the reality, that the Holy City remains *caput mundi*, the 'head' or capital of the world.

If Rome was not built in a day, neither could it be built by one man, even one as driven and talented as Bernini. Before there was a fully developed commercial market for art, great artists required great patrons, and Bernini had the greatest patrons of all: the popes. Reimagining a city is an act of political will as much as a work of art: in seventeenth-century Rome, political, economic and spiritual power collected around the person of the reigning pope, and a succession of popes made Bernini their man.★ He was discovered as a

★Bernini's long life stretched across the reigns of ten popes: their names as well as those of a few of their predecessors will feature in this story. Some of them reigned very briefly—Leo XI, for example, was Pope for just twenty-six days—and others didn't play a very large part in Bernini's career. Please do not be put off by the thought of having to remember so many different pontiffs: rather like the characters in a Russian novel, the important ones will become obvious. Popes will be referred to by their given names until they became Pope, and then by their regnal names. For example, the man we know as Maffeo Barberini until his election in 1623 then becomes Urban VIII; similarly, Fabio Chigi becomes Alexander VII.

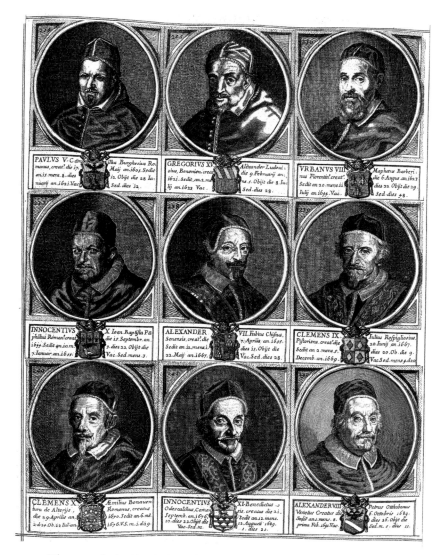

The popes during Bernini's working life. Left to right from the top: Paul V, Gregory XV, Urban VIII, Innocent X, Alexander VII, Clement IX, Clement X, Innocent XI. The last one, Alexander VIII, was a close friend, but only elected after Bernini's death

youth by Paul V (reigned 1605-21), developed a close friend-
ship with the opulent and expansive Urban VIII (1623-44)
and, after an almost career-ending falling out, created sub-
lime work for Innocent X (1644-55). But his most remark-
able and productive relationship was with Alexander VII
(1655-67).

And it was as the ailing Alexander VII neared the end
of his twelve years on the throne of St Peter that the pope
himself and Bernini chose to celebrate his reign and its
vast achievements with this modestly-sized, charming and
frankly enigmatic statue of an elephant. It turned out to be
Bernini's final tribute to his friend and collaborator. Alex-
ander died just days before it was unveiled.

E ASTER SUNDAY, 10 April 1667, and Bernini was a wor-
ried man. A Roman proverb said that 'the pope isn't
sick until he's dead', but Bernini and an increasing num-
ber of Romans knew that Pope Alexander VII was very
sick indeed. Easter Sunday was, as it remains, a time for the
reigning pope to address his flock. That Easter there was
doubt that Alexander would be able to appear before the
large crowd gathering on the piazza in front of the Quir-
inal Palace in Rome, many drawn by piety, others by anx-
iety, or curiosity, or a mixture of all three. Set on the top
of Rome's highest hill, the Quirinal Palace had originally
been a papal summer residence. The relatively cool breezes
and distance from the polluted Tiber provided relief from
the unhealthiness of the Vatican or the inconvenience and

lack of comfort of the pope's traditional residence, the Lateran. Alexander, a life-long invalid, had made the Quirinal his permanent home. Popes were often elderly when elected and not expected to reign for long, and this had been especially the case when Alexander was chosen in 1655. Plagued by a variety of kidney problems from boyhood, his health had declined shockingly during his many years as a papal diplomat in Germany, where he was tormented by the cold and damp and had lost all his teeth. (Rich and articulate as he was, the toothless pope lived on a diet of baby food, and his speech was often hard to understand.) It was frankly surprising that his papacy had lasted for twelve years, but by Holy Week in 1667 it was clear his time was running out. A month earlier he had struggled to preside over a meeting of the College of Cardinals at which he promoted eight clerics to the red hat. Rome had long buzzed with gossip about the ever-ailing pope's health, and on Easter Sunday the crowd at the Quirinal continued to grow, and with it the uncertainty that they would get to see the pope. Finally, Alexander presented himself on the balcony and, with great effort, blessed his flock. It was his last public appearance. Five weeks later he was dead.

In the weeks of the pope's final illness, the finishing touches were being put on two monuments to his reign. The scholarly Alexander had long wanted to establish a great new library, which, in his words, would be 'for the public benefit of lecturers, students and scholars', at Rome's historic university, La Sapienza. With the pope on his deathbed, a

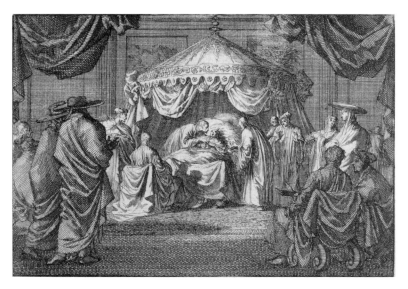

The death of Alexander VII, as imagined by a Dutch artist in 1698

bull—an official decree or charter—was issued naming the new library the Biblioteca Alessandrina in his honour. At the same time, a team of Bernini's craftsmen, led by his most talented collaborator, Ercole Ferrata, was hurrying to finish the elephant and obelisk in the Piazza della Minerva.

The impending death of a pope always threw Rome into barely suppressed panic. Unlike a hereditary monarchy where the formula 'The king is dead, long live the king' epitomises the seamless transition from one sovereign to another, the death of a pope required an election for his successor, a lengthy and uncertain process. Cardinals had to gather, factions form, deals be made, the great Catholic monarchs of France and Spain be consulted, appeased or resisted. It could take weeks or months to elect a new pope.

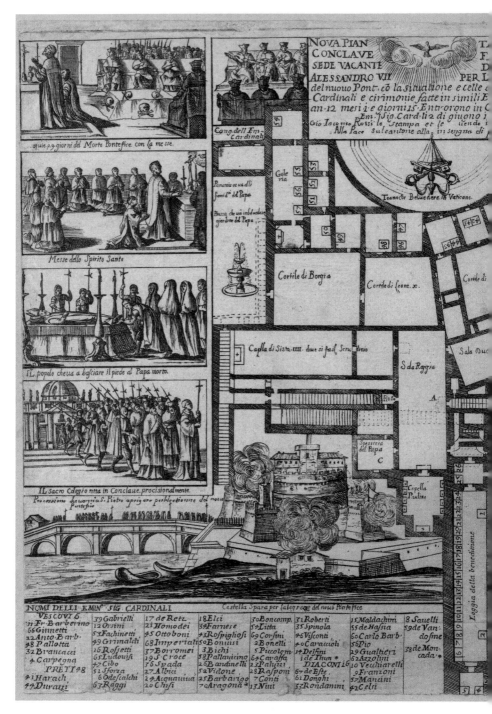

Ceremonies after the death of Alexander VII, 1667. Prayers are said, the people kiss the feet of the late pontiff, and the cardinals process from Saint Peter's to the conclave. Salutes are fired from Castel Sant'Angelo

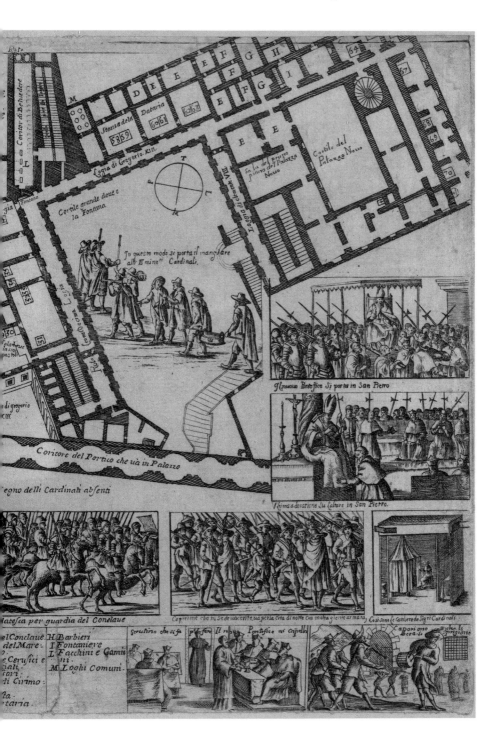

The cardinals are installed in little cabins within rooms at the Vatican; food is brought to them under guard. Armed militias patrol Rome. Once chosen, the new pontiff is chaired through the city

Nor was it just Rome that would be nervous. A papal election threatened the precarious stability of Europe, still recovering from the trauma of the Thirty Years' War and slowly adjusting to the fading of Spanish military and economic strength and the increasing aggression of France under the young king, Louis XIV. Unlike any other sovereign, the pope was master of two empires, spiritual and secular. As supreme pontiff of the Catholic Church his domain spread across the world. He commanded obedience from Jesuit missionaries in China and converted tribes in South America. And even though aggressive Protestantism had been eroding papal authority in Europe for over a century, kings and merchants and craftsmen and peasants from Poland to Portugal still acknowledged the pope's religious authority. Of equal, maybe greater, practical importance was the pope's political power base. Seventeenth-century Italy was, as Metternich cynically described it in 1814, 'merely a geographical expression.' The peninsula was divided amongst dozens of city states, principalities and duchies, most with their own customs, dialects and favourite foods. It was a crazy patchwork of conflicting sovereignties, shifting alliances and failed ambitions. The Kingdom of Spain remained the greatest power in the land, controlling the whole south of the mainland, along with Sicily and Sardinia. Spain's royal cousins, the Austrian Habsburgs, coveting a window onto the Mediterranean, put constant pressure on the slowly declining Republic of Venice. To the northwest, France loomed over Lombardy and the Duchy of Savoy. Tuscany was in play. The

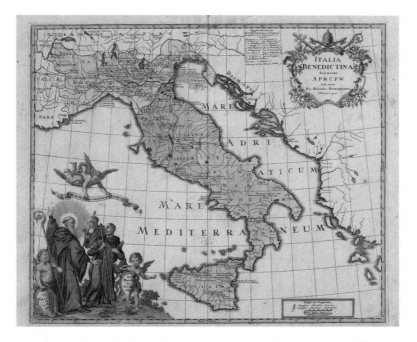

Map of Italy: the Papal States are in green, stretching across the middle of the peninsula. Rome is close to the southernmost tip of the States

pope's secular domains, the Papal States, were central to the geography and politics of Italy, stretching diagonally across the peninsula from the sunny Sabine Hills south of Rome to the fogs of the Po Valley bordering Venetian territory. Perugia, Bologna, Ferrara, Rimini, Spoleto, Ravenna and Ancona were all papal cities, but the cornerstone of the Papal States was the status and security of Rome, *caput mundi*, an epithet that had less to do with Rome's size or wealth or political significance, than with its absolute and unquestioned centrality to European civilisation. The fate of all this was in the balance with every change of papal ruler.

In Rome itself, during the anxious weeks of Alexander's last illness, his relatives, colleagues and retainers tensely awaited the sound of the 'Patara', the great bell of the Capitol whose tolling would signal the pope's death. Their incomes and privileges and status would die with the pope. A new pope would bring with him a new family that had to be enriched with benefices and sinecures and who needed to aggrandize old palaces or buy or build new ones. And there would be new favourites to fill the papal court: musicians and poets and scholars and painters and sculptors and architects. Not just patronage, but papal authority died with the pope too: the normal workings of justice were suspended, prison gates were opened and old scores were settled as vengeance was sought for resentments that had simmered for years. The civic government of Rome, the Popolo Romano, which had little authority and little to do while the pope lived, vainly attempted to impose some order on the city after the pope's death. This period known as the *sede vacante,* or vacant see, was a time for lawlessness and anarchy. It was a time too for the populace to express, often violently, their grievances against the papal régime that had just ended. Bernini, the papal favourite, had much to fear for the safety of himself and his family, for his business, his honour and his reputation.

BERNINI HAD GROWN UP amidst the marble dust and chisels of the sculptor's workplace. His father, Pietro, was a successful sculptor, even a modestly well-known one,

celebrated for his extreme technical skill in stone carving. But Pietro's technique far outran his compositional and æsthetic abilities, and he never quite got to the first rank of practitioners. Born in 1562 in Sesto Fiorentino, on the outskirts of Florence, the son of a cobbler, his natural talents took him far from his origins in the Tuscan peasantry, gaining him an apprenticeship in Florence, from which he moved to Rome for four years and then further to Naples, where he settled for twenty years. At the end of the sixteenth century, Naples was, after Paris, the biggest city in Europe, and the seat of a powerful and rich viceregal court that ruled all of Southern Italy and Sicily on behalf of the Spanish Habsburg monarchy. The embellishment of Neapolitan churches, palaces and monasteries provided ample and well-paid work for Pietro, who married a local girl and fathered thirteen children. Gian Lorenzo, his first son, arrived on 7 December 1598.

Pietro's work in Naples brought him to the attention of the papacy, always on the lookout for artists and craftsmen. In 1605 he was summoned to Rome to work on the decoration of Santa Maria Maggiore, one of the four major papal basilicas as well as one of the city's seven pilgrimage churches. This was a typical career path for artists on the way up in the sixteenth and seventeenth centuries. Make a mark in one of Italy's many regional court cities and then wait for the call to Rome, where the papacy had the grandest commissions and the greatest budgets on offer. In Rome, Pietro was paid well enough to build a substantial house

alongside Santa Maria Maggiore, and produced his most important work there, a large, complex and uninspiring bas relief of the Assumption of the Virgin as an altarpiece for the baptistery, and a great deal of sculpture for the huge and lavish chapel which Pope Paul V was building for his own tomb and that of his predecessor and patron, Clement VIII. The papal tombs of the Pauline Chapel, as it is known, were grander than any yet built, consciously intended to outdo those of Sixtus V and Pius V, located in their own chapel on the other side of the church. It was a familiar pattern. Papal one-upmanship fuelled the architectural and artistic development of Rome as each new family attempted to overshadow its predecessors with more lavish palaces, chapels and tombs. The Pauline Chapel still dazzles today with rare marbles, lapis lazuli and gilding, proclaiming the arrival of Paul V's family, the Borghese, and at the same time confidently asserting Catholicism as a religion which was both triumphant and *de luxe*. A feature of Clement VIII's tomb is Pietro Bernini's bas relief of the crowning of the pope, and it is generally agreed that the young Gian Lorenzo assisted his father on it, probably carving the pope's portrait, which has a vivacity and truthfulness lacking from much of the elder Bernini's rather generic work. Gian Lorenzo would have been in his early teens at the time. It would be an impressive enough achievement for a young sculptor— were it not that Bernini had already established himself as a boy wonder with two previous portrait busts.

In 1610 or thereabouts the not-yet-teenage Bernini

One wall of the Pauline Chapel in Santa Maria Maggiore, with typically fussy
reliefs by Bernini's father Pietro (1612-4). Gian Lorenzo may have assisted
with the relief at centre top showing the coronation of Clement VIII

sculpted a portrait of the late papal courtier Giovanni San-
toni for his monument in the church of Santa Prassede. Santa
Prassede is one of my favourite Roman churches, small and
ancient, overshadowed now, as it was then, by the bigger and
grander Santa Maria Maggiore. In Santa Prassede, the mosaics
of the San Zeno chapel are among Rome's best early Chris-
tian art and there is also a spectacular and of course dubious
relic: the column used for Christ's flagellation. Amongst these

Bernini, Bust of Giovanni Santoni, c. 1610

treasures it's easy to miss the smaller than life-sized head of Santoni peering out from an oval cartouche on one of the nave pillars. Deftly carved, the bust would be a credible work for a mature sculptor, let alone an eleven year old. Two years later, Bernini made a great artistic leap forward with his portrait of Antonio Coppola, a prosperous and well-connected Florentine surgeon who had endowed a hospital in Rome for his fellow Florentines. The hospital is long demolished, but the neighbouring parish church of the Florentine community in Rome, San Giovanni dei Fiorentini, still stands. Bernini, Florentine by descent though Neapolitan by birth, was commissioned to sculpt Coppola's memorial bust from the physician's death mask. He created a striking and commanding image, referencing ancient sculpture, but also infused with life, thanks to the way Bernini turned Coppola's head and shifted his glance downwards, as if the late physician was quizzically

examining his admirers. Indeed, the Coppola bust is the first hint that Bernini would transform the practice of portrait sculpture, bringing both an emotional depth and a vivacity that had never before been achieved. It is hard to accept it as the work of a thirteen year old, not just because of the beauty of its carving, but more for the remarkable maturity of its psychological insight. Bernini was on his way to accomplishing what had really never been done before, even by his greatest predecessors such as Donatello and Michelangelo: he took this hard, unyielding material and infused it with spontaneity and liveliness. It was an achievement that was enthusiastically received by his contemporaries. The priest and poet Lelio Guidiccioni praised the 'miracles Bernini performs in making marbles speak'. What have become known

Bernini, Bust of Antonio Coppola, 1612

as Bernini's 'speaking likenesses'—of which this was the first hint—reached perfection some years later in 1632 with his celebrated bust of Cardinal Scipione Borghese, but these early efforts show just how high the teenage Bernini was aiming.

In one of the few anecdotes about his childhood that Bernini told and retold—he was an enthusiastic and repetitive raconteur, possibly a bit of a bore—Cardinal Maffeo Barberini came to Pietro's workshop and, having admired one of the young Bernini's sculptures, said teasingly, 'Take care, Signor Bernini, this child will surpass you and will certainly be greater than his master.' To which the elder Bernini replied, 'That doesn't worry me. Your Eminence knows that in this game the one who loses wins.' At least, that's how Bernini told it, implying that his father was lucky to have such a prodigy of a son. Like the few other aspects of his childhood that Bernini mentioned, there was no acknowledgement of the positive role his father must have played in his development as an artist. Bernini consistently portrayed himself as a boy genius, fully formed in childhood thanks to divine inspiration. But his technical skill in carving must have been learned in his father's workshop and, just as importantly, while Pietro Bernini was not one of the top artists in Rome, he was famous enough to be a classic stage father, able to make his son known to significant members of the Roman establishment who could protect and promote the young genius.

In his later years, Bernini, never one for understatement, claimed to have carved the first of his notable portrait busts

at the age of eight. Bernini's self-mythologising makes it hard to establish an accurate chronology of his childhood accomplishments. But whether at age eight or ten or twelve, he was a prodigy beyond doubt and soon came to the attention of one of the most important people in Rome, Cardinal Scipione Borghese.

S CIPIONE WAS THE SON of Paul V's sister and his papal uncle's favourite nephew. Sonless popes needed a family member they could rely on, and Paul made Scipione his cardinal-nephew. Papal nephews had been entrusted with signficant roles from the early Middle Ages, but from the sixteenth century the position became a formal one. At a time when family ties were the most significant guarantee of loyalty, the pope's nephew or *nipote*—from which we derive the term nepotism—as a close relative occupied the highest rungs of the papal court. Scipione was thus the second most powerful figure in Rome. In a further sign of favour, Paul gave him permission to use the Borghese name and coat of arms even though he had been born a member of the less exalted Cafarelli family. As the pope's prime confidant and private secretary, a great deal of power and a much greater deal of money were soon concentrated in Scipione's hands. They were not, admittedly, very clean hands. The Cardinal's passion for his male protégés was notorious. When his friend and lover Stefano Pignatelli was also made a cardinal, an anonymous protestor wrote: 'Why is everyone so surprised? Spain campaigns for her candidates, France for

hers; everyone wants his own man to be made Cardinal. So why shouldn't Cardinal Scipione's penis get what it wants too, its own man in the College of Cardinals?' Scipione was an equally insatiable and unscrupulous collector of art, and also of artistic talent. He arranged to present Bernini to his uncle the pope, who asked the young artist to draw a head of St Paul. Bernini did so with such confidence and speed that the pope exclaimed to his attending cardinals, 'This child will be the Michelangelo of his age!' and rewarded the boy with a handful of gold medals and his continuing interest.

Around 1613 Scipione began building a sumptuous *villa suburbana*, a country house just beyond Rome's city walls, as a showcase for his rapidly growing collection of ancient and modern art. It's now a public museum, the Galleria Borghese, but it was created by Scipione to entertain his friends and to impress those he wished to do business with. Soon his Roman and Greek antiquities and his paintings by Titian and Caravaggio were joined by a series of sculptures he commissioned from Bernini. Between 1621 and 1625, Bernini produced three large works for Scipione, *David*, *The Rape of Proserpina* and *Apollo and Daphne,* which immediately became the villa's star attractions. Bernini's contemporary biographer Baldinucci breathlessly described how *Apollo and Daphne* was received: 'As soon as it was finished such acclamation arose that all Rome rushed to see it as though it were a miracle.' And when Bernini—then in his mid-twenties—walked through the streets of Rome, he 'attracted everyone's eye. People watched him and pointed him out to others as

Bernini, Scipione Borghese (detail), c. 1632

a prodigy.' Bernini's trajectory was steep, and from that time onwards his fame spread throughout Europe.

Even today after the work of so many other sculptors has been absorbed, the three great Borghese Berninis still mesmerise with the beauty and skill of their carving, the boldness of their conception and their sheer energy. For me the most interesting is *David* which, unlike many contemporary depictions of the Old Testament hero, shows him not triumphantly carrying the head of the dead Goliath, but instead captures him just at the moment he is about to hurl his shot at the Philistine giant. The sculpture is also a shot hurled by 'the Michelangelo of his age' at the original Michelangelo,

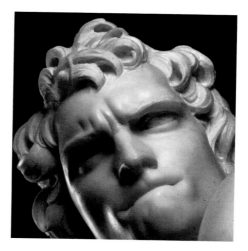

Bernini, David (detail), c. 1623-24

whose *David* had been commissioned by the civic government of Florence over a hundred years earlier. Michelangelo's *David* is a static portrait of idealised male beauty, Bernini's a dynamic proclamation of youthful power and determination, as much about the young sculptor on the threshold of fame as it is about the Biblical duel. That Bernini intended this autobiographical element is clear because we know that the *David* is a self-portrait. As Baldinucci tells us, 'While Bernini was working on the figure in his own likeness, Cardinal Maffeo Barberini came often to his studio and held the mirror for him with his own hand.' Bernini, only in his early twenties, was getting close to the top of Rome's artistic establishment, carving at the command of the most important Cardinal, Scipione, while another of the church's great men, Cardinal Barberini, assisted.

FOR ALL the generosity of Scipione's commissions and encouragement, it was in fact Maffeo Barberini who would have the greatest influence on Bernini's future career. Barberini was elected pope in the summer of 1623, assuming the regnal name of Urban VIII. He was fired with ambitions both for the aggrandisement of his family and the magnificence of his papacy. Self-regarding, talkative, intolerant, æsthetic—he was an early patron of Caravaggio—and greedy beyond even the shocking norms of the time, Urban transformed the young Bernini—still just twenty-four years old—from a 'mere' prodigy of a sculptor to a position of unrivalled artistic dominance in Rome.

Accustomed though they were to opulence and corruption, the Romans were still repelled by the speedily acquired wealth and arrogance of the Barberini family. As usual, only more so, papal relatives were given highly rewarded jobs. The papal historian Mark Roberts reminds us that it was said of the multiplying Barberini that Cardinal Francesco was 'a saint without miracles', Cardinal Antonio 'a friar without patience', Cardinal Antonio the Younger 'an orator without eloquence' and Prince Taddeo 'a general without swordsmanship'.

The family's heraldic symbol, the bee, appeared everywhere in Rome, on fountains, churches and palaces. Even in the heart of the Vatican, bees swarmed around the twisted columns of Bernini's Baldacchino, the bronze canopy he designed to shelter the high altar of Saint Peter's. There must be thousands of the Barberini insects in Rome; no doubt an

BARBERINI BEES ON A CABINET THAT BELONGED TO URBAN VIII
WHILE STILL A CARDINAL (DETAIL)

ambitious PhD student will some day tell us exactly how many. Those bees underline just how important symbolism was in Baroque Rome. The Barberini family grew from an increasingly successful dynasty of tailors who moved thirty-five kilometres north of their home in Barberino Val d'Elsa to establish themselves in Florence. They were originally called Tafani da Barberino. It was not an elegant name: *tafani* means horseflies and three of those malevolent creatures adorned their coat of arms. As the family grew in wealth and status, the horseflies became embarrassing and were replaced by the altogether more appropriate bees, symbols of industry, social order and hierarchy, ideal for a family that reached for and won the papacy.

Maffeo, born in 1568, was three years old when his father died, and he was sent to Rome to be brought up by his uncle Francesco, who was both very rich and a major player in Church politics. He received a Jesuit education at the Collegio Romano and went on to study law at the University

of Pisa, an important training ground for the élite. A Venetian ambassador to Rome described Maffeo on his election as 'exceptionally elegant and refined in all details of his dress', with 'a graceful and aristocratic bearing and exquisite taste. He is an excellent speaker and debater, writes verses and patronises poets and men of letters.' He had also been besotted with Bernini since around 1617 when Bernini was in his late teens. As Bernini's son put it: 'Cardinal Maffeo took complete possession of Bernini as if he were one of his own.' Although Bernini was no intellectual—as far as we know he had little formal education—he was praised for his wit and the fluency of his conversation, some of which he must have owed to Barberini's early tutelage. In the first years of their relationship, Barberini seems to have been more of a

Bernini, Urban VIII, (detail), c. 1637-38

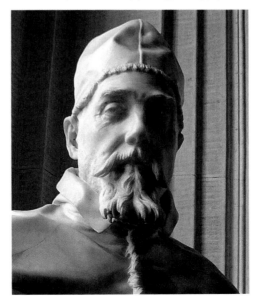

mentor than a patron and did not in fact give Bernini much work, though after his elevation to the College of Cardinals he did ask Bernini to sculpt portrait busts of his mother and uncle. These were relatively modest commissions compared to the Borghese sculptures which were being created around the same time. But everything changed the moment Barberini became pope. As Bernini's son recalled, almost as soon as he was elected, Urban summoned Bernini to attend him, so eager was he to use Bernini's talent 'for the benefit of his pontificate, for this prince of great and glorious ideas was nurturing within himself most noble projects and grand visions'. 'It is a great fortune for you, Cavaliere,' Urban said, 'to see Cardinal Maffeo Barberini made pope, but our fortune is even greater to have Cavaliere Bernini alive during our pontificate.'

BERNINI WAS THUS transformed almost instantly from a jobbing sculptor, albeit the best and most fashionable in Rome, to one of the pope's right-hand men and the virtual artistic dictator of Rome. The 'noble projects and grand visions' brought him numerous appointments ranging from Chief Architect of Saint Peter's Basilica to 'Inspector of the Conduits of the Fountains in Piazza Navona'. Without any formal training in much beyond sculpure, but with supreme confidence and ambition, Bernini turned his hand to whatever the pope ordered. This is not as unusual as it may sound. The divisions between the arts were less rigid in Renaissance and Baroque Italy. Giotto's painting helped

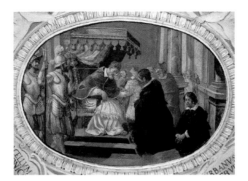

Pope and sculptor at work together: Bernini presents a drawing
for reliquary niches in Saint Peter's to Urban VIII, 1630

to kick-start the Renaissance, but he also acted as architect for the bell tower of Florence Cathedral. Michelangelo effortlessly moved between sculpture, painting and architecture. Bernini's contemporary Pietro da Cortona was equally celebrated for his frescos and his buildings.

Bernini was going to be very busy. With the impending Holy Year of 1625 only eighteen months away, there was the usual flurry of tidying up and rebuilding, as the custodians of Rome's religious heritage made sure that their churches were ready for the expected tens of thousands of pilgrim tourists. When relics of Saint Bibiana, an early Christian martyr and patron saint of hangovers, were discovered, Urban ordered the rebuilding of her church and gave Bernini the job. It was the beginning of his career as an architect. As a sculptor he had a profound knowledge of stone and he was also able to rely on the skills of senior members of Rome's flourishing building trade. The pope also ordered

43

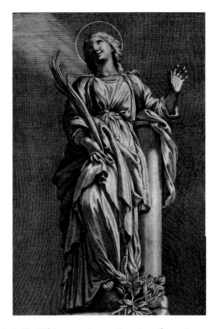

Bernini, St Bibiana, 1624-26, print of c. 1675-1719

a statue of the saint herself for the church and this marks a further step in Bernini's rising status. The full-length statue is the mature Bernini's first major work designed for public display. The great Bernini authority Rudolf Wittkower positively gushed that, with Bibiana, Bernini 'represented the summit of sublime emotions. Religious enthusiasm had never found such realisation in Renaissance or post-Renaissance sculpture.' Personally, I find her sickly and unconvincing. But I am impressed by the cleverness with which the newly expert architect uses a window in the ceiling to shine a heavenly light on Bibiana's face. This is the moment Bernini begins to bring all the arts together to af-

fect the viewer directly, merging the work of art and its context into one grand statement. And Bernini gets well paid for it too: twice as much for the statue of Bibiana as for each of the mythological works he had carved for Scipione. The golden gravy train of Barberini patronage was pulling out of the station, and Bernini was on board.

During the twenty-one years of Urban's reign, a flood of papal commissions came Bernini's way. They included the Baldacchino of Saint Peter's; his work as Chief Architect of Saint Peter's, especially the redevelopment of the four great piers below the dome; the tomb of the Countess Matilda; fountains for the Barberini Palace and the Vatican; a tomb for Urban himself; busts and bas reliefs and designs for medals. For all of these Bernini was handsomely rewarded. Honours and emoluments, not to mention sinecures for his family, had already started to flood in for Bernini in the short reign of Urban's predecessor, Gregory XV. Indeed it was Gregory who had started the ball rolling by making Bernini a Knight of the Order of Christ—after which he was always known by the title *Cavaliere*—in gratitude for an excellent portrait of the pope. So Bernini was becoming grand—and very rich too. But it was the Barberini patronage that accelerated the pace spectacularly.

THIS MAY BE a good time to talk about money. Comparing wages, prices and purchasing power across the ages is exceptionally difficult. Products which were once cheap may now be very expensive, things that now seem to be

Gold scudo of Gregory XV, 1622, approximately actual size

necessities often didn't exist in previous years. In the Papal States the central unit of currency was the Roman *scudo*, divided into 100 *baiocchi*. One *scudo* could buy you a litre of wine, a litre of oil or the services of a street prostitute. A skilled worker, like a mason, earned about 85 *scudi* a year; the average worker got by on 50 *scudi* a year—that is, the equivalent of 50 litres of wine. For his 1612 bust of Antonio Coppola, Bernini—or rather his father, as the teenager was too young to be paid on the books—was paid a respectable 50 *scudi*. Within a few years he was earning some hundreds of *scudi* for each of the marbles he carved for Cardinal Borghese. His 1632 bust of Borghese himself came with a payment for 500 *scudi*. But in this period, before there was a well developed commercial market for artists, the most important commissions often came from potentates who preferred the grandeur of gifts to the grubbiness of invoices. Cardinal Richelieu 'paid' for his portrait bust by giving Bernini a jewel studded with thirty-three diamonds along with a cash payment handled by his assistant Mazarin. Bernini

understood the rules of this game, and as the greatest of artists, practised an equally lordly pricing policy. When Francesco d'Este, Duke of Modena and one of Italy's richest rulers, wished to have his portrait carved, he approached the two leading sculptors of the day, Bernini and his great rival Alessandro Algardi. Algardi came back with a quick and business like quote: 150 *scudi* not including the cost of the marble, the bust to be finished in just over a year. Bernini responded altogether differently. He played hard to get. He couldn't possibly quote a price or delivery date and anyway he 'works only as favour for friends, or at the command of important personages.' Of course the Duke chose Bernini and, when the bust was delivered late the following year, rewarded the sculptor with the astonishingly huge sum of 3,000 *scudi*. With such commissions and his steady stream of work for the papacy, Bernini amassed a fortune somewhere between 300,000 and 600,000 *scudi,* which, however you try to translate it into modern terms, was a very large estate— perhaps only half a million litres of wine, but also 12,000 man-years for an average worker.

WHO WAS THIS spectacularly rich man, who earned every *scudo* from his art? It's difficult to tell. If the artist is well studied, the man is elusive. We do have two contemporary biographies, however, which give us a place to start. One, by his son Domenico, is clearly an act of filial devotion; the other, by Filippo Baldinucci, was written to order for Bernini's patron Christina of Sweden. They are

both relatively good on fact, long on hyperbole and short on insight. The job of the early modern artist biography was more to polish the myth than to display unvarnished truth. So both biographies praise Bernini's skill, intelligence, wit, diligence, piety and transcendent genius. Here's a sample from Domenico's book: 'For the excellence of his accomplishments and the magnitude of the acclamation bestowed upon him, the Cavalier Bernini truly had, and has, no equal in our times. His fame can rightfully count him among the most remarkable men of genius of times past...' There's not much flesh and blood there.

The closest I get to Bernini's personality is the extensive diary kept by the French courtier Paul Fréart de Chantelou, who served as Bernini's minder during the artist's five-month stay in France in 1665. Chantelou was hugely admiring of Bernini's talent, but also keenly aware of his shortcomings: an inseparable trio of arrogance, self-love and petulance. Chantelou was too discreet to name them as such, but their consequences are nonetheless carefully recorded. We will look at Bernini's French trip later, but for now let's have Chantelou's initial description of the artist in his late sixties and at the zenith of his fame. Bernini 'is a man of medium height, but well proportioned and rather thin. His temperament is all fire. His face resembles an eagle's, particularly the eyes. He has thick eyebrows and a lofty forehead... He is an excellent talker with a quite individual talent for expressing things with word, look, and gesture, so as to make them as pleasing as the brushes of the greatest

Bernini, Self-portrait, c. 1635

painters can do.' Chantelou's description is well matched by the many self-portraits Bernini painted and drew, which show piercing eyes, a dark piratical look, and a sense of tremendous physical and intellectual energy. Voluble and volatile, Bernini was very much his Neapolitan mother's son, for all his pride in his Florentine ancestry. His self-assurance—cockiness even—does not seem to have been matched by the same level of self-awareness. Even the late, great self-portrait drawing (see p. 250), which shows clear signs of oncoming frailty, lacks the analysis and penetration that Rembrandt could deploy when painting himself. Like the

biographies, Bernini's self-portraits are only a partial truth, a mixture of how Bernini saw himself and how he wished others to see him. Forever performing, Bernini was naturally the unashamed self-promoter he had to be. Modesty didn't get you far in seventeenth-century Rome.

THIS IS HARDLY surprising. An important part of Italian culture was, and still is, the need to *fare bella figura,* 'to make a good impression'. This is not just about outward show, although this aspect has helped to create global luxury businesses like Armani, Gucci and Ferrari. For individuals, it is about looking right, playing your social role with style, and behaving with the dignity and magnificence appropriate to your actual or aspired station in life. The flip side of *bella figura* was disfigurement, defacement, slashing, a punishment meted out to misbehaving prostitutes and faithless lovers.

In 1636 or maybe 37, Bernini, a bachelor in his late thirties, fell in love. It would have been a good time to make an appropriate match. Here he was, busier and more famous than ever. He had completed the Baldacchino of Saint Peter's to huge acclaim, and was about to begin work on a pair of bell towers to frame the basilica's façade. He had the admiration, the ear and the financial support of the pope. But the object of his passion was hardly a catch in the same league. Costanza, beautiful and in her early twenties, could point to grand ancestors in the past, but her father was merely a footman in a noble household.

Not that Bernini seems to have been daunted in any way. In

fact, he was so in love with Costanza that he demonstrated it in a way that for his time was entirely remarkable. He carved a marble bust of her. Carving a bust is time consuming and expensive, even for a sculptor; but, more importantly, the appropriate subjects of marble busts were grandees, sovereigns, mythological figures and princes of the church. Emphatically not girlfriends. As far as we know, this is possibly the first time in the history of European art that an 'ordinary' woman had been so grandly portrayed. And this marble bust is intensely personal, a love token for Costanza, voluptuous and dishevelled as if she has just tumbled out of Bernini's bed. Or, it has to be said, some other bed; perhaps even her husband's.

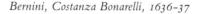

Bernini, Costanza Bonarelli, 1636-37

For Costanza was not a free woman. She was married to Matteo Bonarelli, one of Bernini's assistants. There were many such: demand for Bernini's work required the employment of large numbers of sculptors and craftsmen, about whom we will hear more later. Some of them, like Ercole Ferrata, became well known in their own right. Others, like Matteo Bonarelli, were more reminiscent of Bernini's own father: fine, even outstanding craftsmen, but who lacked the creative spark that could propel them to the top rank.

Worse even than the peccadillo of marriage was Costanza's seduction by—or of, who knows?—Bernini's younger brother Luigi. When he heard of it, Bernini exploded with rage and violence. He ran with a drawn sword through the church of Santa Maria Maggiore hunting Luigi, though in the event, fortunately, he merely beat him with an iron bar and broke some ribs. As for the three-timing Costanza, she was attacked on her doorstep by one of Bernini's servants who, carrying out the punishment of *sfreggiatura*, slashed her face with a razor. Bernini's mother was in such despair over this family feud that she wrote to Pope Urban's cardinal-nephew, Francesco Barberini, begging him to 'rein in the impetuous actions of this her son who by now permits himself all things, almost as if for him there were neither Rulers nor Justice.' Bernini had clearly got too big for his boots: even his mother said so. But the situation was delicate. However outrageous the behaviour, Bernini was an indispensable part of the papal household in his emerging role as image-maker-in-chief. There was simply no other artist who could so

skilfully express the magnificence and power of the Church of Rome. Francesco would have been painfully aware that a solution needed to be found. Bernini was fined and encouraged, perhaps ordered, to get a wife. His errant brother Luigi was spirited out of Rome to a safe haven in Bologna. Costanza was consigned to the Casa Pia, a monastic halfway house between jail and convent for ex-prostitutes and disobedient wives. She was released after four months and went back home to Matteo. Bernini got married. Thus was justice done and face saved—though not Costanza's—in Baroque Rome.

Bella figura also involved being a good Catholic, especially if, like Bernini, you were part of the papal inner circle. Following the Bonarelli affair and his marriage, Bernini the extravagantly jealous lover seems to have become extravagantly religious. Or at least that's what his son tells us: 'Every Friday for the space of forty years, he attended the devotions of the Good Death, at the Church of the Gesù, where

The Gesù in around 1670

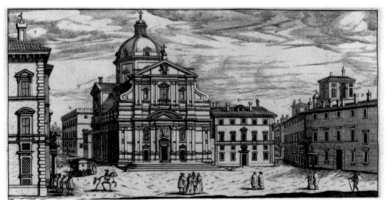

very frequently, at least once a week, he received Most Holy Communion. For the same long space of time, every day, after finishing his work, he would visit that same church where the Most Holy Sacrament was exposed for adoration...' Certainly the Gesù, the huge and opulent mother church of the Jesuit Order, was an important place for Bernini. The Jesuits were at the peak of their influence at the time and leading Jesuits, especially the Superior General Gian Paolo Oliva, were among his closest friends. But it's hard to believe that the busiest artist in Rome could be so regular in his devotions and also that the highly sexed, tempestuous, arrogant man that Bernini so clearly was could quickly morph into such a model of piety. We can never know how sincere Bernini was in his religiosity: in the 'world's theatre' that was Baroque Rome, the principle players assumed multiple parts, and hypocrisy was no sin.

THE RELATIVELY MILD treatment of Bernini over the shocking Costanza episode should not come as a surprise, any more than the lavish rewards he was beginning to receive. In the increasingly luxurious and secular atmosphere of the early seventeenth-century papal court, talent was keenly sought out and zealously protected. Art mattered a great deal in Rome, not just for the æsthetic satisfaction it brought, but because it was understood to be a projection of papal power, exalting the authority of the Church and its supreme pontiff. Painters, architects, sculptors and associated craftsmen were drawn to Rome by this flow of patronage from popes,

papal officials and families on the make, and Rome became the artistic hothouse of Europe. Even unæsthetic popes like Michelangelo's patron Julius II had understood the power of great art as spin and propaganda. Without downplaying the æsthetic achievements of Bernini and his fellow artists, it is important to recognise that the power context in which they worked required that art should be both beautiful *and* useful. Popes spent lavishly on the beautifying of Rome, and this spending had political reasons and political consequences. Nor was this view restricted to Rome. If we look around the other courts and capitals of Europe in what is often called the Age of Absolutism, there is an extraordinary increase in magnificence, as rulers compete with each other to build more lavish palaces, stage more compelling rituals and pageants, and to control and spread their images as wise, benevolent and all-powerful monarchs. Louis XIV's Versailles may be the most spectacular example of such showmanship, but it is not so much exceptional as symptomatic of the age.

ROME, THOUGH, was different, with a greater and more evident history grander than that of any contemporary state. No ruler of the Eternal City could be unaware of the Emperor Augustus' famous boast that he 'found Rome a city of brick and left it a city of marble'. Few of the popes, however, had the time, resources or talent to rise to the challenge and significantly change the urban fabric. Of the ones who did, Alexander VII was certainly the greatest; but we shouldn't forget that earlier if less glamorous predeces-

sors had literally paved the way for Alexander's grandiose achievements.

To understand the history of the triumphant redevelopment of Rome, we need in fact to go all the way back to the Great Schism of the fourteenth century. In 1378 Christian Europe was fractured when French resentment at the election of the deranged Italian Pope Urban VI—who had executed five of his own cardinals and proved his madness to contemporaries by condemning corruption in the Curia—led the French king to choose his own pope. For the next thirty-nine years, there were two, sometimes even three, rival popes and Rome, no longer the sole papal capital, suffered. When, finally, the rift was healed with the coronation of the Roman aristocrat Odo Colonna as Pope Martin V in 1417, the new pope found Rome 'so ruinated that it looked nothing like a city... the churches fallen down, the streets

Martin V (reigned 1417-31)

empty, the city full of dirt and mire and in extreme want of all sorts of provisions... There was neither the face of a city nor any sign of civility there.' Indeed the Rome that Pope Martin found on his entrance was an awesome, but sorry sight. Ancient Rome had been home to a million people: after centuries of mediæval decline the population hovered around a mere 100,000, huddled in a few neighbourhoods within the third-century Aurelian walls, most especially on the left bank of the large bend of the Tiber, the district centred around the Pantheon. The Roman Forum, once the heart and brain of the world's greatest empire, was neglected, overgrown and popularly known as the *campo vaccino*, 'the field of cows', a place for grazing cattle. Whole areas of the once densely populated ancient city were now the *disabitato* or uninhabited zone.

Martin set to work immediately improving his city, and Rome increasingly became a building site, with new or improved roads, churches, fountains and monuments. For the next two hundred and fifty years Rome was to be liable to spasmodic, spectacular growth spurts. As the leading historian of the building of Rome has discovered, 'between 1550 and 1650, some 150 palaces were either built *ex novo* or substantially rebuilt and expanded, as were about 300 churches'. It's hardly surprising, then, that by Bernini's time one third of all Roman workers were employed in the building trades.

Overleaf: Rome in c. 1561. Even in the mid-16th century less than a third of the area within the Aurelian walls is built up. The Pantheon is visible, surrounded by houses; the Colosseum and the Forum, towards the centre of the area walled in by the ancient Romans, are beyond the outskirts of the inhabited area

Grotta ferrata

Marino

Via Latina

Cerchis di Caracalla

S. Lorenzo

Via Tiburtina

Via Prenestina

COELIVS

ORIENS

VIVARIVM

EXQVILINVS

VIMINALIS

QVIRINALIS

COLLIS HORTVLORVM

SEPTENTR

GAB. PALAEOTIO PONTIFICIO STLITIB IVDICAN
DIS DVODECIMVIRO INTEGERRIMO

Expressi tandudum mi Reuer: Dñe meis æneis tabellis Io. Antonij
Dosij floren. manu delineatis Vrbem Romam Vrbium, ac Terrarũ,
gentiumq; omnium, Reginam qualis qualis his temporibus apparet,
æ, ut ea in lucem prodiret audentius, tuo nomini dicata exit, quod hu-
iusce Vrbis te amantissimum fuisse semper accepi: proinde editam
tibi, do, dicoq, ac trado. Vale Bartptolemei Phaletij tui nominis semp
obseruantissimi memor. Romæ Calendis Ianuarij ꝏƆLXI.

Sebastianus a Regibus Clodiensis in ære incidebat

PORTÆ.		PONTES	11 Aq.Daccia.
A. Porta Flaminia nunc Populi.	N. P. Fontinalis nunc Sephmiana.	1 Pons Aelius vulgo S. Angeli.	THERMAE
B. P. Collatina nunc Pinciana.	O. P. S. Spiritus.	2 P. Ianiculus vulgo S. Xisti.	12 Thermæ Diocletiane.
C. P. Collina nunc Salaria.	P. P. Torrionis.	3 P. Fabricius vulgo 4. Capi.	13 Th. Constantiniane.
D. P. Viminalis nunc S. Agnetis.	Q. P. Posterula Pertusa et Vaticani.	4 P. Certius vulgo S. Bartholomei.	14 Th. Antoniane.
E. P. Esquilina nunc S. Laurentij.	R. P. S. Petri.	5 P. Palatinus vulgo S. Mariæ.	15 Th. Titiane. vulgo 7 S
F. P. Prenestina nunc Maior.	S. P. S. Angeli alias Cartelli.		AMPHITHEATRA
G. P. Coelimontina nunc. S. Ioannis.		AQVÆ ET AQVÆDVCTVS	16 Amp. Vespetiani dicitũ
H. P. Latina.		6 Aqueductus Claudie.	17 Amp. Castrense.
I. P. Capena nunc S. Sebastiani.		7 Aquæ Marciæ.	18 Theat. Marcelli.
K. P. Ostiensis nunc S. Pauli.		8 Aq. Auguste.	
L. P. Naualis nunc Porturiu.		9 Aq. Virginis vulgo fons Triuij.	
M. P. Ianiculensis nunc. S. Pancratij.		10 Aq. Cabra vulgo la Marana.	

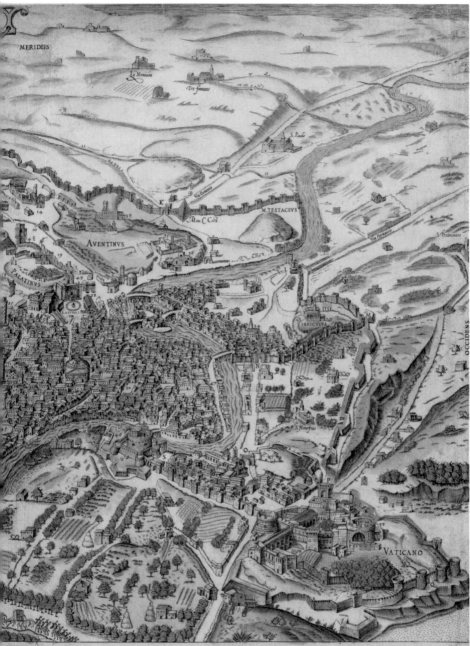

CIRCI	TEMPLA		VARIA
...cus maximus vulgo Cerchi.	26 Pantheon vulgo la Rotonda.	37 .T.S.Saui.	44 Villa Iulij III.
...cus Agonalis.	27 Templum Lateranense.	38 .T.S. Gregorij.	45 Mausoleum Aug.
ARCVS	28 .T.S. Marie maioris.	39 .T.S. Stephani rotondi.	46 Moles Adriani Castel S. Angelo.
...re. Claudij dictus di Portugallo.	29 .T.S. + in hierusalem.	40 .T.S. Clementis.	47 Domus Fernesior.
...re. Iani quadrifrontis.	30 .T. Trinitatis.	41 .T.S.Laurentij in palisperna.	48 Septizonium Seueri.
...re. Titi Vespesiani.	31 .T.S. Marie Populi.	42 T.S. Petri ad vincula.	49 Forum Boarium.
COLVMNAE	32 T.S. Petri.	43 T.S.Ioan. ante portam latinam.	50 Beluedere.
...olum Antonini.	33 .T.S. Petri in monte aureo.		
...olum Traiani.	34 T.S. Marie in Trastiberi.		
	35 .T.S. Sabine.		
	36 T.S. Alexij.		

Martin's fourteen-year reign brought the early Renaissance to Rome. He employed leading Florentine artists such as Masaccio and Ghiberti, and set to work restoring the Vatican and Lateran, the Pantheon and the Capitol. Significantly for the future of the city, he reinvigorated the office of the *maestri di strada*, the magistrates of the roads, who had powers to repair and improve Rome's neglected streets and bridges. Through a papal bull of 1425 he made these previously civic officials part of the machinery of his government, marking the beginning of a more intense involvement by the popes in the development of the city.

The continued improvement of infrastructure, the widening and straightening of streets, the building of bridges, the modernisation of the water supply, were all matters of urgency for a succession of popes, and vital if Rome was to reclaim its place as the capital of the world. It was not just a question of the glorification of God and the Church. It was also essential to invest constantly in attracting and managing an ever-larger number of visitors to the city. The need for such improvements could even be a matter of life and death. During the Holy Year of 1450 an ancient Roman bridge, the Ponte Sant'Angelo, collapsed under the strain of the crowds, and hundreds of pilgrims were drowned in the Tiber. But Holy Years were very good news indeed for those who owned or worked in inns and shops and taverns, for the sellers of religious artefacts, the hirers of horses, the barbers and beauticians, the physicians and tailors and booksellers and prostitutes of the Eternal City. From 1475 the

Holy Years were doubled in frequency to once every twenty-five years, and by 1600 there were half a million pilgrims to be welcomed. Taking good and profitable care of them was a major task for the state.

A generation after Martin, Pope Sixtus IV strengthened the powers of the maestri di strada to make them in effect the planning authority for Rome. He also brought them even more closely under papal control by putting them on his payroll. Sixtus was clear about his intentions towards Rome, describing himself as 'Urbis Restaurator', the re-builder of the city, and writing that 'amongst countless other cares we must also attend to the purifying and beautification of our City, for if any other city should be clean and fair, certainly this one, which is the head of the world, should

Sixtus IV (reigned 1471-84)

be...' While previous popes had built, enhanced or restored churches and chapels, Sixtus was the first pope to take a comprehensive view of Rome, based both on the need to provide a great setting for his papacy and to address the vital but mundane issues of moving visitors and residents around the city. Anticipating the needs of the pilgrims who would arrive for the Holy Year of 1475, he built a new bridge—the Ponte Sisto—in response to the tragedy of the Sant'Angelo bridge. He also began the long process of straightening Roman streets and paving Roman squares, which were all too liable to turn into quagmires in wet weather, with brick (replaced in the longer term by the small black *sampietrini* stones that remain such a recognisable feature of Rome). And he addressed the issue of the city's unreliable and limited supply of water by restoring an ancient Roman aqueduct, the Acqua Vergine, which to this day supplies water to some of Rome's most famous fountains, including the Trevi and two of those in Piazza Navona.

Not wishing to let anyone forget his public works, Sixtus plastered Rome with over a hundred Latin inscriptions extolling his projects. So, for example, anyone approaching the pope's new bridge would be informed that 'You who cross over by means of the gift of Sixtus IV, ask God to save and preserve for us for a long time the best supreme pontiff. And blessings to you, whoever you are, when you will have prayed for these things.' Such inscriptions have been part of the Roman cityscape since at least the first century BCE, and the popes used them lavishly, hoping to immor-

The Ponte Sisto as it looked in Bernini's youth, c. 1595

talise themselves and their good intentions and, in an age before mass media and advertising, perhaps to address the concerns of the people who were perpetually disgruntled by high taxes and extravagant spending. The people, however, couldn't read Latin.

L ESS THAN forty years after the death of Sixtus IV, the religious consensus in Europe was shattered by the Reformation: the pope's monopoly on spiritual authority was gone forever. The Church, shaken by the speed and popularity of the Reformation, regrouped; and over eighteen years' worth of conferences known collectively as the Council of Trent (1545-63) worked out a strategy for confronting the Protestant challenge. Among the bundle of policies emerging from Trent was a restatement of the value of the arts in promoting Christian belief. Contrary to Protestant

63

discomfort with visual display, the Church of Rome declared that through the arts 'the people [should] be instructed and confirmed in the habit of remembering and continually revolving in mind the articles of faith.' Painting and architecture, sculpture and music would all become weapons in the battle for souls.

In 1585, almost exactly a hundred years after Sixtus IV vacated the papal throne, the next great builder pope, Felice Peretti, was elected. Peretti took the regnal name of Sixtus V in tribute to his predecessor, with whom he shared both membership of the Franciscan order and ambitious visions for his capital. Romans looked forward hopefully to the reign of the new Sixtus. Thanks to the maladministration of his immediate predecessor, Gregory XIII, Rome was going through one of its periodic bouts of chaos and uncertainty: banditry flourished and the papal treasury was bare. Sixtus imposed discipline on the messy papal finances and ruthlessly suppressed the Roman crime wave. (He seemed to enjoy his role as a hard man. Replying to four arrested brothers who asked for mercy, he told them that 'as long as I live all criminals must die.') And he brought a grand conception of Rome which has earned him recognition as one of the great fathers of urban planning.

Sixtus' vision for post-Tridentine Rome was to link the seven pilgrimage churches of Rome together with a network of broad, straight roads and to signpost the squares around them with ancient obelisks dragged from the ruins. It was a huge undertaking and Sixtus was fortunate to

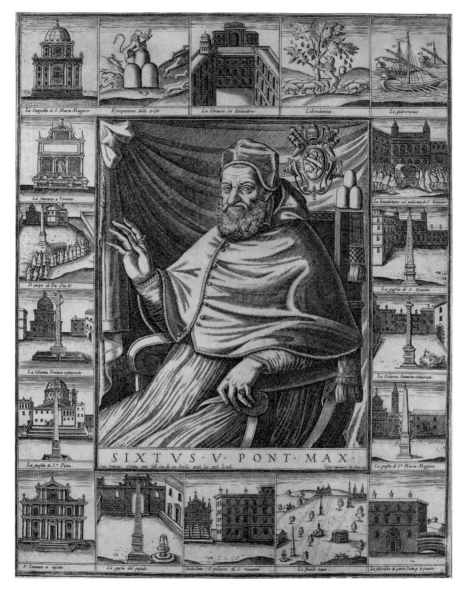

Sixtus V (reigned 1585-90), surrounded by his achievements, with obelisks prominent. Second from right at the bottom is a sketch plan of the new roads linking the pilgrimage churches

have the architectural and engineering skills of Domenico Fontana. Fontana, a northerner from distant Lake Lugano, praised the boldness and usefulness of the pope's plans which meant that 'everyone either on foot, on horseback or in a coach can arrive almost straightforwardly from any part of Rome to the most famous churches, and, since these roads are always full of people, houses and shops are extensively being built there.' Sixtus understood that making it easier for people to move around Rome would both increase church visiting and encourage the economic development of previously neglected parts of the city. No wonder Fontana went on to praise Sixtus, who 'with such an amazing soul and at unbelievable cost built the mentioned roads… no matter the hills or valleys which stood in his way.'

After only five years as pope, Sixtus died of malaria in 1590—a reminder of how hazardous the Roman climate was until the early twentieth century—with many of his plans unfulfilled. Yet in that short time he had reaffirmed the importance of the grandeur and beauty of Rome to the future of the Church and bequeathed a compelling vision of the city to his successors. 'There are so many novelties, buildings, roads, squares, fountains, obelisks and other wonders which Sixtus V, God bless his soul, built to embellish this dry old lady,' a pilgrim wrote, that 'thanks to that fiery and enthusiastic spirit, like a phoenix it was resurrected from the ashes into this New Rome.' As the twentieth-century American city planner Edmund Bacon put it, with Sixtus's innovations 'the idea of order has been implanted.' And this

idea of order was pregnant with the great Baroque city to which Alexander and Bernini gave birth.

B UT WAS ROME's increasing grandeur anything more than an exercise in smoke and mirrors? As a secular ruler, the pope could not compete with his fellow sovereigns. The Papal States' population of a million or so was tiny compared to that of France or of the far-flung Habsburg dominions. The pope had no standing army and relied on mercenaries. Moreover, from around 1600, just after Bernini's birth, the economy of the whole of the Italian peninsula began to decline as it shifted from the industrial and commercial economy that had created the great Renaissance fortunes to an increasingly agricultural one. The Italians had been innovators in woollen manufacture, in banking and shipping; now the action was shifting radically away from the Mediterranean as the Dutch, the English and the French took the lead in what used to be Italian specialities. For all the display of riches, the reality was that throughout all of Bernini's life Italy was becoming ever less important economically. This decline made the pope's spiritual and diplomatic power, and how that power was portrayed, all the more critical.

The reforms and the strategy elaborated at Trent were vital in pointing the way. So successful were they at reinvigorating the Church and rebuilding its confidence that, by the time the Bernini family arrived in Rome in 1606, the Counter-Reformation had evolved into what has justly been called a Catholic Restoration.

Only twelve years later, in 1618, however, the opening salvo was fired in what became the tragedy of the Thirty Years' War. Marked by savagery, horror and a contempt for civilian suffering unequalled until the Second World War, the conflict eventually involved almost every dynasty and nation state in Europe and caused at least eight million deaths, at a time when the population of Europe was around 75 million. The spark was the Holy Roman Emperor's threat to the religious freedom of Bohemian Protestants; the conflagration involved thirty years of armies criss-crossing Central Europe, bringing not just death in combat but also pillage, plague and famine. The war made strange bedfellows too. Ostensibly a struggle between Catholics and Protestants, it saw Catholic France allied with Protestant powers to contain the power of their Catholic rivals, the Habsburgs; Muslims supporting Protestants; and Protestant England sometimes for, and sometimes against, the Catholic Holy Roman Emperor.

Although the Papal States were never more than a minor military power, the Church had long played a role in sorting out European conflicts, thanks to the pope's status as head of the one universal church to which all his fellow European rulers subscribed. That consensus was broken by the Reformation, but popes still aspired to be peacemakers and maintained an ever-growing network of papal ambassadors, or nuncios, throughout Europe. It was his work as one of these diplomats labouring in the lengthy, failed attempts to bring the Thirty Years' War to an end, and to reassert some

sort of continent-wide papal authority, that brought the up-and-coming Fabio Chigi to prominence. Eventually Chigi parlayed prominence into elevation to the papacy; and, as Alexander VII, he became Bernini's greatest and most ambitious patron.

T HIS IS the moment to look briefly at Fabio Chigi's background, life and achievements, in order to understand the context of his partnership with Bernini. Born into a prominent and influential family of bankers from Siena, he was the great-nephew of Agostino Chigi, the most opulent and successful financier of the High Renaissance. Agostino amassed huge wealth as the banker for Julius II, the pope who commissioned Michelangelo to decorate the Sistine Chapel. In gratitude for financial services rendered, Julius adopted Agostino and his brother, making them members of the powerful della Rovere family. Apart from his role as a banker, Agostino also had major commercial and industrial interests in the salt trade and the mining of alum (vital for tanning leather and dying cloth). A man of great appetite and refined taste, he built an exquisite villa near the Vatican where he installed his mistress and entertained lavishly among extensive frescoes by Raphael and Sebastiano del Piombo. After Agostino's death, the family fortune was dissipated, and his collateral descendent Fabio was raised in grand if constrained circumstances, though well aware of his ancestral heights. Sickly, clever and pious, Fabio was clearly destined for a career in the Church. He studied philosophy, theology

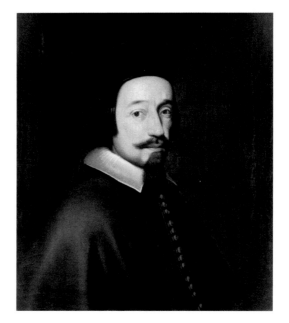

Chigi when papal nuncio, c. 1646

and law at the University of Siena, and then went on to Rome, where he associated with a number of prominent Jesuits. Before long he was talent-spotted by Pope Urban, who admired his abilities as a poet and Latinist and appointed him as vice-legate, or papal representative, to Ferrara, before sending him to Malta with the job of inquisitor and papal visitor. The four years in Malta were an administrative triumph, but the heat was a disaster for Chigi's health as his lifelong kidney problems got worse. After lobbying by an influential friend, the Jesuit poet and academic Sforza Pallavicino, Chigi was transferred north as nuncio at Cologne, a key city-state within the Holy Roman Empire and a

significant player in the religious conflicts of the time. But the transition from the Mediterranean sun to the cold and damp of the Rhine Valley only damaged Chigi's health yet further. Over his thirteen years in the Rhineland, he lost all his teeth, and his kidney stones became even more painful. Paler and frailer than ever, he laboured to assert papal influence as the great powers of Europe slowly moved towards the peace treaty that would bring the misery of the Thirty Years' War to an end.

When not focussed on the enrichment of his family and the beautification of Rome, Chigi's master Urban VIII had struggled to establish a grand and influential foreign policy. The Italian peninsula was on the margins of the Thirty Years' War and this seems to have encouraged Urban to pursue a somewhat reckless foreign policy close to home, aimed at consolidating and expanding his own secular realm, the Papal States. Urban's extravagant spending on Saint Peter's and other Roman projects, his relentless enrichment of his own family and the cost of his war against the neighbouring Duchy of Castro, blighted the last years of his reign and paved the way for a violent reaction against the Barberini family. Inspired by his namesake Urban II, the eleventh-century pope who inspired the First Crusade, Urban also hoped to create a pan-European alliance that would drive the Muslim Turks out of the Mediterranean. It never happened. He also tried to retain papal primacy at the top table of European diplomacy, making unsuccessful efforts to mediate an end to the Thirty Years' War in 1635 and again in 1638.

The tangle of alliances, the complexity of protocol, the suspicion and cynicism created by a seemingly endless conflict, all conspired to make peace seem ever more distant. But the diplomatic wheels kept turning and in late 1641 a preliminary peace treaty was agreed, paving the way for a full-scale peace conference. This was delayed, inevitably, by disputes over precedence, procedure and accreditation, but finally, in December 1644, delegates from all over Europe gathered in Westphalia. Gathered, but hardly together. So bitter was the hatred that the Protestant powers convened at the town of Osnabrück while the Catholics met thirty miles away in Münster. Altogether, 176 delegates were there to represent 196 sovereigns: with the exceptions of Poland, Russia, Turkey and England, every power in Europe had a place at the conference. Attempting to preside over at least part of this nightmarish cocktail of big and little power

The Dutch envoy arriving in Münster, 1644

politics and confessional differences were the two Catholic mediators, the Venetian ambassador, Alvise Contarini, and the papal nuncio, Chigi.

THERE WAS a further complication. Urban had died four months before the peace talks began. By the time of his death, hatred and resentment of the Barberini could barely be contained. Urban's grand projects had drained the public coffers and, coupled with the lengthy, expensive and badly managed war to conquer the Duchy of Castro on the border with Tuscany, had meant ever higher taxes, ever more expensive bread and even less than the usual, minimal public services. Urban had been an exemplary prince of the seventeenth-century Church: sophisticated, erudite and astonishingly greedy. His death triggered a paroxysm of physical and verbal violence.

Destroying the statues of unpopular popes had become a customary feature of the *sede vacante*. Michelangelo's bronze of Julius II had fallen victim to a mob in Bologna in 1511, and in 1559 Paul IV's statue had been decapitated and the late pope's sculpted head dragged through the streets of Rome for four days by a howling crowd. As news of Urban's death became known, a mob rushed to the Palazzi dei Conservatori on the Capitoline Hill aiming to destroy Bernini's marble statue of the late pope installed in the council chamber there. They arrived to find armed guards, locked doors and boarded-up windows, and headed instead to the nearby Collegio Romano where a less formidable stucco

statue of the pope was undefended. Forty-five minutes later it was dust. Then rumours spread that there was a portrait bust of Urban in Bernini's studio: the Barberini sent a posse of armed guards to protect it and, while the mob was distracted, the bronze was sent to Spoleto, where it can be seen today in the cathedral. But Bernini's relief was only temporary. While the physical violence stopped, the rhetorical abuse continued. As a contemporary report put it: 'The people vented themselves against dead pope Urban VIII and the Barberini with injurious words and with the pen, writing of him every evil; wherewith were published an infinite number of compositions in Latin and in the vulgar tongue, in prose and in verse... Some were bizarre and facetious, others satirical and stinging, and others too sharp and unworthy of a Christian.'

Bust of Urban VIII safely installed above a door in Spoleto Cathedral

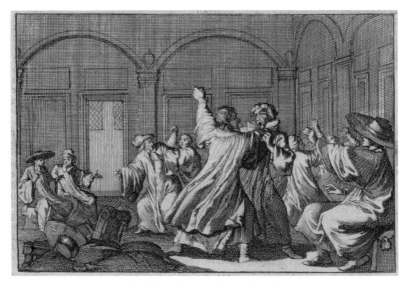

Cardinals brawling at the conclave of 1644

Six weeks of chaos followed while the conclave sat to choose the next pope. We can imagine Bernini's anxiety. Would his career be wrecked by his long and profitable relationship with the hated and discredited Barberini? Such parochial issues carried little weight in the deliberations at a time when all the main pressures were international. Urban had been widely thought of as pro-French, so the political manoeuvring around the choice of his successor was feverish. Cardinal Mazarin, who was one of the papal electors as well as the chief minister of France, tried and failed to secure the election of another pro-French pope. With the enthusiastic backing of Habsburg Spain, Giovanni Pamphili, former nuncio to Madrid and scion of a great Roman family, became the new pope, taking the name of Innocent X.

The Possesso of Innocent X, the solemn procession from the Vatican to the Lateran, that inaugurated the papal reign. The Pope is seen in a litter in the second row from the bottom, preceded by the maestri di strada

This was a generic print, reissued with the new pope's portrait and name hurriedly inserted. In fact Innocent broke with tradition and the procession culminated at the Piazza Navona, his family seat

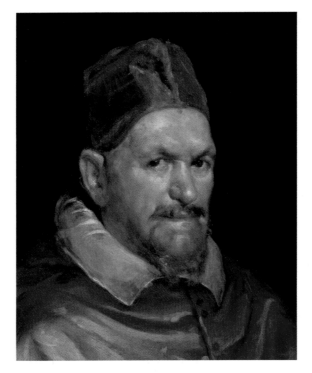

Circle of Velázquez, Innocent X, 1650

THIS WAS BAD NEWS for Bernini. Innocent began a savage persecution of the late pope's family and legacy; the Barberini fled Rome for exile in France. Bernini was unprotected, tainted. As his contemporary biographer Baldinucci tersely put it, 'When Innocent X was elevated to that supreme office, a vast field of intrigue opened up against Bernini with little regard for the memory of Urban VIII.' Papal favour almost immediately turned to Francesco Borromini, a former assistant of Bernini turned bitter rival. Then there was what could be called the affair

of the bell towers. Urban had commissioned Bernini to construct two bell towers on either side of the façade of Saint Peter's. There were sound æsthetic reasons to do so. Carlo Maderno's façade of the basilica was thought to be too wide, and framing it with bell towers seemed like a good way to correct the proportions and add greater dignity to the building. But the engineering was tricky and the Vatican subsoil unreliable. Almost as soon as the first tower was finished, cracks began to appear. There were fears that the whole façade would crumble. A committee of investigation was established. Bernini was blamed. The bell tower was demolished by papal order in 1646. It seemed that a brilliant career was ending in disgrace.

The foundation stone of Bernini's bell tower for Saint Peter's,
broken up after the tower's demolition

Bernini, Truth Unveiled by Time, 1645-52

Bernini's fame, however, was his insurance policy. In spite of Innocent's disinclination to employ him, there were more than enough commissions to keep the workshop busy and to pay for the increasing grandeur of Bernini's large, recently acquired house in the Via della Mercede. But having been the favourite of previous popes, Bernini did not like being shut out by the incumbent, especially when the biggest, most lucrative and most prestigious jobs were all in the papal gift. More in anger than regret, he began carving a large allegorical sculpture of *Truth Unveiled by Time,* a not even thinly disguised message that his overwhelming talent would ensure his eventual return to favour. In the event, Bernini did manage to finish the more than life-sized figure of Truth, but he was in the pope's good books before he got around to Time.

Innocent's family power base was the neighbourhood of the Piazza Navona, with a grand palace and a very large church—Sant' Agnese in Agone. Innocent wanted to further embellish 'his' square with a major new fountain featuring a recently discovered obelisk. In terms of prestige, fountains were of great importance in Renaissance and Baroque Rome, bringing supplies of fresh water deep into crowded neighbourhoods and offering the opportunity for grand architectural gestures commemorating their patron's largesse and care for the public welfare. Rome's most important architects, with the exception of Bernini, were invited in 1647 to submit their ideas for the Piazza Navona fountain. By this time, Bernini had had enough of the papal cold shoulder

and resorted to subterfuge to enter the competition. With the possible aid of his friend Prince Niccolò Ludovisi, he had a large-scale model made of solid silver of his design put on display in the house of Innocent's powerful sister-in-law Donna Olimpia Maidalchini on a day when the pope was due to dine there. As recounted by Bernini's son, Innocent was dumbstruck. He immediately recognised the model as the work of Bernini and announced that 'We must now have no choice but to employ Bernini... anyone who does not want to use Bernini's designs must simply keep from even setting eyes on them.' It may or may not be a true story, but it is certain that somehow Innocent saw a model of Bernini's proposal and decided to hire him. After being ignored for a little over three years, Bernini had returned to papal favour. Relieved and gratified, he kept *Truth* in his studio as a symbol of his success and specified in his will that his descendants should never sell it.

Piazza Navona's Fountain of the Four Rivers, unveiled in June 1651, is the most spectacular monument of Innocent's reign, a masterful work of sculpture and engineering which daringly balances a huge obelisk on a sculptural base in which personifications of four of the world's great rivers are ranged around a large void making the obelisk appear to float above the water. The original silver model with which Bernini impressed the pope has long vanished, but such was the awe and curiosity that the fountain inspired that a large gilt bronze model of it was ordered by Innocent and sent as a diplomatic gift to Philip IV of Spain. However, the

Bernini, Lower section of model of the Piazza Navona fountain, c. 1647

Roman populace whose taxes helped to pay for it were less impressed than the pope, the king and future generations of tourists and art historians (not to mention Eiffel, who is sometimes said to have been inspired for the shape of his Tower). In Rome the popular refrain at the time was '*pane, pane, non fontane*' or 'bread, bread, not fountains'.

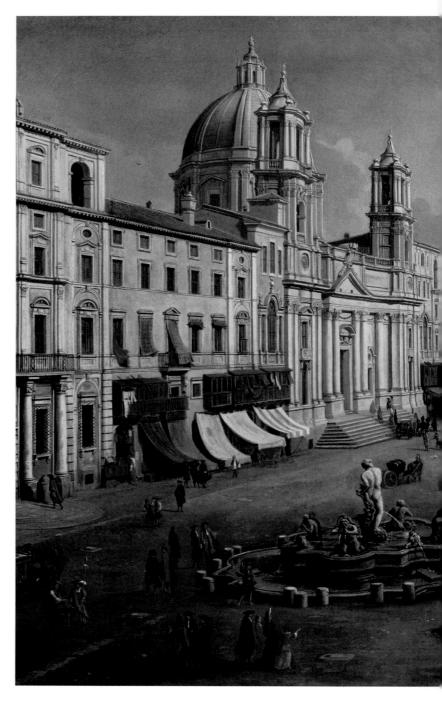

Piazza Navona in 1699 (detail of a painting by Gaspar van Wittel).
The Pamphili palace is to the left of the great church of Sant'Agnese

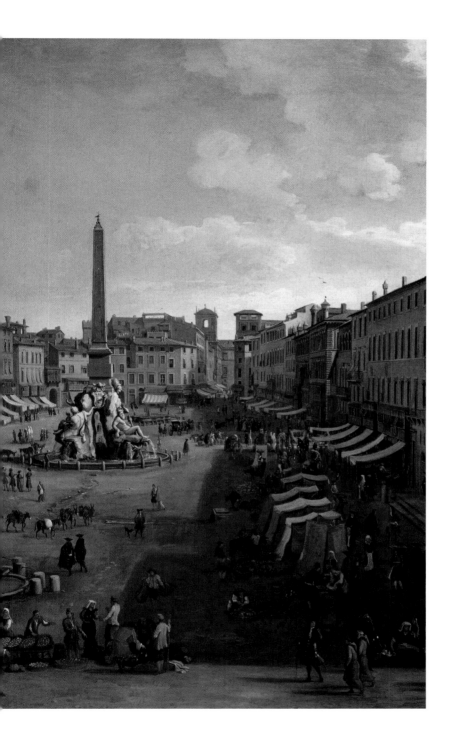

I N SPITE OF Innocent's campaign to rid Rome of all Bar-
berini influence, he was content for Urban's protegé
Fabio Chigi to continue as a papal ambassador. The peace
negotiations to end the Thirty Years' War dragged on, with
month after month of shuttle diplomacy between Münster
and Osnabrück, between sovereigns and their ambassadors,
between allies and enemies, all the while further impeded by
the need to translate documents from Italian to French to
Latin and by discussions of diplomatic niceties. Chigi grew
ever more frustrated, complaining that, 'In Münster cere-
monial has taken the place of peace negotiations, against all
reason.' The gloomy Westphalian weather reflected the lead-
en pace of progress. Chigi amused himself by writing a long
poem, *On the Rains of Münster.*

All the while, the opposing armies fought on, hoping for
a breakthrough victory that would provide them with the
leverage they needed to sign an advantageous peace. The
end came suddenly, with a string of Franco-Protestant vic-
tories in the spring and summer of 1648: the Holy Roman
Emperor, Ferdinand III, decided that his Catholic Alliance
simply couldn't go on. In October 1648, after nearly four
years of negotiation, peace treaties were signed at Münster
and Osnabrück which together are known as the Peace of
Westphalia. When the ink dried it was clear that thirty years
of the most extreme suffering hadn't significantly changed
the map of Europe. The Netherlands and Switzerland were
recognised as independent states, Sweden expanded its Baltic
territories, France gained a foothold on the Rhine. In terms

of religious practice, the Holy Roman Emperor's attempt to reimpose Catholicism, which after all had started the whole affair, was reversed. Perhaps the Thirty Years' War could be judged as a marginal win for the Protestants, but its real significance was in marking the start of a new form of European politics, in which reasons of state replaced religious belief as a motivating force. Cardinal Richelieu and his successor Mazarin knew that an alliance with Protestant Sweden was good for Catholic France and were consequently deaf to papal pleading. For our story, for Bernini, for Rome, the greatest consequence of the Thirty Years' War was the death knell of papal political influence and the growing power and aggression of France under its young king, Louis XIV.

DESPITE ALL the diplomatic labours expended by Chigi and his colleagues, the Peace of Westphalia also demonstrated, irrefutably, that the pope's role as European negotiator-in-chief and peacemaker was broken. Innocent was so distressed by the terms of the Peace that he issued a document, *Zelo Domus Dei,* furiously denouncing those aspects of the treaties he thought were detrimental to the Church. In many ways, Chigi, as the pope's man on the scene, had failed, but he had failed in a task in which no one could have succeeded. He returned to Rome a disappointed man, but was nonetheless rewarded for his hard, if ineffective, work with promotion to papal secretary of state in 1651. This appointment catapulted Chigi to the highest levels of the Roman court. The cardinal-nephew and the

secretary of state were the pope's two closest confidantes. While the cardinal-nephew was much more richly remunerated—after all he was a member of the papal family—the secretary of state was increasingly more powerful thanks to his greater control of correspondence, diplomacy and administration. And Chigi was more powerful than most secretaries of state had been because Innocent's cardinal-nephew was neither strong nor clever (and was eventually expelled from Rome in disgrace). So Chigi was back in Rome as Pope Innocent was entering his late seventies. There would be a papal election before too long and the new secretary of state was inevitably being talked up as a possible successor. From Bernini's point of view these developments were entirely positive. Innocent had supported him, but reluctantly; there was no warmth between them. On the other hand, Bernini and Chigi were on the closest terms.

THEY MAY WELL have met earlier in their careers, but real friendship blossomed shortly after Chigi's return to Rome, when the two men met in a cardinal's antechamber in the Vatican Palace. As Bernini's son described the encounter, it was love at first—or perhaps second—sight: 'Such were the greetings and displays of esteem exchanged between the two men that one could well comprehend, from that moment on, the depth of the hitherto hidden mutual attraction with which talent binds the spirit of her disciples. From this reciprocal esteem there was readily born between the two men a most tenacious reciprocal bond of friendship and

affection, which was then to grow, ever advantageously, with the passing of the years.' Thus began a sixteen-year partnership between the future pope who had the soul of an artist and the artist who had the soul of an imperious pope.

Their first joint project was the restoration and improvement of the Chigi family chapel in the church of Santa Maria del Popolo. Nearly 150 years after its design by Raphael the chapel was unfinished and neglected—an embarrassment to the future Pope. The church is prominently sited, right next to the most important gateway through which foreign visitors entered Rome. Chigi who had recently been appointed Cardinal priest naturally wanted the chapel to exalt his family and also perhaps to signal his future ambitions. The job suited Bernini too. He had already challenged Michelangelo with his own *David*, now by finishing Raphael's work, he was clearly establishing himself as the equal of the other great Renaissance master too. Bernini created portrait medallions of the Chigi ancestors for two pyramidal shaped tombs—another example of Egypt in Rome—and carved two great statues, *Daniel* and *Habakkuk,* to create a chapel newly fit for a would-be Pope.

Work was still continuing on this commission when Innocent died in January 1655. Once again, the papal election was lengthy and highly political; and once again it pitted French interests against Spanish. Cardinal Giulio Sacchetti was again the leading contender, enthusiastically backed by Cardinal Mazarin and the French. Consequently the cardinals were told that the King of Spain was effectively

Wide-angle view of the Chigi Chapel in Santa Maria del Popolo, with the pyram-
idal tombs to right and left, and Habbakuk and the Angel
in the niche to the right of the altar (1652-55)

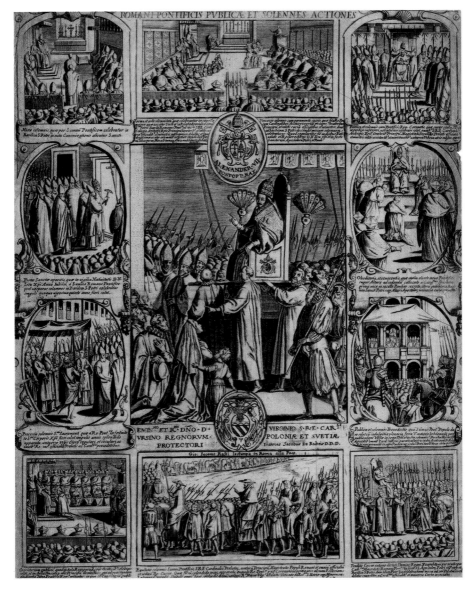

The public and solemn deeds of the Roman Pontiff 1655. Following the example of Sixtus V, Alexander VII declared a Jubilee for his accession, and this print shows the various ceremonies involved

vetoing Sacchetti's candidacy. The French then announced that they would veto Chigi. After eighty days of wrangling and a last-minute plea by the also-ran Sacchetti that France should drop its opposition, Chigi was elected with the backing of an energetic group of independent cardinals known as the *squadrone volante* or flying squad, and took Alexander as his regnal name.

Alexander's papacy got off to a promising start, by apparently providing a contrast with the corruption of his Barberini and Pamphili predecessors. He repudiated nepotism and refused to hand out well-paid jobs to his family, remarking that as Fabio Chigi he had brothers and nephews, but as pope he had no relatives. Unfortunately his resolution turned out to be neither practical nor long-lasting. Just over a year after his election he summoned his family from Siena and began the inevitable doling out of sinecures, estates and titles.

Meanwhile, however, the new pope had scored a notable triumph in his election year with the arrival in Rome of the newly converted Queen Christina of Sweden. Christina's father, Gustavus Adolphus, the Lion of the North, had been the outstanding Protestant hero of the war. Now his daughter had abdicated her throne and was coming to Rome as the pope's vassal. Her turning to the Church of Rome seemed to rebuke the Reformation and partially redeemed the disappointing—for the Catholics that is—outcome of the Thirty Years' War. This diplomatic coup was to be marked by elaborate processions and ceremonies to welcome the former queen.

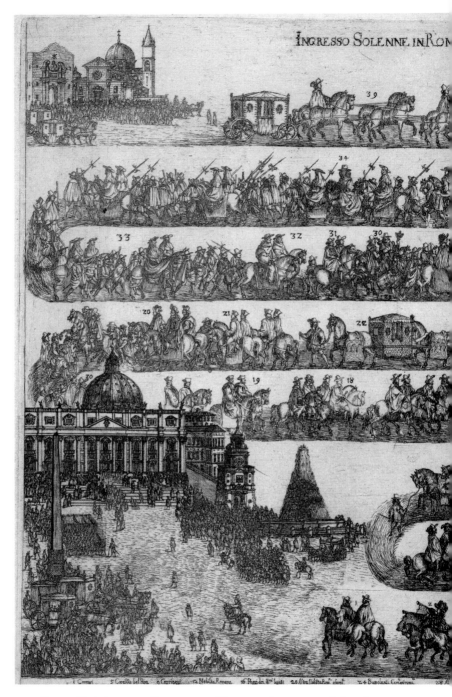

Queen Christina enters Rome, 1655. The procession starts top left at the Porta del Popolo, and finishes at St Peter's, bottom right.

*Fireworks are let off at the Castel Sant'Angelo, bottom right. The queen is
at no. 34, in the second row*

A cavalcade of richly decorated horses and coaches included a Bernini-designed silver carriage for Christina herself. Roman dignitaries, musicians, soldiers and clergy met Christina at the Porta del Popolo—hastily refurbished by Bernini and bearing a Latin inscription announcing that it was 'adorned for the happy and prosperous entry in the year 1655'—and escorted her to the Vatican where she was given the honour of an apartment and a few days later a rare invitation to dine in public with the pope, though, as a woman, she was seated at a separate and slightly lower table than her host. Formidably clever, patron of artists and intellectuals, she turned out to be a disappointment as a war trophy. Although Christina's eccentricities were well known, encountering her in person could be a shock. A congregant at her conversion ceremony wrote in horror that 'her demeanour in the church was very scandalous—laughing and giggling. And curling and trimming her locks, and [the] motion of her hands and body was so odd that I heard some Italians near me say, *E matta, per Dio!*, 'By God, she is mad!' During her stay in Rome—thirty-four years with a few lengthy breaks—her unconventional behaviour, regal demands, political intrigues and sometimes questionable piety infuriated and exhausted her hosts. Alexander was driven to complain that she was 'barbarously brought up and living with barbarous thoughts'. Somehow Bernini, not just because he was ever the skilful courtier, developed a warm and long-lasting friendship with her. In his will he left her a larger than life-size bust of Christ.

Dinner given to Queen Christina by Pope Clement IX in 1667

Five months after Christina's arrival, in May 1656, plague struck Rome, having already savaged Naples. Alexander immediately stopped traffic and visitors from the South, imposed quarantines and established a plague hospital. Most importantly he himself stayed in Rome. By the time the plague ended a year later, 'only' 15,000 Romans had died: by contrast, both Naples and Genoa had lost about half their population. Alexander was much praised for his firm response and the civic authorities of Rome proposed that his statue be erected in the Capitol. Alexander turned down the offer, either through modesty or his awareness of the often gruesome fate of papal effigies.

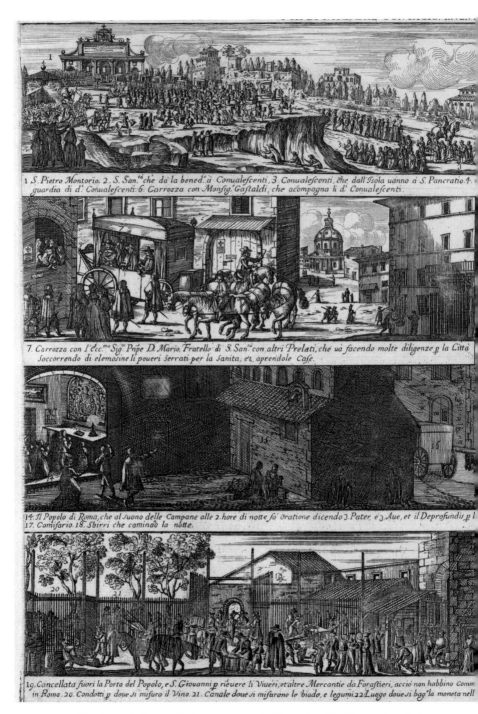

1 *S. Pietro Montorio.* 2 *S. San.^{tà} che dà la bened.^{a} à Conualescenti.* 3 *Conualescenti, che dall'Isola uànno à S. Pancratio.* 4.
guardia di d.^i Conualescenti. 6 *Carrozza con Monsig.^r Gastaldi, che acòmpagna li d.^i Conualescenti.*

7. *Carrozza con l'Ecc.^{ma} Sig.^r Prñpe D. Mario, Fratello di S. San.^{tà} con altri Prelati, che uà facendo molte diligenze p la Città*
Soccorrendo di elemosine li poueri Serrati per la Sanita, et. aprendole Case.

14. *Il Popolo di Roma, che al Suono delle Campane alle 2 hore di notte fà Oratione dicendo 3 Pater, e 3 Aue, et il Deprofundis p l*
17. *Comisario.* 18. *Sbirri che caminaô la notte.*

19. *Cancellata fuori la Porta del Popolo, e S. Giouanni p riéuere li Viueri, et altre Mercantie da Forastieri, acciò non habbino Comm*
in Roma. 20. *Condotti p doue si misura il Vino.* 21. *Canale doue si misurano le biade, e legumi* 22 *Luogo doue si bag.^a la moneta nell*

The plague in Rome. In the centre, no. 8, Alexander VII blesses a hospital;
at no. 7 his brother takes food to people in lockdown

nno fatto la Quarantena à S.Pancratio, e uanno alle Prigioni nuoue, doue si fa la quarantena polita, S. Soldati, che uanno per

d'al Lazzaretto dell'Isola, et al ricinto di Trasteu.e serrato à 23. di 12. S.Saba doue sono ricourati è riue- 13. Hospid.e degl'Incurab.e doue sono ri-
e. 10. Isola di S.Bart.e 11. Spurgo à Marmorata. stiti li poueri Mend.e dalla Camera. couerate le poure Mend.e dalla Cam.e

ati di S.Paolo. 15. Chiesa che suona le campane alle 2. h.e di notte. 16. Carrozza, e Carrettone, che portano di notte gl'amalati, è morti.

3. Porta Pia con steccati, doue si fa il campo del bestiame, che li forastieri conducono. 24. Cancellata p la strada delle mura per
serrare d.o bestiame. 25. Altro steccato, che ua a S.Agnese.

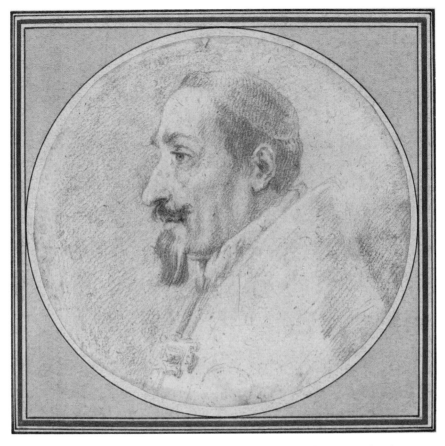

Alexander VII towards the beginning of his reign, in a drawing attributed to Andrea Sacchi

NO POPE BEFORE or since Alexander has had a great-er involvement with the architects and artists in his employ. We see this in the diaries which Alexander began keeping a few months after his election and maintained until a week before he died. He sometimes listed his projects as

if to remind himself of all he already done and what he still planned to do. For example on 10 June 1662 he noted:

> the Piazza del Popolo, its gateway and
> twin churches;
> Santa Maria della Pace and the new
> street approaching it;
> the Pantheon;
> the piazza and fountain in front of Santa
> Maria in Trastevere;
> the pyramid of Cestius;
> the Collegio Romano;
> the Sapienza University;
> Santa Maria in Lata;
> the piazza and colonnade of Saint Peter's;

along with some forty other projects for churches, streets, piazzas, fountains and ancient monuments. The diary lists hundreds of meetings with the artists, architects and advisers: Pietro da Cortona, Borromini, the Oratorian and taste-maker Virgilio Spada. But no name appears more frequently than Bernini, who sees the pope sometimes weekly, sometimes every three or four days. Indeed Bernini is mentioned nearly four times as often as any other person. The pope's focus was intense, ranging from trivial operational issues like street cleaning to the detailed evolution of the plans for the setting of Saint Peter's, to the design of candlesticks and vestments. He studied and discussed models and drawings and his language shows

that he regarded himself not as a mere patron but as a collaborator: 'We have made many projects with Bernini,' he writes. Even experts find his handwriting hard to read, but the bold strokes and aggressive slant of the diary entries clearly show energy and determination. There was an urgency with which Alexander drove Bernini and pushed his projects to completion in spite of constant worries about cost. That urgency reflected both Alexander's precarious health and his political failings.

Throughout his papacy, Alexander's ambitions to reassert papal power on the international stage were thwarted. As a contemporary reporter noted, his 'papacy was an unhappy one, as there was famine, plagues, floods, wars…' Alexander turned ever more inward, lavishing more time, attention and money on his projects for Rome. It may be that this was compensation for his loss of political clout, and that, in a reordered Europe, the pope realised that his greatest strength lay in what we would now call the 'soft power' of cultural supremacy. As nuncio, as secretary of state and now as pope, Alexander was skilful, diligent and hard-working, but he was ill-suited to turn the tide that ran against him and his Church. Perhaps no man could, especially one who preferred intellectual discourse to the rough and tumble of power politics. Judging his reign, one of Alexander's biographers quoted the epitaph of an earlier pope: 'Oh! How much depends upon what epoch the life of even an excellent man falls into!'

Foregoing the customary post-lunch siesta, Alexander

*Interior design, probably for a library or study, commissioned by
Alexander VII. The decoration includes painted architectural
scenes relating to some of Alexander's projects*

would spend his afternoons with his circle of intimates dis-
cussing science, literature and the arts and the planning of
his new Rome. The pope described his favourite activities
as 'looking into paintings, sculptures, ancient and modern
medals, archives in particular and above all to know the truth

about… this special city.' He loved writing and reading poetry, amused himself with composing elegant Latin inscriptions, and took perhaps too great an interest in the details of the many cultural projects he supported. Francesco Buti, the Italian-born French civil servant, described how Alexander 'should be treated like a child… in this way one could get anything one wanted from him, big things in exchange for little ones; his temperament was such that he grew angry over trifles…'. Buti then went on to condemn the pope's micro-management by remarking that he was 'greatest in the least things, least in the greatest'.

P ERHAPS ALEXANDER'S uneven temper had to do with the ill health he had endured almost all his life. Certainly he was keenly aware of his own mortality. Days after his election as pope, he asked Bernini to supply him with a carved marble skull to contemplate, and a lead and cypress coffin to be placed in his bedroom. In an era when life was short and medical treatment usually futile, and often more painful than sickness, a liking for such a *memento mori* or reminder of death was hardly unusual, although Alexander was perhaps more enthusiastic than most. As a supporter of the Jesuits, the pope was also in sympathy with the Bona Mors, the Jesuit-approved Confraternity of the Good Death, who intended through a series of devotions and spiritual exercises to prepare their devotees to die at peace with God. Bernini, with his many Jesuit friends, was a member of the Bona Mors, regularly attending their weekly meetings in the Gesù, the

Bernini, design for a funeral monument, c. 1640–c. 1660

Jesuits' mother church. Yet, while Alexander and Bernini spent a great deal of time contemplating death and the afterlife, what impresses, in spite of age and, on the pope's part, infirmity, is the relentless energy which he and Bernini brought to the making of their new Rome. A French traveller, observing the stark contrast between the pope's frailty and his abilities, noted the lack of teeth which affected his speech and 'as for the capacity to chew… he is compelled to take liquid foods and those that have no need to be broken up. He succumbs often to stomach pains…' In spite of that litany of disabilities, 'the pope's application to business could not be more intense'. And increasingly the pope's business was building. Few were surprised by the pope's coffin and skull, but many were impressed by another prized possession in his private apartments: 'The pope has a beautiful and curious model of the city of Rome made of wood in his chamber, as if his highest wish were to make the City more beautiful.'

105

As Bernini's son told it, 'from the very beginning of his pontificate, Alexander, seeing that he had at his disposal a man of such rare genius, shared with Bernini those lofty ideas he had been nurturing in his mind for the adornment and glory of the temple of Saint Peter of Rome, and of the state.' Alexander's ideas still shape Rome today and inspire us nearly four hundred years later; yet originally they must have been little more than pipe-dreams. He had not been a shoo-in as pope, and indeed contemporary sources tell us that he was genuinely reluctant to be put forward as a candidate. But immediately he was in office Alexander began to turn his dreams into reality with astonishing speed and decisiveness. Within a year the new pope was overseeing the development or improvement of Piazza del Popolo, the church of Santa Maria della Pace, the Cathedra Petri and the grandest of all papal projects, the creation of a new square for Saint Peter's. It was all as Domenico Bernini described it: 'a new order of achievement… in the form of works all splendid in their magnificence and arduous in their execution, which the Cavalier Bernini so felicitously completed during the twelve years of this pontificate.'

WHEN THE ENGLISH diarist, garden designer, town planner and virtuoso John Evelyn arrived in Rome in 1644, he admired Bernini's work at Saint Peter's and described the artist as 'a Florentine sculptor, architect, painter and poet…'. Evelyn then went on to praise Bernini's other talents, reporting how he recently 'gave a public opera (for

so they call shows of that kind), wherein he painted the scenes, cut the statues, invented the engines, composed the music, writ the comedy, and built the theatre.' Skilled in so many fields, Bernini had a strong desire to combine all the arts in order to produce an overwhelming emotional response. One of his early biographers, his friend Filippo Baldinucci, made the point that it was 'common knowledge, that he was the first to unite architecture, sculpture and painting in such a way that they together make a beautiful whole.' Or, Baldinucci might have elaborated, to blend the arts till they merged indistinguishably. The Baldacchino could be sculpture or architecture. The Cathedra Petri is sculpture and architecture and painting and clever lighting all at once. The apotheosis of Bernini's innate sense of drama is perhaps the Cornaro Chapel, which he designed in the 1640s. Dedicated to St Teresa, it shows the pure white marble saint in her supreme ecstasy, writhing under the love of God which has been transmitted by the boy angel and his golden arrow, in a tabernacle lit by a hidden window. To either side, members of the Cornaro family in marble relief lean out of their theatre-box pews gesticulating, marvelling, reflecting. Above, painted angels fly around heaven; below, skeletons inlaid into the floor move their creaky, resurrecting bones. 'Ingenuity and design constitute the Magic Art,' Bernini declared, 'by whose means you deceive the eye and make your audience gaze in wonder...' In those few words, we have his own definition of the Baroque.

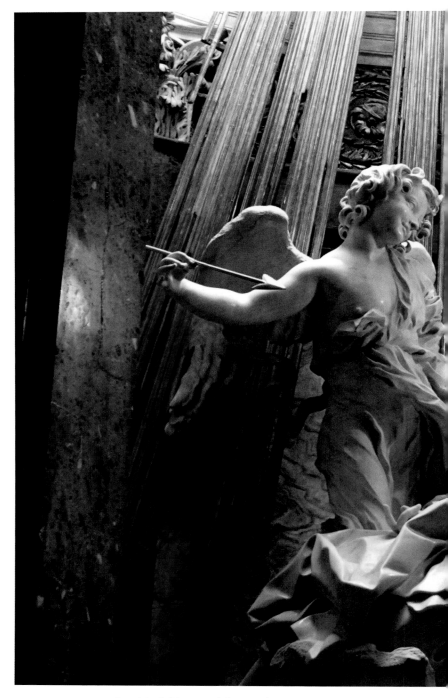

Bernini, St Teresa and the Angel, 1647–52

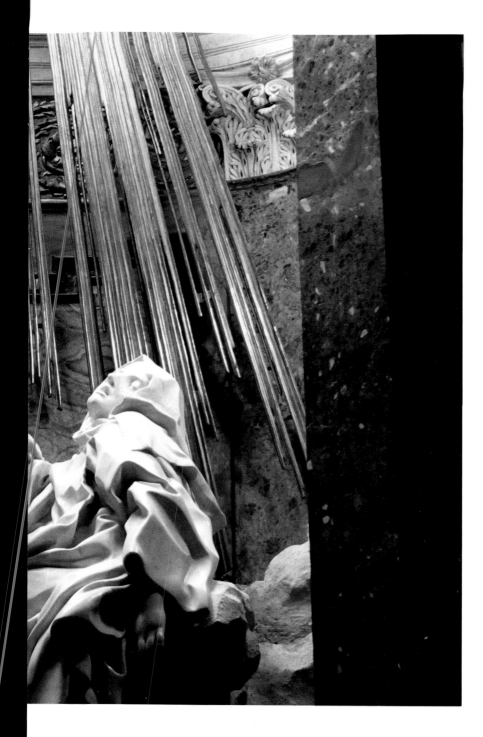

*B*ERNINI'S REPUTATION has risen, and fallen, and risen again, depending on the popularity or otherwise of the Baroque. Many have found the style too Catholic, or too authoritarian, or just plain too much. Others—me included —are consistently delighted and often puzzled by the inventiveness and exuberance that take it to the threshold of craziness. But friends and foes alike have long agreed that Bernini is the undisputed master of the style, the 'genius of the Baroque' as the subtitle of one book describes him.

Baroque is easier to recognise than to define. It began around 1600, expired by the mid-eighteenth century, and was bracketed by two periods—the Renaissance and the Neoclassical—that were more devoted to the forms, rules and proportions of classical antiquity. Baroque on the other hand was most definitely not a rules-based style, and its love of swirling, bulging, rippling, thrusting forms made many uncomfortable. The great Victorian critic John Ruskin— nothing if not a puritan—regarded Bernini and the Baroque as positively villainous and morally corrupting. 'It is impossible,' he wrote, 'for false taste and base feeling to sink lower.' Rather more good humouredly the twentieth-century Italian journalist Luigi Barzini declared that 'the Baroque is when you can draw a straight line but choose instead to draw a curve. The baroque is when you are bored with the melody and wish to listen to the variations.'

The origins of the term itself are rather derogatory; most likely it comes from the Portuguese word '*barroco*', meaning a misshapen pearl. It is easy to see why well-mannered

generations past may have found the Baroque rather embarrassing, like a guest who talks too loud or someone who keeps bursting into tears. It is, as we have seen, emotional, demonstrative, bombastic and theatrical. By the same token it could be manipulative and propagandistic. It lent itself quite unashamedly to being an expression of state and institutional power, and it is hardly surprising that the Baroque flourished in what historians call the Age of Absolutism, becoming the favoured house style of autocrats such as Louis XIV and a string of popes. It was art with a message, which could be about the glorification of either the Catholic Church or a ruling dynasty, or both; and it excelled at emotionally inviting, or should I say bludgeoning, the public into acquiescing in that glorification. Not to put too fine a point on it, Baroque is a bully. The English writer Herbert Read found this particularly objectionable; he declared that 'to use art is to abuse art.' So if you feel that art exists in a political, social or religious vacuum, perhaps you should look away now.

Under threat from the Reformation, and particularly from the legitimisation of Protestantism that was the consequence of the Peace of Westphalia, the Catholic Church in the seventeenth century needed powerful weapons. It enthusiastically enlisted the confidence, emotional power and unapologetic sense of luxury of the Baroque for its struggle. Baroque can work on the smallest, most intimate scale, but is most explicitly about power when it comes to urban planning and landscape design, where the use of strong axes

and great vistas shows a new urge to order and master the environment. The architectural theorist Sigfried Giedion put it well when he summed up the Baroque's ability 'as a new power to mould space, and to produce an astonishing and unified whole from the most various parts.' This new power, such an exciting arrival of the early seventeenth century, is nowhere more apparent than in its transformation of Rome's often unruly cityscape; and nobody understood better how to use it than the team that were Bernini and Alexander VII.

M ORE THAN any other style before or since, the Baroque was singularly focussed on heightening the drama of life. Sforza Pallavicino, historian of the Council of Trent, poet, theorist of æsthetics, and one of Pope Alexander's house intellectuals, argued that God 'gilded heaven with light to enamour mortals with it, so it is fitting that churches are illuminated with gold, so that the people fall in love with them, and run towards them...' He then went on to say that 'the people want theatres' and it was imperative 'to make the theatres curing sin more sumptuous and pleasant than those where sin goes to feed.' What better description could there be of art in the service of the church? And Pallavicino's use of the word 'theatres' is important, because when we enter the world of Baroque Rome, we find that the whole city has been turned into a vast theatre, a backdrop for not only great religious processions and state rituals but for everyday life as well.

Bernini was more narrowly theatrical in his important, though amateur, activities as a writer, designer, producer and occasional actor in plays for his own household and his circle of friends. During the winter carnival season in Rome, elaborate plays, usually more notable for their scenery and effects than the quality of their writing, were staged in Roman palaces until Innocent banned them in 1650. Bernini's involvement in these entertainments dated from the 1620s. The confidant as well as the servant of Rome's power elite, Bernini didn't shy away from poking fun at the great and good, nor from reminding them that they too were role-playing. As a letter of 1633 reports, Bernini 'produced a comedy that he had composed in which there are things to make anyone who has experience of the Court die with laughter, because everyone, prelate or cavaliere, especially if he is Roman, has his part.' There are numerous other mentions of Bernini's plays but only one script survives, his unfinished comedy *The Impresario*, thin on plot, long on bawdy farce and social satire, whose title character Gratiano, a thinly disguised Bernini himself, has difficulties in creating a play at the command of his princely patron. When Shakespeare wrote 'all the world's a stage and all the men and women merely players,' he was inspired by the earlier thoughts of the Italian poet with the pen name Palingenius, the English translation of whom has a marginal note saying 'the world a stage play.' Echoing that same spirit of the time, Bernini has his character Gratiano declare 'the world's nothing but a play'.

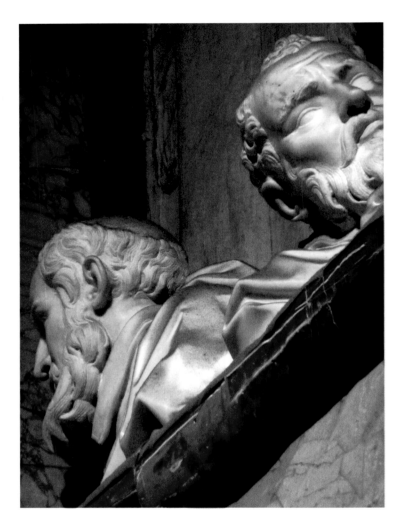

*Two members of the Cornaro family, part of the audience watching
the miracle from boxes either side of Bernini's statue of
St Teresa and the Angel, 1647-52*

If the world was indeed a play, Rome was both a theatre and the home of multiple theatres in which squares and major streets and the forecourts of churches and palaces provided a backdrop for the drama of life in the Eternal City. Certainly, grand cityscapes heightened the experience of everyday life—something that every tourist in Rome still experiences—but they also provided a series of stages for the many civic and religious rituals and processions that filled the Roman calendar, and all of which projected the power, majesty and significance of the pope and his Church. Enhancing the drama of everyday life seems like a perfectly legitimate aim for architecture and it is perhaps a little surprising that when the Baroque style is described as 'theatrical' it is often with a hint of a sneer, as if the Baroque is mere showing off and fancy dress when compared to the more organic Gothic, or to the chaste and rational appeal of Neoclassical.

I N THE WORLD of Baroque Rome, ambition was expected and rewarded, and the rise and fall of families was much faster and more dramatic than in the relatively stable courts of hereditary monarchs. It's no coincidence that the Italians invented both political science and opera. Guido Bentivoglio was a papal diplomat and intimate of Urban, and a patron of Van Dyck and Poussin who landed on the wrong side of history when he condemned Galileo. He had a good chance of becoming pope, but he died during the conclave of 1644. Viewing papal Rome from the top, he observed

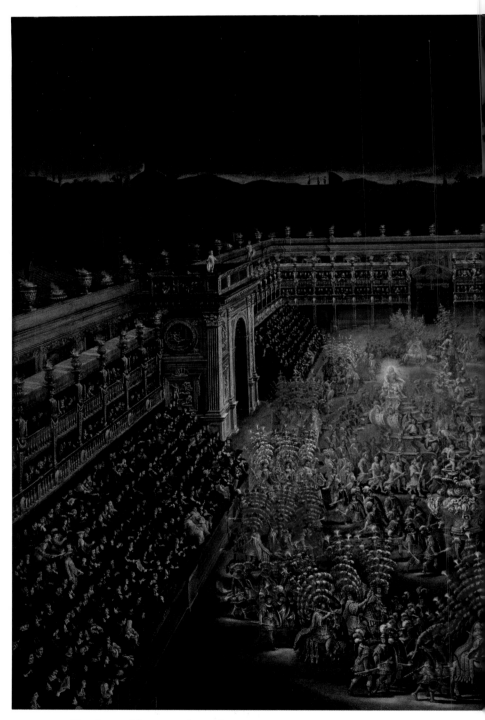

*The Carousel festivities of 28 February 1656 in honour of Queen Christina,
at the Palazzo Barberini, formerly home of Urban VIII's nephews,
and lent to Christina. Note the large dragon*

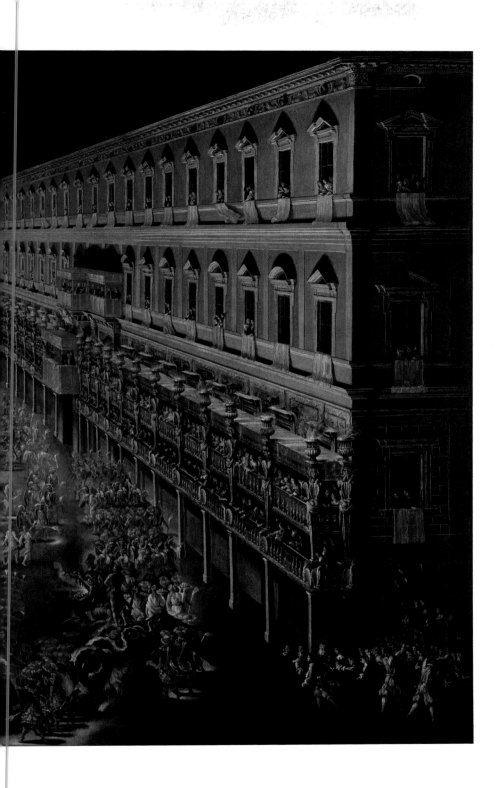

how vice and virtue were 'two fighters continually engaged in combat on this worthy stage and who make every effort now to raise and now to lower this or that person...' He went on to portray Rome as combining 'many theatres into one great, extremely challenging stage'. It is revealing that the key figures of Baroque Rome, like Bentivoglio, thought of themselves as players on the Roman stage. It was indeed part of the contemporary mindset to think of Rome as not just a theatre, but *the* theatre. Pope Gregory XV's nephew Ludovico was one of many who called Rome 'the world's theatre'; Galileo wrote about his reception in Rome that 'I felt I was appearing publicly in the theatre of the world.' This sense of theatre permeated Italian consciousness: one of Alexander's catafalque inscriptions praising the late pope's reconstruction of Saint Peter's Square and its embracing colonnade, described the work as what 'you would call a theatre, where Religion makes a show of herself with majesty.'

The idea of Rome as 'the world's theatre' was also promoted through maps and prints. Having given so much time, effort and money to the creation of his new and improved Rome, already being referred to as 'Roma Alessandrina', the pope was keen to broadcast his achievements. Publishing in Rome was closely controlled by the papacy and Alexander was well aware of the power of printed imagery, which had been so successfully exploited by the Protestants in their long propaganda war against the Church: without the printing press the Reformation would not have happened so

quickly. He found an ally and superb publicist in the print entrepreneur Giovanni Giacomo de Rossi.

De Rossi began currying papal favour in 1657 when he proposed to publish a series of portraits of the cardinals and Alexander granted him a valuable ten-year licence to do so. The cardinal portraits sold well and the pope supported de Rossi's next project. Maybe nowhere is the character of the reimagined Rome of Bernini and Alexander more clearly set out than in the resulting series of three volumes of topographical etchings by Giovanni Battista Falda, published from 1665 onwards. The title page announces Falda's work as *Il Nuovo Teatro*, 'The new theatre of perspective views showing the new and partially finished buildings of modern

Falda and de Rossi's print of the Piazza de Santi Apostoli. On the right is the revolutionary palace façade designed by Bernini with much input from the pope to be a suitable residence for his cardinal-nephew, Flavio Chigi

Rome.' Falda's prints clearly, charmingly and somewhat mis-leadingly—streets are too broad, vistas are too wide, people are too small—present Rome as a city reborn. Such publications spread Alexander and Bernini's achievements far and wide. Samuel Pepys, who never visited Rome, nonetheless had volumes of Falda's engravings and a copy of Falda and Rossi's huge map of Rome, the *Nuova Pianta*, hanging on the wall of his library.★

IN SPITE OF his early successes, it was Alexander's trage-dy to be overwhelmed by the great facts of seventeenth-century European geopolitics. Like his predecessors, Pope Alexander wrestled with the best way to contain the ex-pansion of Ottoman Turkey. Venice was on the frontline, thanks to her island possessions, and she made constant de-mands for military and financial help from a depleted papal treasury. The decline of Spain and the rise of France were equally destabilising. Spain had burst on the European scene following national unification in the late fifteenth century and fuelled by gold and silver from the newly 'discovered' Americas. Yet little over a hundred years later the country was on its way to being a busted flush, thanks to a parochial and idle aristocracy, a poorly developed economy based on plunder rather than entrepreneurship, and an effete and in-ept ruling dynasty. The decisive defeat of the much feared Spanish army by the French at the Battle of Rocroi in 1643

★ See the reproduction on pp. 272-273 and the details on pp. 274-283.

announced that Spain's time was up. France emerged as Europe's superpower, with highly talented military leadership, three times the population of Spain and the rudiments of a modern economy. The 1659 Peace of the Pyrenees was a further blow to Spanish pride and power. This conclusion to twenty-four years of war between France and Spain gave France some important territorial gains and set the seal on what it had already won in the Thirty Years' War. Just as Spain was humbled by this peace, so was Alexander, who was pointedly not invited to play a role in brokering peace between the two mightiest Catholic powers. France had no serious territorial ambitions on Italy and was content to let a weakened Spain keep its Italian lands, but French policy, as formulated first by Cardinal Richelieu and then by Cardinal Mazarin—ironically both princes of the Church—seemed ever more determined to contain or reduce papal power. Even though Louis XIV did not take personal control of France until the death of Mazarin in 1661, France had already set out on an expansionist course which would only accelerate. Writing some years later, Louis boasted that 'All my subjects supported me to the best of their ability: in the armies, by their valour, in my kingdom, by their zeal, and in foreign lands, by their industry and skill; in short, France proved the difference between herself and other nations by her achievements...' With his autocratic and bullying character, Louis XIV made humiliation became a new weapon in France's diplomatic arsenal. Alexander was to be its most prominent victim.

T HE POPES and their brother sovereigns unapologetically used the arts to project their power and status. As the political philosopher Montesquieu put it in the next century, 'The magnificence and splendour which surround kings form part of their power.' This awareness was taken to new extremes by Louis, who allowed himself to be portrayed as Apollo the Sun God, as Hercules, as Alexander the Great, as the Good Shepherd, as St Louis, and to be praised in poetry and prose and through architecture, sculpture and the striking of commemorative medals. Now Louis was determined that Europe's most celebrated artist should add to his 'magnificence and splendour': he wanted Bernini in Paris.

This was not the first time that the French had tried to commandeer the talents of Rome's great image maker. As early as 1643, Mazarin, at the behest of Louis XIII, did his best to entice Bernini north. Pope Urban, Bernini's principal employer at the time, said absolutely not. In his words, Bernini 'had been made for Rome and Rome for him'. Mazarin carried on trying, giving Bernini his 'reassurance that at every time and in every place I will embrace with particular pleasure all opportunities to advance your interests and glory when you are here in His Majesty's service.' Bernini continued to refuse. But the balance of power had changed considerably by the time the next Louis invited Bernini to France.

Not too long after Alexander's exclusion from the Peace of the Pyrenees, the Sun King found a new excuse to further humble the pope. On the evening of 20 August 1662,

a group of the pope's Corsican troops somehow got into an altercation with the bodyguard of the recently appointed French ambassador. The argument escalated into brawling and gunfire. The ambassador's residence and his wife's carriage were attacked and one of his pages killed. In retaliation, Louis seized Avignon—in France, but still a papal enclave—and marched his troops to the borders of the Papal States. Two years of high tension followed until Alexander agreed to the embarrassing Treaty of Pisa, which required his representative in France to apologise publicly for the bad behaviour of the papal guards and forced the pope to order and pay for a pyramidal monument to the incident in Rome.

Monument erected in Rome 'in execration of the heinous deeds against the excellent Duke de Créquy, ambassador for the Most Christian King'

Although it was not among the formal provisions of the treaty, some sort of side deal may have been done during the negotiations which resulted in Louis acquiring the long-sought-after services of Bernini. At the very least, France used its growing political leverage over the papacy to insist that Louis got Bernini, if only on loan. A little over a year after the treaty was signed, Alexander formally agreed that Bernini would be allowed to go to France. Just as Queen Christina's coming to Rome was meant to exemplify the Church's spiritual power, Bernini's summons to France was exemplary realpolitik: there was a new balance of power and the riches of Europe were Louis' to command.

THE IMMEDIATE pretext for Bernini's trip to France was to design improvements to the Louvre, which was then the monarch's principal residence. First, drawings were sent, but then Louis began demanding, in the politest terms, that Bernini himself was needed in Paris. On 11 April 1665, Louis wrote to the artist that 'I bear such singular esteem for your merit that my desire is indeed great to see and come to know closer at hand so illustrious a personage.' Delay was no longer possible. Just over a fortnight later Bernini set off from Rome with a small entourage. The papal court feared he might never return, given the potential rigours of the journey for the ageing artist, not to mention the further blandishments Louis might offer him when once arrived in France. As they made their way towards Paris, the travellers were entertained lavishly and large crowds gathered to

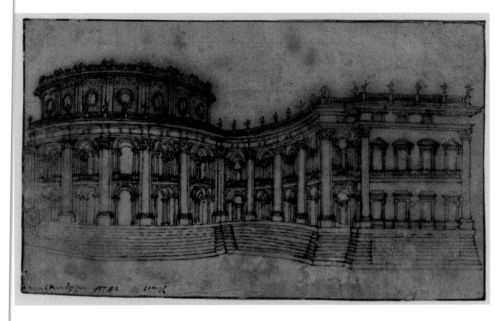

Bernini, freehand study for the first project for the east façade
of the Louvre, 1664

welcome them, as well as gawp at the exotic arrival. Bernini himself described the progress sardonically as 'the elephant was then travelling around'.

But against all expectations the five-month stay in Paris was not a success. Bernini's plans for the Louvre were comprehensively rejected by Colbert, the king's first minister and fixer-in-chief. The proposed improvements, Colbert declared, were lacking in comfort, security and grandeur. In any case, as the royal right-hand man was also dedicated to a protectionist trade and manufacturing policy, it is hard to see how he could have supported the employment of an Italian

for such a key monument to French prestige. Bernini didn't help matters either, continually belittling French taste and talent, remarking for example that the decoration of Paris churches reminded him 'how poor and feeble French style was'. When Colbert's assistant Charles Perrault criticised Bernini's Louvre design, the Italian exploded. 'It is not for the likes of you, Monsieur Perrault, to make objections of this kind,' he harrumphed. 'You may have some understanding of the uses of a palace, but the design is the concern of someone more skilled than you are. You are not worthy to brush the dust off my shoes.'

The intrigues of the French Court brought out the worst of Bernini's arrogance, quick temper and sharp tongue. When he left Paris at the end of October, there must have been relief all around. Bernini continued, largely I think as a face-saving exercise, to provide drawings for the Louvre, none of which were used. It wasn't until over ten years later, in 1677, that he finished and had delivered to France a large equestrian statue of Louis, commissioned as a kind of consolation prize. Bernini had never attempted anything comparable apart from the statue of the Emperor Constantine in the Vatican, so it was a signal honour that he was allowed to make the statue for Louis; but in the event the King hated it so much that he had it partially recarved and installed in an obscure part of the gardens at Versailles. By far the most successful result of the trip was Bernini's magisterial bust of Louis, also now at Versailles, in which the Sun King emerges from a fantastic swirl of

*Bernini, Louis XIV, 1665. The king sat to Bernini five times
for preliminary sketches, and twelve times while
the bust was being carved*

drapery. It's a defining and glamorous image of the absolute monarch who tormented Pope Alexander and provided Bernini with his greatest failure.

Detail from a portrait of Bernini in the 1670's, by Il Baciccio,
who emulated his method of allowing sitters to move about naturally

A FEW DAYS after his arrival back in Rome, on 9 December 1665, Bernini had a meeting with Alexander. Frequent rumours about the pope's deteriorating health had reached Bernini in Paris, but Alexander was thankfully no more ill than usual, and he was eager for Bernini to return to work on the three great papal commissions in progress.

128

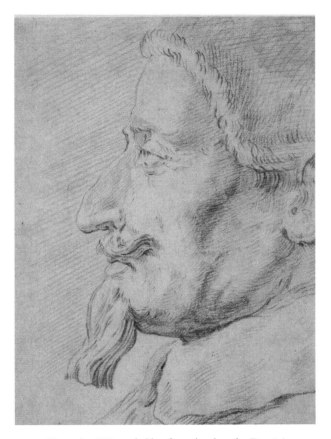

Alexander VII, probably after a lost bust by Bernini,
c. 1657–70

These were the colonnade that defines Saint Peter's Square,
the new setting for the throne of Peter, the Cathedra Petri
(arguably the supreme symbol of the papacy), and the Scala
Regia, the ceremonial entrance to the Vatican Palace.

At this point, Bernini had been involved in Saint Peter's
for over forty years, one of a long succession of artists and

architects. The old Saint Peter's basilica dated back to the reign of the Emperor Constantine. Its rebuilding had been a major papal project since the mid-fifteenth century, but it had only proceeded fitfully until Julius II made the radical decision in 1505 to demolish the old church and build a monumental new one. For the next 120 years a succession of popes and Italy's greatest artists and architects, including Raphael, Bramante, Sangallo the Younger and Michelangelo, struggled to complete the great new church amidst constant debate over whether it should be in the shape of a Greek or Latin cross, and of course the inevitable questions about how to pay for it all. Although the causes of the Reformation were many, and a long time coming, what particularly roused Martin Luther's ire was the cost of papal building works in Rome. He railed against the sale of indulgences—essentially passes out of purgatory—in order to raise money for the rebuilding of Saint Peter's. 'If you want to give something,' Luther exhorted his followers, 'you ought above all else, without considering Saint Peter's building or indulgences, give to your poor neighbour.'

The status of the mother of all churches, and seat of the reigning pope as Bishop of Rome, belongs to the church of Saint John Lateran, but Saint Peter's is of paramount importance. It is the pope's local church and, built over the site of the martyrdom and burial place of Peter, is the architectural embodiment of the apostolic succession. In 1626, Urban VIII was finally able to preside over the dedication of the new basilica, but even before that he had employed Bernini,

then only in his mid-twenties, on the greatest task of his career so far. Soon after Urban's election as pope, he had ordered Bernini to design and oversee the building of the Baldacchino, a grand ceremonial canopy to shelter the high altar of the basilica. This colossal bronze construction—nearly thirty metres high—took eleven years to finish and proved Bernini's genius for invention, as well as, for the first time, his exceptional managerial abilities. Facing numerous technical challenges and organising a large team of collaborators, Bernini secured his role as artistic supremo of Rome, a man who was not only able to design, but could also deliver, large

Crossing of Saint Peter's, with the full-size wooden model of the Baldacchino used as part of the design process, 1628–31

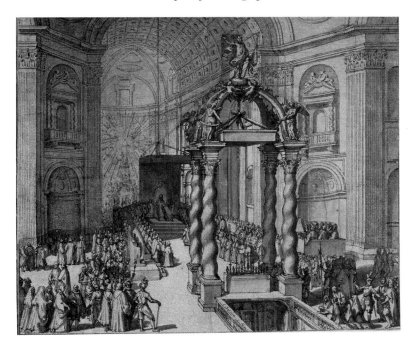

and complex projects. Along with his work at Saint Bibiana, (see above, pp. 43-44), the Baldacchino represents the major step change in Bernini's career as he moved away from being 'merely' the most talented sculptor in Rome. In concept, too, it marks the beginning of what Bernini becomes most celebrated for: casting aside the distinctions between art forms to create a work which is overwhelming in its emotional intensity. The Baldacchino dissolved the boundaries between architecture and sculpture in an unprecedented way. 'What appears to the viewer is something completely new,' his contemporary biographer Baldinucci declared, 'something he had never dreamed of seeing.' At the same time, Bernini was innovating in his business practice, creating a workshop on a scale that rivalled that of Rubens. The sheer size of the Baldacchino and subsequent papal projects meant that almost every sculptor of talent in Rome—including many with considerable personal reputations—was, at some stage or another, part of the Bernini machine. It can't have been easy for them. Regardless of their individual artistic character, so many were employed for so long by Bernini that his style became theirs and that of their own assistants and apprentices in succession. Although Bernini's son Domenico was eager, perhaps over-eager, to point out his father's generosity towards painters—'nothing gave him greater pleasure than to look admiringly at paintings and praise their artists. However, when it was not possible to praise a work he preferred to remain silent, rather than to speak ill of it'—Bernini's behaviour towards any rival sculptor

Putti with the papal tiara and keys, possibly modelled by Stefano Maderno,
on one of the crossbeams of the finished Baldacchino

or architect was hardly generous. His fierce temper and
waspish turn of phrase were quickly aimed at anyone who
threatened his dominance. The case of the now largely for-
gotten Francesco Mochi is instructive. Mochi was a dar-
ing and skilful sculptor who, in spite of being nearly twenty
years older, often found himself assisting Bernini—until he
was suddenly cast into the wilderness, along with the men-
tally unstable Borromini. According to Domenico, possibly
echoing his father's words, Mochi 'showed himself on many
occasions most ungrateful towards his Master'. It seems in
fact to have been payback time for an earlier slight. The 'un-
gratefulness' seems to have had much to do with Bernini's
father's failings as a sculptor. Before he became pope, Urban
had commissioned Pietro Bernini to carve a St John the

Baptist for his family chapel in Sant' Andrea della Valle. Displeased with the weak and awkward sculpture produced by Pietro Bernini, Urban asked Mochi to carve a new St John as a replacement. Bernini's rage at this insult to his family must have been formidable. The pope backed down and Papa Bernini's sculpture stayed in place. Years later, Bernini was still persecuting the hapless Mochi and there were even fears that he might destroy some of Mochi's work. Throughout Bernini's career, artistic supremacy slid all too easily into artistic dictatorship.

THUS WE CAN imagine the meeting of December 1665, between Bernini and Alexander, after the artist's return from Paris, as one of two autocrats, each supremely used to unquestioned command. But the two men also shared a striking æsthetic perceptiveness, grandiose and practical at the same time. For all the years of work spent on the embellishment of Saint Peter's, when Alexander became pope, he looked at the vast basilica and found it wanting: not as a building, but within the context of his grand vision for Rome. Alexander studied Rome in a way that previous popes hadn't. Even before he moved to the Quirinal Palace, where his apartments commanded a majestic view of the city that his predecessors in the Vatican Palace lacked, Alexander was notable for the amount of time he spent looking at his city. Contemporary accounts and Alexander's own diary record his journeys through Rome, sometimes on foot, sometimes carried in a sedan chair. For example, on a

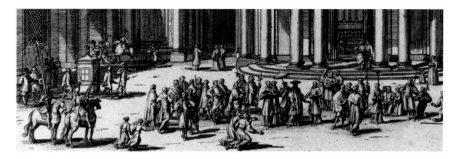

The pope visits Santa Maria della Pace (detail). He is in the centre, under the papal parasol (the umbraculum); his sedan chair waits to the left

late February day in 1657 the pope travelled from the Vatican to the Piazza del Popolo, then down the Via del Corso, on to the Palazzo Borghese, along the river and back to the Vatican. It was highly unusual for a pope to make such excursions that weren't part of a public ritual or procession. The urban historian Dorothy Metzger Habel is right to call them 'the equivalent of modern-day fact-finding missions'. With a city planner's eye, Alexander understood how buildings fitted into the cityscape, how they were approached, and how they related to the other buildings and to the streets and squares and traffic around them. He also understood how Rome could be a thing of beauty, an expression of power and a tourist magnet.

With this vision, it is hardly surprising that Alexander found the approach to Saint Peter's inadequate for the world's greatest church. Sixtus V had signposted the piazza in front of it with the obelisk from the Circus of Nero where Peter was crucified, but the piazza itself was cramped and lacking

Saint Peter's Square as it looked in the 1620s

in dignity. It couldn't accommodate large crowds or provide decent sight lines for the great occasions when the pope appeared above Saint Peter's central door to bless the people of Rome and the whole world—*urbi et orbi*—or when he delivered the papal blessing to pilgrims from the window of his private apartments in the Vatican Palace. Alexander determined to create a new square in front of Saint Peter's to fulfill these papal needs, and as a statement of papal grandeur and a triumphant Church.

At the end of July 1656, it was announced that Bernini was to design a grand colonnade to reshape the square in front of Saint Peter's. Two weeks later Alexander noted the basic elements of the design in his diary. It was not without controversy. One cardinal fulminated against it as 'a mere ornament and an unnecessary building'. In his memorandum justifying the project, Bernini was resolute that it was 'a

visible sign of the piety of a Pontiff and appropriate to the grandeur of an Alexander.' It was a shrewd phrase: the pope often encouraged comparisons with his great namesake. Modesty was not one of Alexander VII's main attributes.

As usual for such a grand papal project, the new square was a collaborative effort. Alexander depended not only on Bernini, but on an informal brains trust consisting of Father Virgilio Spada, not particularly a supporter of Bernini's but a long-standing papal architectural advisor, and Lucas Holstenius, the papal librarian who researched the use of colonnades in the ancient world. Although the innovative 'oval' shape—not really oval at all but a square with half circles at either end—had been fixed by the spring of 1657, the plan evolved slowly. Later in the year, Alexander noted that he'd spent the day 'with Bernini and we made many drawings.'

Bernini's original plan for the colonnade of Saint Peter's, as shown on one of the forty-five medals issued by Alexander VII to publicise his achievements

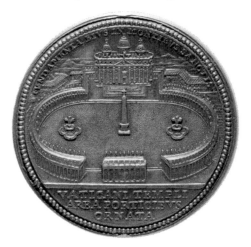

The cornerstone for the project was laid in the summer of 1657 and full-size models of the columns were ready for display in late 1659. But the huge scale of the project—some 386 columns and 96 statues—meant that the square wasn't finished until 1672, five years after the pope had died.

A SIDE FROM the practical issues of dealing with visitor numbers, Bernini wished to create a suitably dramatic approach to what was the centre of the Christian world. Although today a broad, characterless avenue ordered by Mussolini leads into the square, Bernini's intention was that pilgrims would enter crabwise around either side of a freestanding colonnade—and then find themselves dazzled by the vast space of the piazza. This then led into a smaller (but still very large) trapezoidal square that served as a sort of anteroom to the basilica itself. The freestanding colonnade at the entrance was never built, but nonetheless there was huge uplift as the faithful made their way through the cramped neighbourhood streets and suddenly emerged into the new piazza with its embracing colonnades. This is not just a figure of speech. For Bernini and his fellow artists, always keen to present art as an intellectual rather than a manual endeavour, there had to be a *concetto* or ingenious idea informing any work of art. As he himself explained it: 'since the church of Saint Peter's is the mother of nearly all the others, it had to have colonnades, which would show it as if stretching out its arms maternally to receive Catholics, so as to confirm them in their faith; heretics, to reunite them

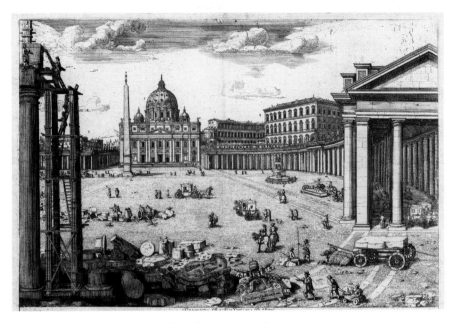

The colonnade, with building work in progress, 1666

to the Church; and infidels, to enlighten them in the true faith.' The persuasive, the theatrical, the religious combine in this epitome of the Baroque æsthetic.

The purely visual impulse played a role too. As Bernini explained to his friend, the French courtier Fréart de Chantelou, he had responded to the widely held opinion that Maderno's frontispiece to the basilica was ill-proportioned. 'The façade had always been too low in relation to its width,' he told Chantelou, so he had 'studied the problem and found that by adding a low colonnade on either side the façade could be made to appear higher by contrast and the fault was thus corrected.' It was characteristic of Bernini to find

inspiration in such problem solving; he would say that 'the good artist is the one who knows how to create things of beauty by finding ways to make use of what is deficient and defective.'

The remarkably restrained colonnade contradicts some common ideas about Baroque extravagance. Bernini chose to execute it in the sober and unadorned Doric Tuscan style. The columns and statues are carved from roughly textured travertine, most of which came from the quarries at Tivoli, just north of Rome. Cheaper and softer than marble, travertine could be more quickly carved—an important consideration when there are 96 statues on order—but it also provided a low-key contrast to the thrilling richness of Saint Peter's interior.

L ESS THAN a year after beginning work on the piazza, Bernini was commissioned to construct a new setting for the Cathedra Petri. This ancient relic was reputed to be the chair of St Peter himself, and was consequently the most tangible evidence of the pope's role as the Vicar of Christ. Bernini's solution is a huge construction of bronze, marble, gilt, stucco and clever lighting which was best summed up by the art historian Rudolf Wittkower: 'often imitated but never equalled, the Cathedra is the spiritual and artistic climax of the Full Baroque.' It is a piece of immense technical daring: the throne of Peter appears to float above the four twice-life-size statues of the saints at its base, as if their thoughts alone were supporting the papacy. It required

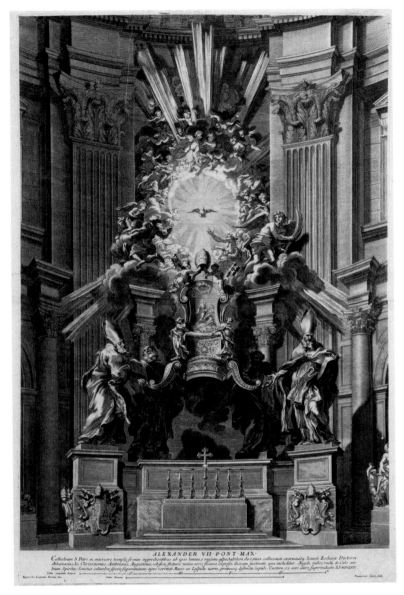

The Cathedra Petri, 1647-53

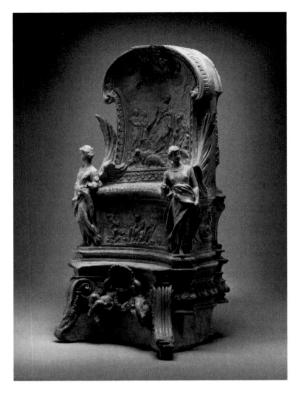

Bernini, first terracotta sketch for the Cathedra Petri, 1658

hundreds of drawings, small clay sketches, full-size models and the collaboration of thirty-five artists and key craftsmen over a period of nine years, during which it grew in size and complexity. Set in the apse of the basilica, the Cathedra crowns the journey from the secular world of Rome's streets to the spiritual realm. Bernini's son Domenico wrote that the piazza and the Cathedra Petri 'were, so to speak, the beginning and the end of the magnificence of that great basilica; there the eye remains no less astonished at the church's

entrance through the portico as at its terminal point in the Cathedra.'

Bernini's contribution to Saint Peter's was immense. Aside from the Baldacchino, the colonnade and the Cathedra Petri, Bernini's problem-solving abilities were stretched to the limits fitting a grand ceremonial staircase, the Scala Regia, into the awkward space connecting the piazza colonnade to the Vatican Palace. Then there were the tombs of Urban and Alexander, work on the piers supporting Michelangelo's dome, and the decoration of the nave arches and chapels. Small wonder that Alexander said, 'If one were to remove from Saint Peter's everything that had come from the Cavalier Bernini, that temple would positively be stripped bare.'

What *was* stripped bare was the papal treasury which, though left in robust condition by Sixtus V, had deteriorated in the intervening decades and simply could not keep up with Alexander's demands. Money was always an issue. Alexander, constantly spending, was constantly worrying. Moreover the great expense of papal projects which were creating the grandest, most theatrical city in Europe caused rising discontent among the ordinary residents. 'What is most needed among all these churches, convents, monasteries, hospitals, confraternities, palaces and squares,' the minor civil servant Lorenzo Pizzati wrote, 'is modest housing at fair rental.' The pope, a pamphleteer complained, 'creates glory through stones, through the colonnade of Saint Peter's where he spends a fortune on a dive for footpads and a public lavatory for dogs.' The colonnade

seems to have cost around a million *scudi* at a time when the pope's total annual tax revenue was perhaps not even two million. Unsurprisingly the state debt soared, from 39 million *scudi* in 1661 to 50 million by the time Alexander died six years later. As the papal treasury emptied, Alexander and his supporters promoted the value of the great projects, claiming that they created work, and that the pope 'erected buildings and joined beauty to usefulness', knowing 'how much wide streets and commodious houses contribute to the health and delight of the tenants, and how much these two would help to bring to Rome large and illustrious numbers of foreigners.' Just as Sixtus justified his Roman plans on the basis of the benefits it would bring to the city, Alexander's utilitarian argument seems perfectly reasonable, but hardly sufficient to explain what can also seem to have been a mania for building seasoned with a large dose of self-aggrandisement. Today we enjoy the benefits of Alexander's ego and reckless spending. The harsh but fair judgement of Richard Krautheimer, the leading urban historian of Rome, was that 'catastrophic as it was for the Papal States and the well-being of his subjects, Alexander's financial short-sightedness and unconcern enabled him to give Rome... a new face and to provide her with a new image.'

GRAND PLANS boosted papal egos, but it was also imperative to deal with Rome's creaking infrastructure. Managing Rome's traffic, for instance, was a perennial concern. With his new streets and obelisk-marked squares,

Sixtus had aimed to control the movement of the huge number of pilgrims who came to Rome both in Holy Years and, increasingly, every year. By Alexander's time there was a new traffic problem: carriages. Litters, sedan chairs and merely riding a horse became unfashionable, thanks to the development of relatively lightweight carriages with improved suspension. Owing to the demands of the large number of dignitaries, officials, diplomats and families attached to or attracted by the papal court, there were over nine hundred private carriages in Rome by 1600 and the number increased every year as such vehicles became, like family palazzi, important status symbols. Nor was it just having a coach that counted; the number of horses hauling it

Design for a coach, probably by Bernini's long-time collaborator Johann Paul Schor, c. 1670

and its decoration were vitally important too. One can only imagine the excitement in 1610 when cardinals were given permission for their coach horses to wear red plumes.

The need to deal with this traffic influenced many of Alexander's architectural projects. Soon after becoming pope he began to redevelop the church of Santa Maria della Pace, which had important family significance for him, his ancestor the great banker Agostino having bought a chapel there that he had topped with a fresco by Raphael. Alexander wished to give the church a more impressive façade and ended up also redesigning the approach to it, so that carriages would find it easier to turn around and stop in front of the church, as no one of any importance would dream of arriving by foot. Alexander turned to Pietro da Cortona, more often employed by the pope as a painter than an architect, who devised an elegant setting. Among the usual laudatory inscriptions on and around the church is one that exemplifies the pope's concern with planning and context. Fixed to the wall of an adjoining building, a lengthy and severe injunction warns that anyone 'who intends either to build a structure' around the piazza or 'to raise a wall higher than the front, or to erect a storey or anything else that alters the building' will be punished. Never has a building regulation been so public or so permanent. The pope clearly intended his improvements to last.

Throughout his reign there was a general drive to widen and straighten streets and to tidy up squares, not just to beautify but to make the traffic flow more freely. Alexander's

Falda's print of the street now known as the Corso, 'straightened and enlarged by his holiness Pope Alexander VII', 1665. As usual in these prints, the figures are less than half life size

grandest street plan was the widening of what is now the Via del Corso, essentially the north-south high street of ancient Rome. He wished it to be a fine location for new churches and palaces and a better venue for the annual Roman carnival horse race. Of course he recorded his plans with a commemorative plaque praising his restoration of a street 'once clogged with protruding buildings and now open, once deformed and now straight, for racing, for public convenience and for beauty'. Alexander was proud to describe himself as the city's '*amplificator*': someone who enlarges or widens. It was not an idle boast. At its narrowest point, the street was constricted by a second-century triumphal arch; Alexander quite simply ordered it to be demolished. The arch's relief carvings were sent to the Capitoline Museum, and the

remains were sold off for building materials. This was not a pope to let history stand in his way.

T HERE IS of course a great deal of history standing in the way of any would-be developer or *amplificator* in Rome. Put a shovel in the ground almost anywhere and you will strike the past. Celebrated as *Urbs Æterna*, the Eternal City, since the first century BCE, what gave Rome its 'eternal' quality was its endurance through invasion, plague, plunder and the rise and fall of empires. The presence of both the monumental and the mundane reminders of all those turns of fortune still endow the city with its unique character and beauty. When Raphael was appointed to survey Rome's antiquities he cried out in frustration that many popes had 'allowed ancient temples, statues, arches and other buildings—the glory of their founders—to fall prey to ruin and spoliation.' Ever since the fall of the Roman Empire, the city's rulers have had an ambivalent attitude towards the great deal of the physical past they have had to contend with. On the one hand, ancient remains were an easily exploited source of building materials; on the other, preserving evidence of the city's past greatness enhanced current prestige. That ambivalent struggle between preservation and exploitation is exemplified in the fate of the Pantheon, in the seventeenth century, as today, the most complete surviving building from Ancient Rome.

The Pantheon owed its remarkable state of preservation to its early conversion from pagan temple to Christian

church—Santa Maria ad Martyres—in the seventh century. However, this sacred status didn't prevent Pope Urban from coveting the large amount of ancient bronze in the Pantheon's portico, and in the 1620s he removed over 150 tons of the stuff, with which he intended to cast a number of new cannon to arm the papal fortress of Castel Sant' Angelo. Outraged at this vandalism, Romans lampooned the pope, saying that 'What the Barbarians left undone, the Barberini finished off.' Attempting to mollify the populace, Urban declared that some of the bronze would be used for the construction of Bernini's Baldacchino. In the end, very little if any of the bronze was used by Bernini, and the pope instead stuck with his original plan and cast sixty new cannon. It may therefore have been feelings of guilt that drove Urban to commission some improvements to the ancient building. He ordered Carlo Maderno, architect of Saint Peter's façade, to decorate that of the Pantheon with a pair of bell towers. Unfortunately they were immediately derided as looking like a pair of asses' ears. (They were not, however, pulled down until the nineteenth century.) As usual, Urban installed large Latin inscriptions praising his additions to 'the most famous building in the world', and putting a positive spin on his abstraction of the bronze: he removed, he said, 'a useless and forgotten adornment' and turned it into 'an embellishment first for the apostolic tomb and in the fortress of Hadrian for the instruments of public defence'.

Alexander took an entirely different approach to 'the most famous building in the world'. Unlike his predecessor,

Falda's print of the square in front of the Pantheon, 'levelled and enlarged by Alexander VII'. The entrance was now no longer sunk into the ground

Alexander looked at the Pantheon with the eye of a city planner, and he didn't like what he saw. The square in front of it was a mess, hemmed in by poorly built houses, crowded with market stalls and squalid with the rubbish they produced. Traders had even set up shop in the shelter of the great portico. Exercising both his grand vision and his infuriating attention to minor matters, Alexander determined to re-present the Pantheon. He ordered the demolition of some houses and the regularisation of the fronts of others bordering the square; and he widened the street which led alongside the Pantheon to the nearby Piazza della Minerva. It was a lengthy and frustrating process. The canons of the church fought hard to defend their rental incomes from the market and householders; the traders were remarkably tenacious of their pitches. In spite of being moved *en*

masse to a neighbouring square they came back within nine months. One particularly determined flower seller had to be evicted from his spot beneath the portico three times. Alexander's diary is filled with entries relating to every aspect of the Pantheon and its square.

Over the centuries the level of the ground around the Pantheon had risen by three metres and it was impossible to return to the original Roman ground level, but Alexander had the square regraded, which at least succeeded in raising the entrance back above the level of the piazza. The pope went too far, though, with his aspirations to redecorate the interior. Alexander considered plans to glaze the famous open hole in the roof—the oculus—and to adorn the dome with his name and the heraldic symbols of his family, six mountains and an eight-pointed star. Bernini, who had hoped to restore the Pantheon to its antique appearance, had one of his rare disagreements with the pope. Usually so eager to please—indeed hardly able to resist the wishes of his chief patron—Bernini refused altogether to alter the interior. Another architect, possibly Carlo Fontana, was prepared to do so, but Alexander died before the redecoration could start. One of his last diary entries poignantly and predictably records his need for more money for the Pantheon.

CONSIDERING HIS intense and continuous involvement with Saint Peter's over the twelve-year course of Alexander's reign, it is astonishing how much other work Bernini produced both for the pope and lesser patrons. Alexander

ordered improvements to the papal summer retreat at Castel
Gandolfo, the building of a new church at his family's coun-
try seat, Ariccia, and work on the papal arsenal at Civitavec-
chia. Alexander took a close interest too in the new church
of Sant'Andrea al Quirinale, paid for by the Pamphili family
but just across the road from Alexander's favoured residence,
the Quirinal. Sant'Andrea may be Bernini's most personal
statement of faith. As Wittkower describes it: 'all the lines
of the architecture converge upon the ascending figure of
St Andrew...; praying in the oval space of the church, the
congregation participates in the miracle of the saint's sal-
vation.' Bernini was a contradictory mix of the boastful
and the self-critical, famously dismissive of his own work,
(but who knows whether that was through false modesty or

Bernini, holy water lavabo (detail)
at Sant'Andrea al Quirinale (1658-70)

perfectionism?). One day his son Domenico found him in a corner of the otherwise empty Sant'Andrea and asked what he was doing there. 'My son,' Bernini answered, 'it is only from this one work of architecture that I derive some particular gratification in the depths of my heart… often, seeking respite from my labours, I come here in order to derive consolation in this work of mine.'

Some patrons also provided him with what must have been welcome distractions from his major works. Just as he delighted in his writing and production of amateur theatricals, he may have welcomed these often frivolous minor commissions. For example, he designed a looking glass with the not altogether flattering motif of Time unveiling Truth, as well as a coach, for his friend Queen Christina.

Bernini's work ethic was prodigious, as were his capacity and desire to earn a great deal of money and secure the wealth and prosperity of his family. Following the scandal of his adulterous affair with Costanza Bonarelli, Bernini had married the daughter of a respectable but minor courtier. Caterina Tezio was nineteen years younger than Bernini and with him produced eleven children, nine of whom survived infancy. Two of the Bernini daughters became nuns, and their three sisters married into respectable if unexciting nobility. The pope was able to dispense a great deal of patronage in the form of well-paid and undemanding jobs to Bernini's brothers and sons. His brother Luigi (the one with whom he had so violently quarrelled over their shared mistress) was an engineer of talent who worked on most of Bernini's major projects and minded

the family business while Bernini was in France. Among his other brothers, one was a canon of Saint John Lateran, and another enjoyed an ecclesiastical appointment at Saint Peter's. Bernini's son Pietro rose high in the Church hierarchy but Bernini's wildly ambitious attempts to have him made a cardinal were thwarted by Alexander's death. Only one child, Paolo, attempted to follow in his father's footsteps, but his career as a sculptor was not a success.

At this distance it is impossible to tell if Bernini's domestic life was happy, or indeed even of much relevance to a man who only reluctantly married, and when urged to stop work for the day declared: 'Let me stay here, for I am in love'—in love, that is, with the work in his studio. I can't imagine that too many cosy hours were spent around the family hearth with a man who proudly boasted that 'if he could gather together all of the hours of leisure he had had during his entire life, they would barely add up to a month's worth of time.' Bernini may or may not have devoted a satisfying amount of time to his wife and children, but then he was taken elsewhere. His prodigious appetite for work and Alexander's endless stream of projects made for a perfect marriage.

TWO DAYS BEFORE his meeting with the pope, on 7 December 1665, Bernini celebrated his sixty-seventh birthday at his increasingly palatial house on the Via della Mercede. For what was then considered an old man, he was in good health, and had survived not just the arduous journey to and from Paris but the intrigues of Louis XIV's

court. The pope was gratifyingly delighted to have him back. There were great works to finish and, as ever, new plans to consider.

And there was a birthday surprise too. The monks of the Dominican abbey of Santa Maria sopra Minerva, around the corner from the Pantheon, had just discovered an ancient Egyptian obelisk while digging the foundations for a new garden wall. Such obelisks were rare and much prized. The pope, with his antiquarian and scholarly interests, had been informed and took a great deal of interest. It must have been among the first things he and Bernini discussed when they met, and it would be the last project they worked on together. What would they do?

Excavation of the obelisk in Campo Marzio in 1748. Although this commemorates a discovery almost a century after the one at Santa Maria sopra Minerva, the methods will hardly have changed

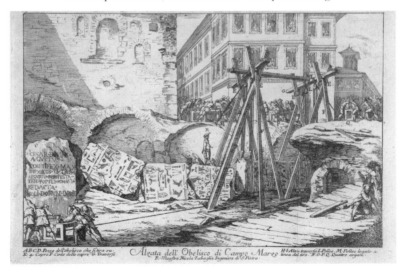

A S IT HAPPENED, it wasn't the first time such a discovery had been made in the grounds of Santa Maria sopra Minerva. Nearly three hundred years earlier, in 1374, workers had found not one but two small Egyptian obelisks while repairing the church's apse. Santa Maria sopra Minerva means 'the church of Saint Mary on top of Minerva'. The name is somewhat misleading because the church is actually built over a temple of Isis, not on the site of the nearby temple of Minerva. But the 'on top of' makes explicit not just the layer-cake nature of long-lived cities, but also the Roman consciousness that the past is always present. The ruins of the Isis temple that lay beneath Santa Maria sopra Minerva had already proved to be a rich source of Egyptian artefacts.

We might wonder why there was so much of Egypt in Rome—indeed, as we saw earlier, there are more obelisks in the latter than the former. In fact, the grip Egyptian civilisation has exerted on the Roman imagination dates as far back as the days of the ancient republic, and persisted right through the mediæval, Renaissance and Baroque years. The intensity and importance of this fascination were far more than just the consequence of Cleopatra's come-hither looks at Cæsar and Mark Antony.

For the ancient Romans there were in the first place highly important practical reasons for this fascination. Strategically, control of Egypt secured the eastern Mediterranean. Economically, Egypt was the granary of the empire. Italy couldn't produce enough food to support Rome's

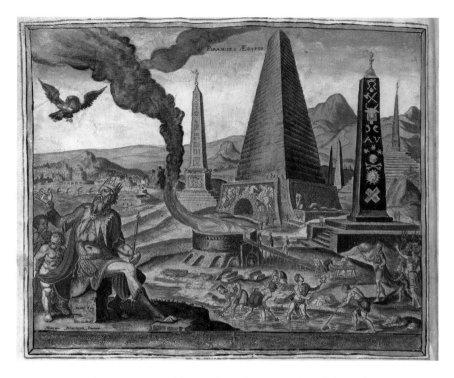

A sixteenth-century view of the grandeur of Egypt, with a plethora of pyramids and obelisks. The city in the background looks very like Rome, where the artist, Marten van Heemskerck, who was Dutch, lived for many years

million-plus population, and grain, especially in the form of the state-subsidised grain dole, was the major part of the plebian diet. When Octavian—the future Emperor Augustus—defeated his arch-rival Mark Antony and took control of Egypt in 30 BCE, his political and financial future was secured. He kept the province as a personal fiefdom, and the revenue pouring in helped to pay for his imperial ambitions. Octavian proudly and quickly minted commemorative

157

coins depicting himself on one side and on the other a croc-
odile—symbol of the Nile—with the inscription *Ægypta
capta*: Egypt captured.

But aside from the political and economic consequences
of the Roman conquest, Egypt had extraordinary cultural
value. The ancient Greek traveller and historian Herodotus,
writing in the fifth century BCE, distilled Egypt's unique
status when he declared: 'This country has more marvels
and monuments that defy description than any other.' Egypt
was regarded as the fount of scientific knowledge too. The
mediæval chronicler Isidore of Seville was merely repeat-
ing centuries of opinion when he wrote that 'the Egyptians
were the first to identify the laws of astronomy, the first to
teach astrology… the discipline of geometry was created by
the ancient Egyptians.' This remained the opinion for cen-
turies to come after Isidore, as did the notion that Egyptian
magic and religion provided special spiritual insight. Indeed,
in its praise of Moses, the Acts of the Apostles noted that he
'was learned in all the wisdom of the Egyptians'. The popes
were not alone in being curious to explore these arcana.

OF ALL EGYPTIAN objects salvaged from the wreckage of
ancient Rome, obelisks with their size, weight, sacred
pedigree and puzzling hieroglyphs were the greatest source
of awe and wonder. Ancient visitors to Egypt from Greece
and Rome had already been stunned by the antiquity of
Egyptian civilisation, even then thousands of years old, and
by the scale and boldness of its monuments; above all they

*Falda's view of the Pyramid of Cestius, 'restored by
his Holiness Pope Alexander VII'*

were fascinated by those two related, archetypal Egyptian forms, the pyramid and the obelisk.

Following Octavian's conquest of Egypt, Romans went mad for Egyptian forms and motifs. The pyramid was tried out, albeit on a modest scale: visitors to Rome will be familiar with the Pyramid of Cestius, the tomb of the rich magistrate Gaius Sextius which still greets those who enter Rome by the Porta San Paulo. It remains remarkably well preserved thanks to its incorporation into the third-century Aurelian Walls and also to the Egyptian interests of Alexander VII, who had it restored in the 1660s. Another pyramid—known as the Pyramid of Romulus from the mistaken belief that Rome's mythical founder was buried within it—was less fortunate, demolished in the sixteenth

century so that its marble cladding could be used to pave the floor of Saint Peter's.

But it was the obelisk that most vividly marked Rome as the successor to the world's most enduring and potent empire. Exactly how far back obelisks first appeared in Egypt has never been determined, but they were long associated with the sun god Ra, and often placed in pairs at the entrance to his temples. 'An obelisk', according to the ancient Roman naturalist and military man Pliny the Elder, 'is a symbolic representation of the sun's rays, and this is the meaning of the Egyptian word for it.' Indeed the Egyptians called them *tekhen,* which derived from their verb 'to pierce', suggesting that these stone needles pierced the sky to provide a link between the earth and the heavenly realm of the gods. Our own word 'obelisk' and the Latin word *obeliscus* have a more mundane origin. The Greeks felt, irreverently, that these great monuments looked like nothing so much as the meat skewer—*obeliskos*—which they used for their barbecues.

The basic form of an obelisk is a single piece of stone—a monolith—with a square base raising up with either straight or tapered sides and topped with a pyramidal cap. Obelisks were made in a wide range of sizes and materials but soon, like all expressions of power, fell subject to the rule that size matters. As Pliny noted, they 'were made by the kings, to some extent in rivalry with one another.' The carving, transport and erection of obelisks required significant technical skills and the great resources that only rich, authoritarian

regimes like those of pharaohs—and, later, emperors and popes—could command.

Although the earliest obelisks may have been erected as far back as the time of Egypt's Old Kingdom, the era when the pyramids were built, most of the obelisks we are familiar with were made during the dynasties of the New Kingdom, between 1600 and 1100 BCE. There is still considerable speculation about how the Egyptians were able to dig out and manipulate huge blocks of stone with little more than massive amounts of man power, ropes, and timber. They did not even have metal tools strong enough to quarry stone. Instead, it seems that when an adequate seam of granite was found in the quarries at Aswan, the surface was first cracked and broken with fire and cold water. Once the basic shape of the obelisk had been marked out, the arduous work of actual quarrying began, with teams of workers pounding the stone with balls of diorite, a stone which is harder than granite. Eventually the obelisk would be freed from the rock and need to be moved into its final position, a hundred miles or more away, processes that would have involved many thousands of workers and a great deal of time. Once the obelisk was quarried there was the slow journey to the banks of the Nile where it would be loaded onto a specially constructed ship for the trip downriver. On arrival, the vast object had to be unloaded, once again hauled cross-country, and then erected, all tasks involving more time and more thousands of labourers. We are talking about moving monoliths that weighed up to 450 tons, about the same as a fully loaded jumbo jet. And such

monoliths are surprisingly fragile. Stone is strong in compression but less so in tension, which means that obelisks are sturdy when standing but vulnerable when lying down or being raised or lowered at an angle. There would be plenty of opportunities for disaster on every journey.

S O IT IS PERHAPS not surprising that successfully raised obelisks are boastful as well as worshipful. The inscription on Pharaoh Hatshepsut's obelisk is typically unambiguous: 'In order that my name may endure in this temple for eternity and everlastingness.'

The sentiment would have appealed to Augustus with his lust for power and self-aggrandisement. He looked in admiration at the works of ancient Egypt—already thousands of years old—and decided to take something back home as a souvenir, war trophy and irrefutable statement that Rome had now surpassed the greatest civilisation the world had known. Egyptian grain would feed Rome and Egyptian stones would advertise Rome's greatness. In 10 BCE Augustus chose two of the largest obelisks in his recently acquired province and ordered them to be shipped back to Rome. Obelisk-carrying ships needed to be built and teams of workmen assembled to dismantle the monuments, load them on the ships, cross the Mediterranean, disembark them at Ostia, Rome's port, cart them the sixteen-odd miles to Rome and re-erect them. As Pliny put it, 'the most difficult enterprise of all was the carriage of these obelisks by sea to Rome, in vessels which excited the greatest admiration.'

Seventeenth-century illustration of method of transporting
obelisks to Rome described by Pliny the Elder

The smaller of the two obelisks, now known as the Monte-citorio, was 22 metres of red Aswan granite weighing over 200 tons, originally commissioned for the temple city of Heliopolis at the relatively late date of around 590 BCE. Augustus erected it in what he intended to be the most privileged position in Rome, a large area of the Campus Martius devoted to promoting the glory of the new ruler. Joining its neighbours, the Altar of Augustan Peace and the large circular imperial mausoleum, the obelisk was made into the

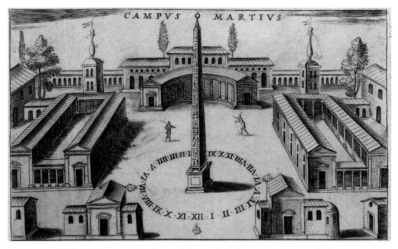

The Campus Martius, with an obelisk set up as a sundial,
as imagined in a print of 1612

gnomon, or indicator, of a giant sundial, and carefully placed to cast its shadow on the Altar of Peace each 23 September, Augustus's birthday. Should there be any doubt about the importance of the monument, a Latin inscription on its base announced: 'Cæsar, emperor, son of the deified Julius, Augustus, chief priest, imperator for the twelfth time, consul for the eleventh, holder of tribunician power for the fourteenth time. Egypt having been brought under the rule of the Roman people, he gave this as a gift to Sol.' Thanks to the soggy ground of the Campus Martius, the giant sundial subsided and became inaccurate within only thirty years.

Augustus's second obelisk was an older one, dating from around 1300 BCE, and slightly larger at 24 metres and 235 tons. Augustus ordered this to be erected on the *spina*, or central reservation, of the Circus Maximus, Rome's largest

164

stadium, where at least 150,000 spectators could watch public games including gladiatorial combat and chariot races.

Having acquired the expensive taste for imported obelisks, Augustus brought more of them to Rome during his long reign. It was a fashion that many of his successors followed, and for the same reasons. Obelisks were used to enhance imperial prestige, to broadcast Rome's status as the world's dominant power, and in some cases to benefit from Egypt's reputed spiritual power. Caligula, Claudius, Domitian and Hadrian all thought it worthwhile to bring obelisks to Rome. Most of the arrivals were genuinely ancient, but some were carved in Egypt by imperial order. Perhaps bespoke obelisks were more convenient.

The very largest of all—32 metres high and weighing 455 tons—was also the last to be brought to the city, in 357 CE. The story of how it arrived illustrates just how much of the obelisk craze was also a game of imperial one-upmanship. This giant among obelisks originally stood among the temples of Karnak, near Luxor. The Emperor Constantine had it removed and taken to Alexandria to await shipment to his new capital, Constantinople. Unfortunately, Constantine died before a suitable ship could be made ready to transport it and so the obelisk was left lying in Alexandria. Twenty years passed before Constantine's middle son, Constantius II, was needled into shipping it to Rome by mischievous courtiers. According to the contemporary writer Ammianus, the gossip was that while Augustus had managed to bring two obelisks from Egypt to

A 17th-century reconstruction of the Circus Maximus, with the obelisks of Augustus and Constantius in position

Rome, Constantius was reluctant to move even this single one, 'overawed by the difficulty of its size'. Determined not to be outdone by Augustus, Constantius duly ordered the obelisk to be shipped to Rome and had it proudly installed in the Circus Maximus alongside the far smaller obelisk of Augustus, which by then had been in situ for nearly four hundred years.

It was a grandiose imperial gesture, renewing contact with the first emperor, but now the age of Imperial Rome was near its end, transformed by the recognition of Christianity as the official religion of the empire in 380 CE and fatally weakened by a series of 'Barbarian' invasions, beginning with the sack of Rome in 410 CE by Alaric and his Visigoth army. 'Who would believe that Rome, built up by the

conquest of the whole world, has collapsed,' St Jerome lamented. 'The mother of nations has also become their tomb.'

WITH THE FALL of the empire, the age of obelisks too appeared to be over. In the centuries that followed, the obelisks tumbled one by one, victims of neglect, fire, earthquake, plunder. Meanwhile, Rome entered its early mediæval period of dilapidation and depopulation, the city's hills were abandoned, and the flatlands of the Campus Martius became the new residential centre.

Modern day visitors to Rome will be familiar with this area, if not with the name, which in modern Italian is Campo Marzio. Along with the area around the Colosseum, it is the epicentre of tourist Rome, the place to buy an overpriced *gelato* or a jocular T-shirt. It's a flat, boggy area, in fact the floodplain of the Tiber, bounded on three sides by the sharp bend of the river, and to the east by the Capitoline, Quirinal and Pincian hills. It was on these hills, and the others that made up the fabled seven hills of Rome (there are far more than seven, of course, and little agreement on which of them make up the magic number), that the earliest Romans settled, long before the city's legendary foundation by Romulus on 9 April 753 BCE.

This combination of river and hills was really the secret of Rome's destiny: it is the first upriver point where the Tiber could safely be crossed, and this valuable spot could be easily defended from the hills. The area at their feet was prone to

flooding, and through the early centuries of ancient Rome the Campo Marzio was little lived in. Its flat topography made it a convenient place, however, for military training—hence its Latin name *Campus Martius,* the 'field of Mars'. By the time of Augustus, however, the Campus was becoming crowded with theatres, civic buildings and temples honouring military victories, culminating, as we saw earlier, in the emperor's own mausoleum, altar and sundial with obelisk gnomon. After a catastrophic fire in 80 CE—Nero's fire of 64 CE wasn't the only one to devastate Rome—the emperor Domitian rebuilt the neighbourhood even more grandly, adding a magnificent circus for chariot races. Its track defines the shape of today's Piazza Navona. A smaller project nearby, but apparently close to Domitian's heart, was the enlargement and embellishment of the temple of Isis. The worship of Isis was one of many exotic Oriental religions

'Madama Lucrezia': archæologists believe this may once have been the cult statue of Isis in Domitian's temple

The arch on the left of this second-century tomb carving may show part of the complex of the temple of Isis. Detail of the Tomb of the Haterii, a family of building contractors who also appear to have been involved with the building of the Colosseum (centre)

enthusiastically adopted by the ancient Romans, and Domitian himself seems to have been a particular devotee of this maternal Egyptian goddess associated with magic, resurrection and kingship.

There is little evidence of what Domitian's temple looked like. With the exception of the Pantheon, a temple that had been converted for use by another Oriental religion, Christianity, none of the other ceremonial and religious buildings of the neighbourhood has survived intact. They were either plundered for building materials, adapted or allowed to fall into disrepair, buried beneath piles of urban rubble and rubbish or sometimes destroyed. What little might have remained of the Temple of Isis was pretty definitively wrecked in 1084 when the Normans sacked and burned the city. Somehow, a handful of its Egyptian features, including the obelisk, survived.

Just under two hundred years later, this was the site

given to the Dominicans to build themselves a church. Out of the nine-hundred-plus churches in Rome, it is the only one built in the Gothic style. The thirteenth century, when Gothic prevailed, was not a propitious time for church-building in Rome, which was then plagued by political and economic instability, a weak papacy and vicious infighting amongst the local aristocracy. In spite of these adverse conditions, the members of the new Dominican Order were determined to have an important presence in the capital of the Christian world. Their mother church, Santa Sabina, was up on the relatively remote Aventine Hill and, with their emphasis on preaching in the vernacular and their desire to reach the growing number of city dwellers, the Dominicans wanted a base in the most densely populated part of town, the Campo Marzio.

Building work on this grand church began in 1280. It was allegedly supervised by the Dominican lay brothers Sisto and Ristoro, the architects of Santa Maria Novella in Florence, which would be a neat story if it could be believed. What is true, however, is that from the beginning the church had strong links with Florence and Tuscany. It was here, for instance, that St Catherine of Siena was buried, as was the artist monk Fra Angelico, one of the fathers of Renaissance art, described on his tomb as 'the flower of Tuscany'. As the most international city in Europe, Rome had many churches serving particular nationalities, including non-Roman Italians. Santa Maria sopra Minerva remained informally the national church in Rome for the Florentines right up until

Santa Maria sopra Minerva, and its famous Risen Christ by Michelangelo, from the 16th-century guidebook, Le Cose Meravigliose dell'alma città di Roma

the late sixteenth century and the building of San Giovanni dei Fiorentini by the Medici pope Leo X. Many Florentine artists contributed to the church. One of Michelangelo's weaker works, the *Risen Christ*, stands by the high altar, a nude figure wearing a risible bronze loincloth added by prudish clerics. A generation earlier, Filippino Lippi, former apprentice to Botticelli, decorated the church's Carafa Chapel with frescoes, including one depicting the Dominican theologian St Thomas Aquinas triumphing over heresy. (This seems particularly appropriate, as the neighbouring monastery was the headquarters of the Roman Inquisition and the site of the 1633 show trial of another Tuscan, Galileo, when he was punished for the heresy of believing that the earth revolved around the sun.)

Even after San Giovanni dei Fiorentini was built, Santa Maria sopra Minerva continued its Florentine connection.

Bernini, Neapolitan by birth but Florentine by ancestry, knew it well; in the decade before the discovery of the obelisk he had contributed two works to the church, an innovative tribute to the nun Maria Raggi, and a vast and elaborate, if stodgy, memorial to Cardinal Domingo Pimentel.

I T WAS IN the foundations of the garden wall of Santa Maria sopra Minerva that a number of Egyptian artefacts were discovered. As we saw, obelisks had more or less disappeared from Rome's townscape, buried or broken objects of curiosity certainly, and also sometimes a nuisance. But the memory of Egypt persisted during the Middle Ages: for example, there are thirteenth-century carvings of sphinxes in the Lateran cloisters. The Renaissance, with its rediscovery of antiquity, saw a significant revival of interest in things Egyptian, much of it connected with the apocryphal figure of an ancient prophet, Hermes Trismegistus, whose attributed writings, a mishmash of Egyptian wisdom, were believed to have somehow foretold the coming of Christianity. Pagan themes were even brought straight into the heart of the Vatican when, in the 1490s, the Borgia pope Alexander VI commissioned Pinturicchio to decorate his rooms with frescoes rich in references to Egypt. The new technology of books printed with moveable type reflected and further popularised the rising interest in Egypt. For example, Pliny's *Natural History,* with its vivid passages on Egyptian monuments, was in print in 1469, fifteen short years after Gutenberg printed the Bible. Herodotus's *Histories* followed as early as 1474.

In this period of heightened interest it was natural that the Vatican obelisk should have become the focus of attention, not just as the only continuously standing obelisk in Rome—supposedly protected because it had witnessed the martyrdom of St Peter—but also because it was conveniently sitting in the pope's backyard. Nicholas V, the greatest builder pope of the fifteenth century, considered moving the Vatican obelisk to the front of Saint Peter's. Surrounded by a high-powered papal brains trust of some of Italy's leading humanists, it's likely that Nicholas would have discussed the project with his chief architectural adviser, Leon Battista Alberti, arch-theorist of Renaissance architecture. There was much learned speculation on the origin and purpose of the Vatican obelisk. Was it, as popularly thought, the tomb of Julius Cæsar? And how did it get to Rome? One of Nicholas's house intellectuals, Angelo Decembrio, disdainfully remarked that the common people 'babble about how the work was carried out not by human power but by necromancy, magical arts and the incantations of Virgil', and, quoting Ovid, he declared that 'great deeds are done by money and by men.' The pope had both money and men, but he died in 1455 before he could issue the orders. The obelisk stayed put, and a century later the great architect Andrea Palladio was able to write in his guidebook to the antiquities of Rome that 'there used to be seven large needles in Rome' but that 'only one [is] still standing today, behind the Church of Saint Peter'. All was about to change.

W HEN FELICE PERETTI became Pope Sixtus V in 1585, thirty years after Palladio's guide was published, a new life for Rome's obelisks began. We have already met this brutal and determined man, whose relatively short papacy of five years saw the outlines of modern Rome come into sharper focus.

A mere four months after his election, Sixtus turned to the old challenge of re-siting the Vatican obelisk and appointed a commission of papal grandees to take charge and determine the best way to move the monolith. The commission's decision to put the job under the supervision of three architects did not appeal to the autocratic Sixtus, who imposed his favourite, the Ticinese architect and engineer Domenico Fontana, to whom he gave a blank cheque. Sixtus decreed that Fontana could 'make use… of whatever workmen and labourers, with the apparatus that may be necessary, of whatever kind it may be, and when in need… compel anyone to

Enthronement celebrations for Sixtus V in front of the unfinished Saint Peter's. The obelisk is in its original position, just visible to the left of the basilica

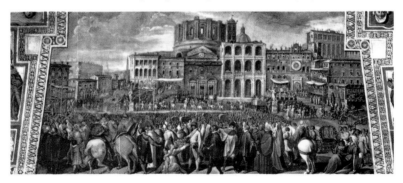

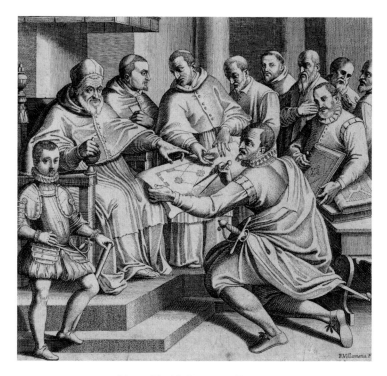

Sixtus V with Domenico Fontana

lend material to him or sell it.' Furthermore, 'No one shall dare impede, nor in any way molest the carrying out of this work of the said Domenico, his agents or workers, but on the contrary, without delay or any pretext, everyone shall help, obey and support him.' Armed with the strength of that mandate, Fontana began work within the month. He devised an ingenious timber tower, which he called the 'castello', to cradle and support the obelisk during the structurally perilous moments when it would be raised and lowered by a complex system of heavy ropes and pulleys.

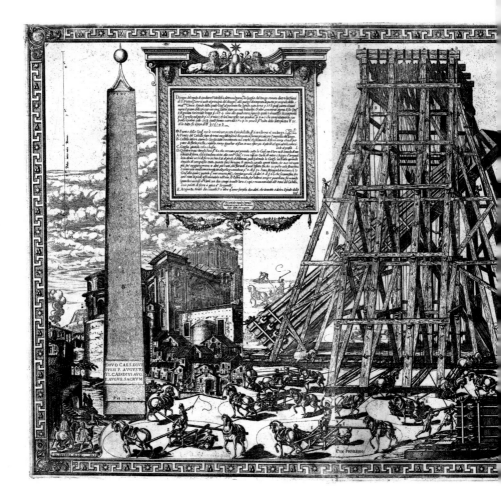

Lowering, transporting and re-erecting the obelisk at Saint Peter's

Work on moving the obelisk began on the last day of
April 1586, with the aid of nine hundred workmen and
seventy-four horses. By the end of September the obelisk
had been transported to and erected at its new location in
front of the basilica, where it still stands today. Fontana was

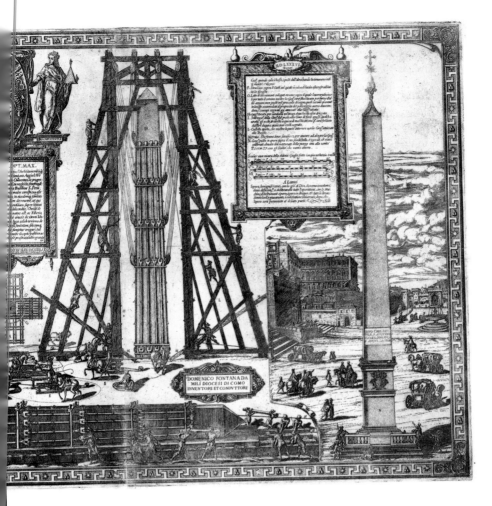

ennobled and richly rewarded by Sixtus. The whole enter-
prise was carefully documented in a large illustrated book
and celebrated by a fresco on a wall of the Vatican library.

Fontana's work was one of the great achievements of
Renaissance engineering and brought him Europe-wide

fame. For Sixtus and the Church the re-erection of the Vat-
ican obelisk was a masterstroke of messaging. Just as Au-
gustus and his successors had used the captured obelisks to
proclaim the universal power of the Roman Empire, Sixtus
made the Vatican obelisk a clear statement that the empire
of the Church had not only overcome the setback of the
Reformation, but was supreme and triumphant. The offi-
cial unveiling of the obelisk's new location on 26 Septem-
ber 1586 was charged with symbolism: the celebration of
mass, a procession of Church dignitaries and the exorcism
of the obelisk itself, circled three times by a bishop who
dipped a bunch of the Biblical herb hyssop in holy water
to sprinkle over the stone. Finally, a large gilt cross with the
pope's heraldic devices of three hills and a star was placed on
top of the obelisk. New inscriptions had been carved into
the obelisk and its base including 'Christ conquers, Christ
reigns, Christ commands. Christ protects his people from all
evil.' And lest anyone doubt who was doing Christ's work,
there were two reminders. 'Sixtus V consecrated to the most
holy Cross this stone torn away and stolen from its original
place under Augustus and Tiberius Cæsar' and more boast-
fully 'By laborious efforts Sixtus V removed the Vatican ob-
elisk, formerly dedicated to the impious cult of pagan gods,
to the threshold of the Apostles.'

Such was the excitement, and so clear the message, that
Sixtus ordered Fontana to move three more obelisks to prom-
inent positions on the pilgrims' route around Rome. Unlike
the intact Vatican obelisk, these three needed a great deal of

restoration. Fragments of the obelisk destined for the Piazza del Popolo, one of the first brought to Rome by Augustus, were recovered from the ruins of the Circus Maximus. The Santa Maria Maggiore obelisk, which once stood beside the Mausoleum of Augustus, had broken into three pieces. The obelisk intended for Saint John Lateran had broken into three pieces too, and had had to be dug out from a depth of seven meters. As the largest obelisk in Rome, moving and erecting it presented considerable difficulties, but Fontana's method worked once again. Towering 32 meters above the Piazza di San Giovanni in Laterano, it is the largest standing obelisk in the world. No-one has dared move it again, nor the other three repositioned by Fontana on Sixtus' orders.

Sixtus' motives in undertaking these enormous works were mixed. As one of his contemporaries wrote in 1587, 'Everyone knows with how much effort His Holiness has been trying to root out heresy and suffocate dark memories of idolatry, by dedicating obelisks and columns to the Saviour of the Universe every day...' (He had also put other pagan monuments to Christian use: by his orders, Trajan's Column became a perch for a statue of St Peter, and the column of Marcus Aurelius a platform for a bronze St Paul.) But there was also the practical and modern attention to the demands of the pilgrim trade. You will remember that Sixtus had wanted to improve and simplify the network of roads that moved Rome's pilgrims around the so-called 'liturgical ring' of pilgrimage basilicas. Thanks

to Fontana's engineering skills, the pope was soon able to leverage the value that obelisks could add to his vision, as signposts to, and markers of, key locations around the city, as well as inescapable and positive statements about the Church triumphant.

In spite of his use of obelisks and triumphal columns, Sixtus hardly loved the past for its own sake. He had few qualms about demolishing ancient monuments, most notably the temple of the Septizodium, some of whose stones were recycled for his own tomb. He even proposed that the Colosseum should be turned into a factory and dormitory for wool workers. Luckily, perhaps, he did not have time to put all of these plans into action. At the time of his election there had been hopes for a long pontificate, but in the event he died after just five years. In that short time he transformed Rome in a way that his contemporaries quickly recognised. 'There are so many novelties, buildings, roads, squares, fountains, obelisks and other wonders which Sixtus V, God bless his soul, built to embellish this dry old lady,' a pilgrim wrote, that 'thanks to that fiery and enthusiastic spirit, like a phoenix it was resurrected from the ashes into this New Rome.'

WHILE THE OBELISKS were an important part of Sixtus' town planning and propaganda campaign, they exercised considerable fascination in their own right, thanks to their age and mysterious origins. They soon became some of Rome's major sights for pilgrims and tourists alike. As

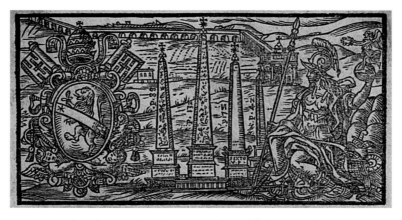

Image on the title page of Le Cose Meravigliose dell'alma città di Roma, 1588

early as 1588, one of the most widely circulated guidebooks to Rome, *Le Cose Maravigliose Dell'Alma Città di Roma*, featured an engraving of Sixtus's four obelisks on the title page of its new edition. A few hundred years later, when Napoleon had just conquered Italy, he suggested a project of tree planting in Rome, only to be rebuffed by the sculptor Canova, who remarked that in Rome they didn't plant trees, 'they planted obelisks'.

Scholars found them irresistible too. Most of Rome's obelisks—with the outstanding exception of the Vatican obelisk—were richly incised with Egyptian hieroglyphs, and the humanist scholars of the Renaissance believed that deciphering them could unlock the arcane wisdom which they believed the ancient Egyptians possessed. Alberti felt that the purpose of this Egyptian writing was to be 'understood easily by expert men all over the world to whom alone noble matters should be communicated'. In other words

the hieroglyphs were a code by which sacred knowledge could be transmitted across the centuries from one intellectual élite to another. The problem was that, no matter how hard they tried, neither Alberti nor his fellow scholars could crack the code. Indeed, hieroglyphs weren't understood until the early nineteenth century when the French Egyptologist Jean-François Champollion was able to translate the inscriptions on the Rosetta Stone. But in the centuries before Champollion much scholarly effort had been expended in studying hieroglyphs, all in vain. Typical was the classical scholar Pierio Valeriano, who spent fifty years on the subject, producing his massive book *Hieroglyphica,* and got it all wrong. When Sixtus V's obelisk expert, the physician, geologist, archæologist and director of the Vatican Botanical Gardens, Michele Mercati, published his guide to the obelisks of Rome in 1589, he regretfully concluded that the meaning of the hieroglyphs was lost forever.

YET THE CHALLENGE of deciphering the hieroglyphs always remained tempting. In Bernini's lifetime it was taken up with renewed vigour by the German Jesuit Athanasius Kircher. This tireless, erudite, and slightly ridiculous figure was the friend and confidant of Bernini and his papal masters Innocent and Alexander. Unlocking the mysteries of the hieroglyphs was a longstanding part of Kircher's encyclopædic workload. Fervently following Plato's saying that 'Nothing is more divine than to know everything', Kircher wrote that knowledge 'gives birth to a daughter, Wisdom,

Athanasius Kircher in 1655, the year he
published Egyptian Œdipus

the explorer of the loftiest matters', whose final destination
is the 'Ultimate Throne of Divinity': in other words, know-
ledge leads to godliness.

Not only did Kircher believe in the importance of know-
ing everything, he actually tried to do so, and in the eyes
of many of his contemporaries succeeded. In more than
forty often massive books, Kircher explored and explained
geology, mathematics, music, light, ancient Egypt, the Tow-
er of Babel, Chinese civilisation, topography, geography,
history, medicine and magnetism. His bibliography is ex-
hausting, as is his prose: Kircher overwhelms with verbiage,
illustration, references and quotations. Somewhat ironically,

the Jesuit Kircher's international celebrity owed a great deal to his well-connected Protestant publisher, Jan Jansson of Amsterdam.

Kircher was reputedly the master of twelve languages and not shy about displaying that mastery; there is a certain feeling of being beaten into submission by his preposterously wide-ranging erudition. Yet his unrestrained ambition to be the most learned man in the world has a certain charm. Kircher's blend of naïvety and arrogance led him to step up to any scholarly challenge issued by his royal and papal patrons. When the Emperor Ferdinand III wondered 'whether there might exist a universal language by means of which someone might correspond with all the peoples of the world', Kircher recorded that 'as there was no one capable of providing a sure ground for such a language, it pleased his Holy Roman Majesty to commit to my feeble talents the solution of the problem.' Needless to say such a universal language was never forthcoming, but in the world of patronage and courtiers that Kircher and Bernini both so skilfully navigated, being eager to please was an essential talent.

K IRCHER WAS BORN in 1602, part of the same generation as Alexander and Bernini. Educated at the Jesuit College at Paderborn, his skills as a linguist and a mathematician won him a number of academic appointments in Germany before he was talent-spotted and hired as Professor of Mathematics at the Jesuit College of Rome in 1633. There he created a museum that dazzled visitors with the breadth of his

Kircher's museum, with model obelisks prominent

knowledge and interests: the collection included a mermaid's tail, a 'magnetic altar', ancient Roman lamps, Chinese tablets and numerous Egyptian artefacts inscribed with hieroglyphs. Kircher arrived at a tricky and confusing time for intellectuals, following Galileo's second trial and condemnation to house arrest. Although Galileo had roused the

particular ire of Urban VIII, many prominent churchmen and Jesuits, including Bernini's friend and nephew of the pope, Francesco Barberini, were probably sympathetic to the astronomer's ideas. In the post-Galilean era of repression, Kircher steered clear of controversy, working hard on his first major book, *Prodromus Coptus* (*'The Coptic Forerunner'*), published in 1636 with Barberini patronage. Kircher shared the hope of others that an understanding of the ancient Coptic language could lead to a translation of the hieroglyphs. Like some of his earlier work and much of his later, this book rang alarm bells in terms of the reliability of his sources and the soundness of his conclusions. Many of his fellow scholars, and all of his patrons, throughout Kircher's very long career, wanted to believe in him, but others questioned his scholarship. He famously attempted to solve the old geometrical puzzle of squaring the circle, and was pleased with the result, although fellow mathematicians were scathing: 'I wish I could hold back the force of my laughter when I think about the Kircherian squaring of the circle,' one of them wrote. Meanwhile, in *China Illustrata,* a typically mammoth Kircher volume, the good Jesuit gave Italian readers a comprehensive guide to a country he had never visited. His last work, *Physiologia Kircheriana,* which appeared in 1680, the year of his death, contained the results of over three hundred important experiments conducted by Kircher, all of them unwitnessed and unverified. No wonder his great contemporary René Descartes sniffed that 'The Jesuit has a lot of tricks,' and concluded that 'he is more charlatan than

scholar'. Yet Kircher's claim to universal know-it-all status was somehow needed in seventeenth-century Rome. His energy, his optimism and his unwavering faith in his own abilities were contagious. At a time when science seemed to be yet another force assaulting faith, what was comforting and useful about all of Kircher's intellectual skulduggery was that, in spite of some more extreme theories, it was able to support prevailing Catholic doctrine.

Kircher seems to have first become interested in hieroglyphs while still in Germany in the late 1620s. This interest culminated in his unwieldy masterpiece, the two thousand pages of his *Egyptian Œdipus,* published in 1655. Before then Kircher's supposed mastery of hieroglyphs had brought him closer to Innocent X, the first pope since Sixtus to rekindle interest in obelisks.

IN 1651, INNOCENT's attention was caught by an obelisk lying broken in four pieces on the outskirts of Rome, where it had been erected in the fourth century by the Emperor Maxentius to decorate the central reservation of a new circus dedicated to his dead son. Although this obelisk was quarried and carved in Egypt, it had been made to the orders of the Emperor Domitian, two hundred years before Maxentius. Not long before Innocent was attracted to the broken pieces, they had piqued the interest of Britain's Charles I, who considered buying them but chose to spend the money on a painting instead. That great collector, the 14th Earl of Arundel, seems actually to have made a

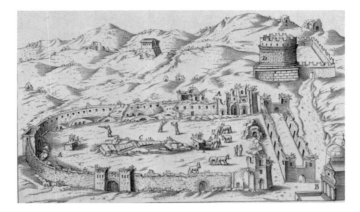

The circus of Maxentius in the late 16th century.
The obelisk can be seen broken in the centre

down payment for the obelisk, but was unable to figure out how to get it back to his estate in England.

Popes were usually keen to secure power bases in Rome in order to establish new family dynasties or enhance the credibility of old ones. Innocent was no exception to this rule. He built a grand church and palace on the Piazza Navona, where his family had been living since the late fifteenth century and, as we have seen, after some intrigue, commissioned Bernini to design a fountain as the square's new centrepiece and as a further Roman attraction for the Holy Year of 1650. The incorporation of an obelisk into the fountain was fitting. Piazza Navona had been the site of chariot races and would have been embellished with obelisks. More significantly, Innocent required a major piece of statement architecture, not just about the magnificence of his family and his papacy, but also about the Church

triumphant, at a time of some despair over the unsuccessful conclusion of the Thirty Years' War. Bernini's design was a masterpiece of beauty, engineering and symbolism. The ninety ton obelisk is spectacularly set on a base depicting the major rivers of the world—the Danube, the River Plate, the Nile and the Ganges, representing Europe, America, Africa and Asia—clustered around a cave-like void and topped not with a cross, like Sixtus's christianised obelisks, but with a dove, conveniently not only the image of the Holy Spirit but also the heraldic symbol of Innocent's family, the Pamphili. The structure of the base reflects Kircher's theory in which rivers were fed from vast subterranean reservoirs

Kircher's theory of the origin of rivers in his Mundus Subterraneus, *1665, one of the first books on physical geography*

FONS ALMÆ URBIS ROMÆ AMPLISSIMUS. EX MARMORE ET SAXO VIVO. In piaffo novono

NOBILISS. CONSULTISS. SPECTATISSIMOQ. VIRO. D.D. CORNELIO DE GRAEF. DOMINO IN POLSBROECK. INCLYTÆ URBIS AMSTELODAMENSIS CONSULI AC SENATORI FONTEM HUNC OBSERVANTLÆ ARTISQ. TESTIMONIUM D.D.D. IOANNES LUTMA IUNIOR.

Two views of the Fountain of the Rivers made in 1652 shortly after its completion. The nearest figure is the River Nile, veiled since its source was unknown

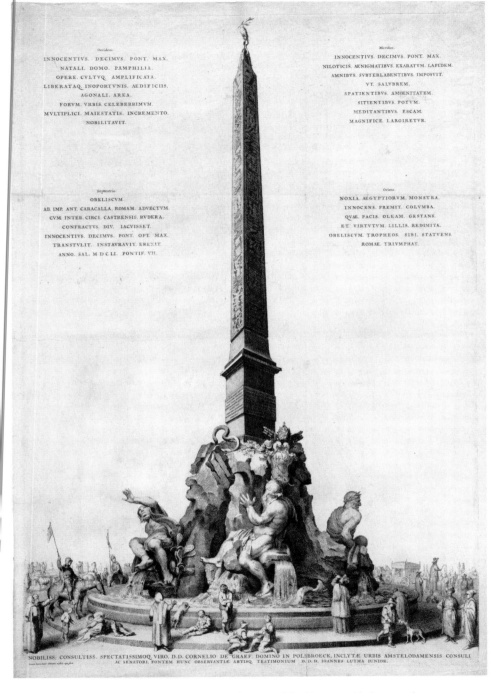

The artist was Dutch, an indication of the Europe-wide impact of Bernini's art

concealed within mountain ranges, an idea which Kircher must have discussed with Bernini.

The two men might well have met before the Piazza Navona project because Bernini was close to the Jesuit's intellectual circle in Rome. They would certainly have come into contact when Innocent commanded the moving and restoration of the broken obelisk and put Kircher, as the Church's resident Egyptian expert, on the task, but it's impossible to tell exactly how or to what extent Kircher contributed to Bernini's design. Kircher helped to compose the Latin inscriptions for the base of the obelisk, which reminded the public that, in commissioning the fountain, Innocent had 'ennobled the celebrated square of the city' and provided 'wholesome amenity for the strollers, drink for the thirsty and material for the meditators'. Bernini's son and official biographer Domenico lavishly praised the fountain as 'among the most outstanding ornaments of Rome and among the most marvellous creations of the world', but, keen as he was to promote Bernini's unique genius, left out any mention of Kircher's role. Aside from the fountain's inscriptions lauding the pope, Kircher also published a large illustrated volume, *Obeliscus Pamphilius,* which further celebrated Innocent's benign patronage and promoted his own erudition through detailed, if completely inaccurate, translations of the obelisk's hieroglyphs. Aside from the interest they had as carriers of hieroglyphs, Kircher seems to have felt that obelisks had been created to channel the reception of 'panspermia', which he considered a sort of universal fertility source coming from the sun.

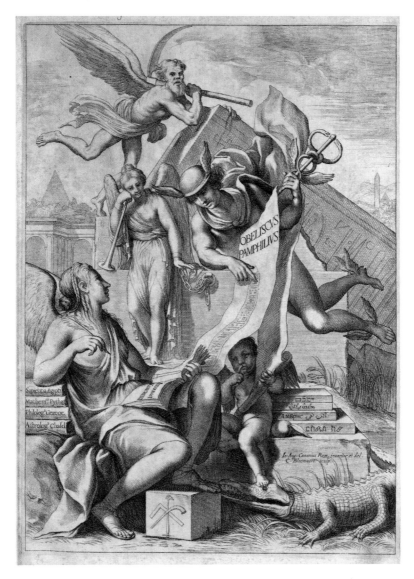

Title page of Kircher's book on the Piazza Navona obelisk. Destructive Time flies overhead, the obelisk has been broken and overturned and the Fame it embodied stands mute and chained. But her meaning is being interpreted by Mercury to a winged figure (the muse of history, perhaps, or a spiritual portrait of Kircher), who leans on a pile of the wisdom of the ancients

WHEN INNOCENT X died, Kircher, like Bernini and all the other courtiers, clients and hangers-on to the papal largesse, must have worried about his position, his income and his future prospects. Fortunately for him (like Bernini, as we saw), the new pope, Alexander, was an old friend. Alexander and Kircher had met twenty years earlier in 1637 when the then Fabio Chigi was Chief Inquisitor of Malta and Kircher visited the island as personal confessor to a travelling German princeling. During his short stay there, Kircher constructed a scientific instrument, the Maltese Observatory, for the Knights of Malta. It was inscribed in twelve languages and reputed to tell the time and date as well as conveying a great deal of knowledge, ranging from the medical to the botanical. No trace of it survives, nor any evidence that it ever worked.

Alexander shared Kircher's interest in mystical knowledge and all things Egyptian, and he warmly welcomed the Jesuit into his court. When the newly discovered obelisk of Santa Maria sopra Minerva was brought to the pope's attention, it was inevitable that he would turn to his favourite architect, Bernini, and his favourite antiquarian, Kircher, for inspiration.

ON THE EVENING of Sunday 4 April 1666, Pope Alexander noted in his diary that he would 'confirm the drawing with the elephant for the obelisk in Piazza della Minerva'. Two days later he met with Bernini to further study the drawings the artist had made for the setting up of

the obelisk. By the end of the month, Alexander ordered the payment of 2,000 *scudi* 'in cash to Father Gioseffo [sic] Paglia the Dominican monk to give to the illustrious Monsignor Alessandro Colonna to use them in the erection of the new obelisk found in the garden of the said convent and to re-construct the steps of the church.' Things had moved quick-ly between the discovery of the obelisk in late 1665 and the confirmation of plans and budgets in the spring of 1666.

It was not as if Bernini and Alexander had little else to do. They were both—by the standards of the seventeenth century—old men, and Alexander was old *and* ill. When Bernini arrived back in Rome from his unsatisfactory visit to the French court, three of Alexander's greatest projects were still awaiting completion: Saint Peter's Square, the Sca-la Regia or grand ceremonial entrance and staircase of the Vatican Palace, and the Cathedra Petri, the great bronze rel-iquary of the chair of St Peter. The Scala Regia and the Cathedra Petri were finished in good time in 1666; work on the colonnades of the Piazza and the statues above them dragged on into the reign of Alexander's successor. Bernini had other projects to think about too, especially the Jesu-it church of Sant'Andrea al Quirinale, the making of two over-life-size equestrian statues of the Emperor Constan-tine and Louis XIV, not to mention numerous less important commissions for busts and bas reliefs.

Why did these two old and busy men bring so much attention and energy to the relatively minor—in the grand scheme of Rome—project for the Minerva obelisk?

In the first instance, Alexander's antiquarian interests and scholarly disposition were excited by the discovery of a previously unknown obelisk. Secondly, the Piazza della Minerva had long interested the pope. It was in the midst of a neighbourhood where he considered establishing his family palace; it was next door to the Pantheon whose importance as the most complete surviving Roman building was universally accepted; it was the power base of the Dominican order and also close to the Jesuit's educational stronghold, the Collegio Romano. Even in the first year of his papacy, Alexander, with his usual and doubtless irritating attention to detail, was ordering his functionaries to demolish dilapidated buildings in the Piazza della Minerva and to tidy up the square 'for the ornament of the city'.

Finally, and perhaps crucially, Alexander's chronic health problems were getting worse. Both men were, a little more than was usual even for the time, interested in death, Bernini with his attendance of the Confraternity of the Good Death, and Alexander who kept a coffin in his private rooms. It wasn't until the pope's final illness in the spring of 1667 that Rome prepared itself for an imminent papal demise: after all, Alexander had been unwell for most of his adult life. But both Alexander and Bernini might have sensed that, by the time Bernini returned from Paris, the papal endgame had begun. The two friends could have felt, perhaps even discussed, that this re-erected obelisk might be the final monument of Alexander's reign. It would also be the most personal.

Alexander sat to the Maltese-born sculptor Melchiorre Cafà for this bust in December 1666, only five months before he died

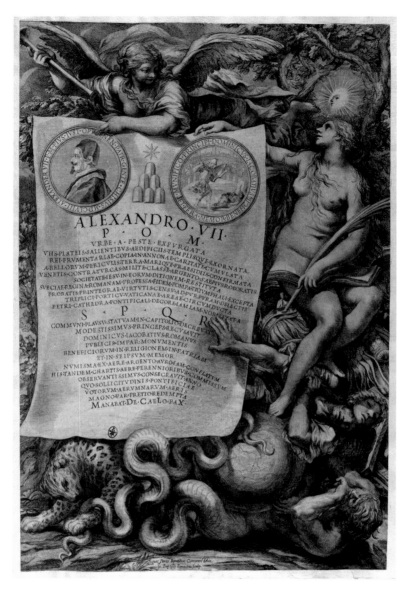

Print recording the medal that commemorated Alexander's swift action in preventing the spread of plague. The innovative reverse, showing Androcles and the Lion, possibly by Pietro da Cortona (who also designed this print), has led to it being called the 'first Baroque medal'

I MENTIONED earlier that soon after Alexander's election as
pope, plague struck Italy in 1656, devastating Naples first
and moving swiftly northwards. Thanks to Alexander's de-
cisive actions, Rome wasn't among the worst-hit cities, and
in gratitude the civic government of Rome voted to erect
a statue of the pope at their headquarters on the Capitoline
Hill. With dignified modesty, Alexander declined the honour,
saying that the only monument he desired would be found
in the hearts of the Roman people. He would obviously
have been aware of the fate of some previous papal statues as
magnets of mob violence and targets for destruction. With
unintentional irony, his refusal of the statue is in itself com-
memorated with a marble plaque in the Capitol, declaring
that as Alexander 'forbade that a statue publicly ordained
to him for saving the city from the plague was erected, the
senate and the people of Rome made visible some memo-
rial to his honour for the greatest leader who has achieved
such things.' A commemorative medal was cast too, which
inspired an accompanying engraving whose text praised 'the
most modest prince'. Papal modesty had its own rules.

Alexander's refusal of a statue became an important part
of his public image. In 1661 Giovanni Andrea Borboni pub-
lished *Delle Statue,* a dense theoretical treatise on sculp-
ture whose frontispiece engraving again paid tribute to the
pope's self-effacement with an allegory of Sculpture lay-
ing down her tools in front of an unfinished statue of the
pope while Modesty lowers her eyes and Fame flies above
blowing her trumpet (reproduced on p. 4). Borboni devoted

a whole chapter of his book to 'the virtue of refusing the honor of the statue'. This did not however apply to portrait busts, and Alexander was much sculpted by Bernini, Cafà and others. When Bernini delivered such a bust to the pope in 1657, Alexander was hardly averse to showing it off and noted with some delight in his diary, 'that today the Cavaliere Bernini brings the large marble of our portrait and many see it.' But there was a major difference between portrait busts intended for select audiences and a public statue for exposure to the crowd.

Like many of his predecessors, Alexander had made plans for a grand tomb in Saint Peter's. A mere five months after he became pope, a contemporary newsletter reported that, 'The new Pontiff, continually meditating on the brevity of human life, beyond the inscribed casket he has had made for his remains, now planned to have his tomb designed, composing on his own the inscription that was to be made.' Bernini was given the commission and Alexander's nephew, Cardinal Fabio, was charged with seeing that it got built. Throughout the whole of his reign Alexander discussed and modified the plans for the tomb, which hadn't even been started when he died twelve years later, and was only finished in 1678. A preparatory drawing of 1660 shows it getting close to its final form, with four allegorical figures surrounding a bareheaded pope, kneeling in prayer. This in itself was a departure from the established convention of an enthroned pontiff wearing the triple crown and giving a papal benediction. In the final design, beneath the praying pope, Death, clutching an hour

Bernini, proposal for tomb of Alexander VII, with nearly naked Truth

glass, emerges from the base of the tomb. This last touch was one of Bernini's most inspired solutions to a practical problem: the space allocated for the tomb was around an existing doorway which Bernini used as a ready-made gateway to the next world. As built, the tomb still had the four allegorical figures, Charity and Truth, Justice and Prudence. This was not, though, Alexander's own preferred line-up, which

had Peace instead of Prudence, and instead of Charity, that papal favourite, Modesty.

EVEN BEFORE he became pope, Alexander was carefully balancing his desire for modesty with his need for display: as Cardinal Chigi, his black velvet and silver coach was a recognised model of good taste and luxurious understatement. Alexander had a strong sense of his own magnificence, amplified through his architectural projects, medals, engravings, inscriptions and also his very name itself, which both paid tribute to his fellow Sienese pope, the twelfth-century Alexander III, and more potently suggested comparison with Alexander the Great. The pope's identification with the ancient Alexander is obvious too in a drawing by Pietro da Cortona, later published as an engraving, which refers to the ambitious plan of the Ancient Greek architect Deinokrates who wished to carve a huge likeness of Alexander the Great into the side of Mount Athos. In da Cortona's drawing, the kneeling artist—probably da Cortona himself—presents the pope with a plan while Deinokrates gestures to the giant sculpted Alexander in the background. Like his namesake, the pope wished to be remembered as a patron of philosophers and a builder of cities.

Other than for his tomb, the only instance in which Alexander agreed to a prominent effigy of himself was a half-length sculpture by Domenico Guidi for the reading room of the Biblioteca Alessandrina, the new library the pope created for the University of Rome, which was then

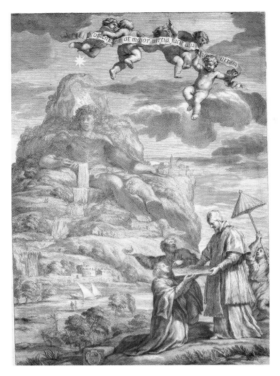

Pietro da Cortona, Deinokrates and Alexander, 1666

becoming well known by its nickname of Sapienza or 'wisdom'. One assumes the demands of modesty would be satisfied by the fact that this new sculpture was intended for the inspiration of students and lecturers rather than for the public gaze. Both the elephant and the university library were end-of-life projects for Alexander—the bull or edict officially naming the new library after Alexander was issued on 11 May 1667, a mere eleven days before his death—more personal than most, and aimed at enshrining his status as a scholar pope.

Even with Bernini's inventiveness, Alexander's tomb was still within a well-established format for papal tombs—an evolution rather than a break with tradition, which would have been unseemly within the context of Saint Peter's. Only being memorialised within the university library and Saint Peter's may have presented a challenge to Alexander, who was known for his walks through the streets of the city, who moved his residence out of the Vatican and into the city, and who had a model of Rome in his private apartments. Alexander was conflicted between a yearning for commemoration and an unusual—for a pope—attachment to modesty. So a grand effigy was out of the question, but a metaphorical commemoration in the streets of Rome, a cenotaph or empty tomb, could celebrate his devotion to the city, exalt his erudition and still satisfy the demands of modesty.

Bernini, preparatory model for tomb of Alexander VII. The head was made moveable so that the composition could be adjusted

Kircher's reconstruction of the Isis temple complex

SOON AFTER the obelisk was discovered in the grounds of Santa Maria sopra Minerva, Kircher was ordered to supervise its excavation and then to study and translate the hieroglyphs with which it was richly inscribed. This assignment produced another of his impressively illustrated books, although lightweight by his standards at just short of two hundred pages. Ever eager to display his erudition and to

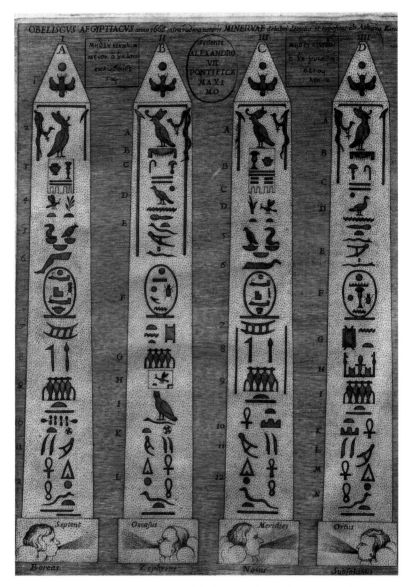

Kircher's careful representation of the hieroglyphs on the Minerva obelisk

please his patron the pope, Kircher provided his usual imaginative interpretation of the obelisk's inscriptions and concluded that it was erected to honour the 'Highest Genius, by the Egyptians called World Spirit, which has its seat in the sun'. Later and more accurate translations tell us that the obelisk was put up in the large provincial city of Sais in the Nile delta and dedicated to that city's patron Neith, a powerful goddess whom Herodotus considered to be an Egyptian equivalent to Athena. The obelisk was made and erected on the orders of the pharaoh Apries, whose nineteen-year reign in the sixth century BCE was an unhappy one, marred by failed foreign policy adventures and civil war at home. Although largely forgotten, he earned a mention in the Old Testament when 'saith the Lord; Behold I will give [him] into the hand of his enemies, and into the hand of them that seek his life'. Seven hundred years after Apries' death, the obelisk was sent to Rome, most likely on the orders of Augustus, and was later commandeered by the Emperor Domitian, who wanted authentic Egyptian decoration for his rebuilt Temple of Isis. The obelisk probably fell down sometime in the late eleventh century, when, as mentioned, the last remains of the temple were destroyed by Normans in their sack of Rome, and it lay buried beneath the garden of the Dominican monks until its discovery.

Alexander and Bernini were driving the Minerva project, but Kircher and the Dominican friar Giuseppe Paglia played important roles from the start. There was tension almost from the moment the obelisk was excavated, thanks to

207

the rivalry between the Dominicans, on whose land it was found, and the Jesuits, like Kircher and the pope's friend and biographer Pallavicino, who made up the pope's artistic and intellectual inner circle. Bernini was close to the Jesuits too. Longer established and more theologically focussed, the Dominicans regarded the Jesuits with a great deal of suspicion, wary of their worldliness and skill at realpolitik and envious of the influence and power they had acquired in the little more than a century since their founding.

How to display the newly found obelisk was a topic of some interest throughout the winter months of 1665-66, with a number of designs produced for Alexander's consideration. As expected, Bernini devised various schemes. So did the somewhat shadowy figure of Paglia, who clearly had architectural pretensions and wanted to assert as much Dominican control as possible. It's hard to believe that Alexander would ever have entrusted the project to anyone other than Bernini, but by at least looking at Paglia's ideas he could mollify the Dominicans. The one design that seems most likely to have come from Paglia shows the obelisk mounted on a plinth decorated with dogs, a not-so-subtle allusion to the Dominican's well-known punning nickname *Domini canes,* or 'God's dogs', in tribute to the tenacity and ferocity of their preaching. Bernini was more inventive and theatrical than the Dominican would-be architect, and his boldest proposals went even further than the balancing act he'd created twenty years earlier for the Piazza Navona. Among Bernini's designs was one featuring a giant of a man

Prints after early designs for the obelisk drawn by Bernini's studio
These versions include dogs.

struggling to hold a teetering obelisk upright, and in another an even more dramatic figure dragging the weighty obelisk to the top of a rocky promontory. This reference to the well-known parable in which Hercules chose to follow the arduous road to virtue rather than the easy road to vice should

*Prints after designs drawn by Bernini's studio for the obelisk,
with various allegorical figures*

have appealed to the austere and self-disciplined pope. But even with the technical skill of his engineer brother Luigi on tap, Bernini's vertiginous ideas may have been beyond the limits of seventeenth-century engineering, as well as being uncomfortably destabilising to look at. Bernini's other

Prints after designs drawn by Bernini's studio for the obelisk,
held up by a muscle-straining giant, left, and by Hercules, right

suggestions were more mundane, with allegorical figures sit-
ting on a plinth and supporting the obelisk. None got Al-
exander's approval. Maybe in some frustration at this point,
Bernini produced a new design that was startling in its wit
and originality. And the pope said yes.

211

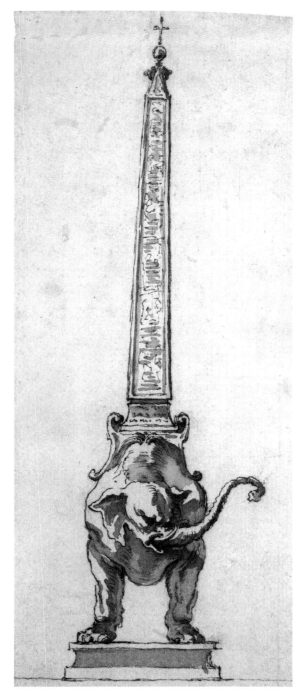

Bernini, sketch proposals for monument incorporating
Francesco Barberini's obelisk

THIS 'NEW' DESIGN was in fact an idea that had been at the back of Bernini's mind ever since a failed project of more than thirty years before when, early in Urban VIII's papacy, his family, the Barberini, were building a massive palace to announce their arrival as the most important family in Rome. After the death of their pet architect, Carlo Maderno, they employed first Borromini and then Bernini, working under the supervision of the pope's extravagant and æsthetic nephew Cardinal Francesco. An antiquarian and collector, Francesco got hold of a late Roman obelisk from the second century CE that had been lying neglected on the outskirts of Rome, and brought it to his new palace, intending to erect it as a scholarly and amusing garden ornament. Bernini designed a novel setting for it with the nine-metre obelisk carried on the back of an elephant. The proposal must have been seriously considered by Cardinal Francesco because, apart from a drawing of it, Bernini also prepared an unusually highly finished and large terracotta model of the elephant. Then, for reasons unknown, the project was abandoned.

The immediate stimulus for the proposed design for the Barberinis may have been an event of May 1630, around the same time that Bernini began working on their palace. 'An elephant arrived in Rome this month,' a contemporary diarist noted, 'something that hasn't been seen for a hundred years, since one was given as a gift by the king of Portugal to Pope Leo X in 1514. But this was a private man, who was charging one ducat for whoever wanted to see it.'

Like thousands of other Romans, Bernini almost certainly paid his ducat to see the visiting beast, which was known as Don Diego. The confident modelling of his terracotta elephant for Francesco suggests that he did—but there were in any case artistic precedents for him to study. We know that he made three sketches of elephants, copying the work of Raphael's pupil Giulio Romano, and he must also have been familiar with the elephant featured in the Bolognese artist Jacopo Ripanda's frescoes in the Hall of Hannibal in the Capitol's Palazzo dei Conservatori, painted around 1510. The elephant of 1630 was novel entertainment, but he also roused profound historical memories of more serious events in the previous century.

T HERE ISN'T MUCH information about Don Diego, but a surprising amount is known about a sixteenth-century predecessor. The election of a new pope was always an opportune moment for European powers to redefine their relationship with the Church through elaborate gift-laden diplomatic missions. When Giovanni de' Medici became Pope Leo X in 1513, King Manuel of Portugal sent such a mission to Rome in the hope that the new pope would confirm the status of Portugal's expanding overseas empire. Chief among the gifts was a well-trained Indian elephant. The Portuguese entourage landed at Porto Ercole and their journey from there to Rome was unexpectedly difficult. The hard Roman roads gave the elephant sore feet and huge, unruly crowds gathered everywhere for a glimpse

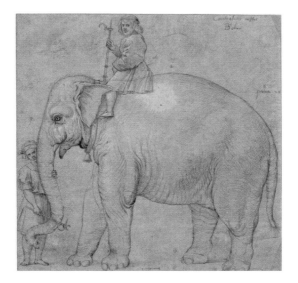

Raphael, Hanno, the elephant of Pope Leo X, 1514

of the exotic animal. When the elephant, named Hanno, finally arrived in Rome, he delighted the pope, who ordered that a home for him should be built in a corner of Saint Peter's Square. Even with such papal attention, three years later Hanno sickened with severe constipation and died, in spite of, or perhaps because of, being administered a half kilo of gold as a laxative. In his lifetime, Hanno had already been the subject of prints and drawings by a number of artists, including Giulio Romano; Leo, bereft, commissioned a life-size memorial fresco of the defunct pachyderm from none other than Raphael.

So the arrival of Don Diego in Rome a century after Hanno was greatly anticipated. Coincidentally, at around the same time a female elephant, called Hansken, arrived in

Hy schermt op de houw.
Il joüe a la taille.

Hy brenght handt water.
Il apporte de l'eau à laver les mains.

Hy veeg
Il s'esco

Hy schermt opde steeck.
Il joüe a l'estocade.

Hy geeft een schoon pootie.
Il baille la pate.

Hy n. empt een stuyver vande aerde op.
Il releve un patar.

Hansken den Olyphant is mynen naem. Ick ben oock t'grooste Beest van
In veel Landen heb ick groote faem. Veele consten can ick mennichde

Hy haelt een Ryckxdaelder weder.
Il va requerir vn Richedaelder.

Hy doet reverentie met de hoet.
Il fait la reverence avec le chapeau

Hy sch
Il ti

Hier danst den Olyphant.
l'Olephant danse.

Hy doet syn reverentie.
Il fait sa reverence.

Hy bedanckt de luyden voor haer gelt.
Il remercie les gens pour leur argent.

16

Hy leyt hem neer.
Il se met à terre.

15

syn haexke word jck gedwongē en geregeert, Daerom coopt dese prent om aente
ck can myn Meester myn heeft geleert. /schouwen, u gelt, sal u niet berouwē.

Hy hael gelt wt de sack
Il tire argent hors le pochet.

14

non bol.

Hy leyt de Jongers op een hoopken
Il amoncele les garçons l'un sur l'autre

12

Hy draegt de trompetter op syn neus.
Il porte le trompetteur sur sa trompe.

13

Holland and spent the next twenty one years touring Europe: Rembrandt drew her portrait in 1637. She too came to Rome but not till eighteen years later, in 1655, where Bernini and other artists must again have seized the opportunity to see a live specimen. It is no surprise that artists should have been attracted to such a novel subject, but elephants had an especially strong historical resonance in Rome, stretching back, via Hanno, to the early third century BCE and the Carthaginian general Hannibal's invasion of Italy.

For Renaissance and seventeenth-century writers and intellectuals, elephants were objects of particular fascination, thanks to the qualities attributed to them since ancient times, notably by the Roman author Pliny the Elder in his *Natural History*. 'In intelligence,' Pliny wrote, the elephant 'approaches the nearest to man... It is sensible alike of the pleasures of love and glory, and, to a degree that is rare among men even, possesses notions of honesty, prudence and equity; it has a religious respect also for the stars, and a veneration for the sun and moon.' Pliny also wrote that elephants were sexually discreet, 'coupling only in secret'.

Although elephants had effectively disappeared from Europe with the fall of the Roman Empire, their distinctive appearance ensured that they continued to feature in manuscript and book illustrations and as decorative architectural elements throughout the centuries. The elephant's strength

Previous pages: Hansken and some of the tricks she peformed during her tour of Europe

218

Iconology of the elephant:
worshipping the sun (left) 'for I am weak' (Psalm 6);
and smelling with its trunk (right) 'fortune yields to worth'

made them obvious weight bearers: carved elephants were used for example to support the eleventh-century bishop's throne in Canosa Cathedral. Thanks to the way elephants were characterised by Pliny and other respected ancient authorities, they had symbolic value too. The Greek text of Horapollo's *Hieroglyphica*, copies of which Alexander had in his library, said that when the Egyptians 'want to indicate a strong man sensitive to what is expedient they draw an elephant with its trunk. For the elephant smells with his trunk and is master of its fate.' In the widely distributed *Iconologia*, a collection of moral emblems much used by artists, Cesare Ripa noted that: 'The Elephant is an Emblem of Religion, as he adores the Sun and Stars.'

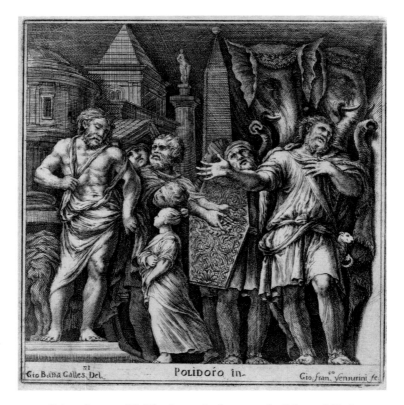

Print after one of Polidoro's exterior frescos on the Palazzo Milesi,
showing a Roman triumph with elephants passing by an obelisk

Rome and indeed the rest of Italy was hardly short of ele-
phant imagery. Some of it—the colossal triumph of Cæsar
painted for the Gonzagas of Mantua or Polidoro's frescos
of another Roman triumph decorating the Palazzo Mile-
si close to the Piazza Navona—celebrated ancient Roman
victory parades with elephants vividly representing the sub-
jugation of exotic peoples by 'civilised' Romans. Elephant
images could even be found in the heart of Rome's civic

government thanks to Jacopo Ripanda's murals for the Hall of Hannibal.

Bernini thought that with its reputed intelligence and piety, the elephant was a fitting beast to decorate a cardinal's garden and, some years later, to honour one of the great Catholic monarchies, the Spanish Habsburgs. He had returned to the theme in 1651 when he created a fireworks-spewing elephant as the centrepiece of a public event to celebrate the baptism of the Infanta of Spain. (Even artists as famous as Bernini were expected to create such ephemeral works to satisfy their patrons. These works might take the form of set designs or decorations for a procession, party or funeral.) So by the time the Minerva obelisk was available Bernini had two elephant designs under his belt: one never realised and the other only for a one-off event.

Bernini, 'machines' for fireworks, 1651

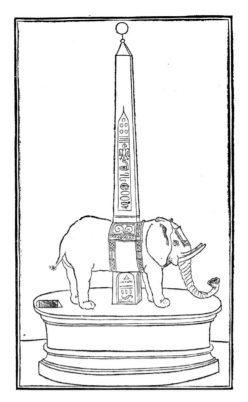

The elephant and obelisk in
Hypnerotomachia Poliphili, *1499*

BERNINI'S MOST SPECIFIC inspiration, though, was neither the performing elephants of 1630 or 1655, nor their predecessor, but an illustration to the bizarre and intriguing fantasy *Hypnerotomachia Poliphili,* written by the Dominican monk Francesco Colonna and published by the celebrated Venetian printer Aldus Manutius in 1499. Its splendid marriage of text and illustration makes it one of the most beautiful early printed books. *Hypnerotomachia* tells the story of

its hero Poliphilo's pursuit of his desired lover through a dreamlike landscape and is well summed up in the words of the late William Ivins, who headed the print department at the Metropolitan Museum: 'It is doubtful whether any equally famous book is as little read as this one, for it is said to be written in a mixture of Italian, Latin, and Greek, with occasional words from various Eastern tongues, and to be so dull that only the most pugnacious of readers can force his way through it.' Nonetheless, *Hypnerotomachia* was greatly admired by generations of intellectuals, possibly because no one could dare admit that they didn't understand it. Numerous editions were published in France and Italy and the first English translation appeared in 1592. Pope Alexander was a devotee: his own copy was heavily annotated.

Early on in his nocturnal journey, Poliphilo comes across 'a huge Elephant of blacker stone than obsidian' wearing an elaborately decorated saddle and carrying 'a mighty obelisk of green coloured stone', on which 'were engraven Egyptian characters'. There are some significant differences between the woodcut in Colonna's book and Bernini's elephant and obelisk as finally designed, but the controlling idea is the same and the book was well known to Bernini's patrons and collaborators.

WHICH IS NOT to say that the book was as well-known to Bernini himself. Given Bernini's close relationship with Alexander and his intellectual circle, as well as his activities, amateur though they were, as a playwright, it's

worth asking just how literate Bernini was. The convention-al view has been, as one scholar, Francesco Borsi, put it, that Bernini was someone who let 'others read for him'. But in her study of the library of Bernini's brother Luigi, some or most of which he may have inherited from the artist, Sarah McPhee found evidence that unlike many of his contempo-rary artists and architects, Bernini's library had 'impressive scientific, historical and literary variety'; that 'Bernini read what his patrons read', and that Bernini was an '*uomo letter-ato*'—a man of letters. Man of letters though he may have been, I doubt his familiarity with such a recondite text and valuable book as the *Hypnerotomachia* and assume that it was first brought to his attention by Cardinal Francesco.

Another compelling source for Bernini's elephant and obelisk design is an engraving celebrating Alexander's elec-tion as pope in 1655, featuring two elephants who pull a chariot, crushing heretics beneath its wheels. Seated atop, a personification of the Church is about to present the keys of St Peter to an angel carrying a portrait of the new pope. It must have been an image that stuck with Alexander. The tradition of the elephant-drawn chariot as part of a formal triumph or victory parade was allegedly established by his namesake, Alexander the Great. The chariot-pulling ele-phants of the engraving wear saddle blankets decorated with the six mountains and eight-pointed star of Alexander's Chi-gi heraldry, along with the oak tree of his family's patron, the della Rovere Pope Julius II. Eleven years later, Bernini put an almost identical saddle blanket on the back of the

Alexander VII crushes heresy, 1655

Minerva elephant, a detail which must have been suggested by the pope.

With Paglia, the frustrated architect, functioning as chief contractor and protector of Dominican interests, Bernini acting as artistic director, the Jesuit Kircher as intellectual advisor, and all under the supervision of a pope with a leaning towards micro-management, the obelisk-carrying elephant could have been a recipe for disaster. But however tense relationships might have been, the project progressed quickly. Within days of Alexander's approval of the elephant design, Paglia was making payments to stone cutters, masons and marble merchants. Most important was the employment of Ercole Ferrata as sculptor.

ERRATA as sculptor? Wasn't Bernini the sculptor, you might ask? Well, yes and no. Almost from the first of his great works, Bernini like others used assistants and collaborators on some or all of his sculptures. For example, the breathtaking tangle of laurel twigs, leaves and human hair that is such a feature of Bernini's *Apollo and Daphne* was actually the work of Giuliano Finelli, one of Bernini's longest-serving assistants. From the Renaissance onwards, as artists raised their status from craftsmen to intellectual workers, what became increasingly important were the concept and design of the work of art. Bernini and his contemporaries especially valued the *concetto,* the ingenious thought that gave birth to a work of art. When Bernini wished to bestow the highest praise on his contemporary, the French painter Poussin, he simply said that Poussin 'worked with his brain'. As for his own work, Bernini remarked that 'the thoughtful artist was never satisfied, for his work could never come up to the nobility of his idea.'

Artists' biographies, beginning with Vasari's *Lives of the Most Excellent Painters, Sculptors and Architects* in 1550, have tended to promote the idea of the artist as sole creative genius, with little or no mention of the subordinates. This was further reinforced by promotional biographies like Domenico Bernini's of his father, and more recently by the lives of Impressionists and subsequent modernists, who are often portrayed as one man or woman struggling against the world. This romantic notion hardly made sense in the seventeenth century, particularly in the context of creating

public or official works of art, which was very much a col-
laborative process. Nothing of this kind got made in Rome
without a patron to commission and pay for it, an artist to
design it and often a very large number of lesser artists and
craftsmen to make it. With the exception of the few years
of anxiety early in the reign of Innocent X, Bernini had en-
joyed an extraordinarily lucky run of papal patronage. Even
in an era where it was 'in the royal interest to keep every-
one suspended between fear and hope', in the words of the
court etiquette writer Matteo Pellegrini, Bernini was almost
always on the papal payroll. His long-running success was
due not just to his artistic genius but also to his political
and courtly skills with patrons, and his ability to recruit and
manage an army of artists and workers. This became appar-
ent during his great project for the decoration of the nave
of Saint Peter's for Urban VIII. This work, which started in
1647 and had to be finished in time for the Holy Year of
1650, employed no fewer than thirty-nine sculptors. One
of them was Ercole Ferrata, newly arrived in Rome. The
young Ferrata had been apprenticed to a distant relative,
a busy but relatively undistinguished sculptor working in
Genoa. Ferrata then moved on to Naples where, in the
words of Jennifer Montagu, he rose from 'carving decora-
tive cherubim and festoons to sculpting proper statues and
portraits'. Somehow he made contact with Virgilio Spada,
priest and architectural adviser to Innocent X, who intro-
duced him to Bernini. Prolific and highly respected, Ferrata
—rather like Bernini's father—was never quite in the first

rank of sculptors, but he was an influential teacher and as an assistant much prized by both Algardi, Bernini's chief sculptural rival, and Bernini himself, with whom he worked on a number of projects. Yet we look in vain for a single mention of Ferrata in Domenico's biography of his father, even though Domenico does express a pious wish 'to make some mention of the individuals whom the Cavaliere employed in the aforementioned projects or who were to lend not little assistance to him in future works when his energies began to wane as a result of advancing age.' Bernini could not possibly have turned out his huge body of work without such help, but he clearly did not much like giving credit where credit was due. Neither did Bernini ever mention his non-artist collaborators like Kircher, let alone the troublesome Dominican Paglia.

HOW MUCH LATITUDE did Bernini give Ferrata? The evolving design of the elephant changed significantly both from the model made for Cardinal Francesco in 1630 and even from the surviving sketches which Bernini presented to Alexander. This whole issue of artistic delegation is a fascinating one. Many of the large number of sculptors Bernini relied upon were, if not as famous as him, significant artists in their own right. The degree of control he himself was able to exercise depended both on the project itself and on the state of his other commitments. As Rudolf Wittkower observed, from the time of the making of the Baldacchino, Bernini began running a very large studio and

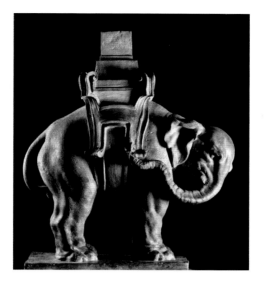

*Bernini, terracotta model of elephant for
Cardinal Barberini' garden*

the artistic consistency and cohesion of Bernini's projects
'depended not so much on Bernini handling the hammer
and chisel himself, as on the degree of his preparatory work
and the subsequent control exercised by his master mind.' In
her discussion of Santa Maria del Popolo, where Bernini
also employed Ferrata as part of the team, Jennifer Mon-
tagu notes that while we can't 'exclude the possibility that
Bernini modified his design in another, lost drawing', it was
'more likely that such modifications were left to the judge-
ment of the sculptors'. But the elephant seems to have been
so much a testimony to Bernini's esteem for Alexander that
I myself suspect Bernini remained very much in control.

It's difficult to evaluate, however, as surprisingly few

drawings survive. The most obvious change in the design that we can identify is that the elephant as executed wears a heavily decorated saddle blanket that extends down to the ground, making the elephant a solid base for the obelisk rather than having the weight carried by the elephant's four legs. Apparently this was due to the objections of Paglia who felt that any empty space between the elephant's legs or beneath him wouldn't be 'solid or durable'. Stubbornly, he chose to disregard Bernini's fabulous balancing act for the Piazza Navona fountain. As Bernini's modern biographer Franco Mormando points out, neither Bernini's son nor his contemporary biographer Baldinucci lists the Minerva elephant in their catalogue of Bernini's works. Is it because Paglia interfered too much?

At any rate, Paglia's views prevailed, and with this change the elephant became less naturalistic and more symbolic. The elephant's head was changed too: the forehead is much more pronounced and the right eye—looking up towards the top of the obelisk—is larger and more human. One art historian has even suggested that Bernini incorporated elements of the pope's physiognomy. This is not as far fetched as it sounds at first. Bernini was well known for his skill as a caricaturist, an art that depends on the ability to identify and exaggerate a subject's most distinctive features and characteristics and convey them as concisely as possible. His famous caricature of Scipione Borghese epitomised that luxury-loving cardinal in a handful of lines. Bernini 'above all enjoyed caricaturing the likenesses of princes and

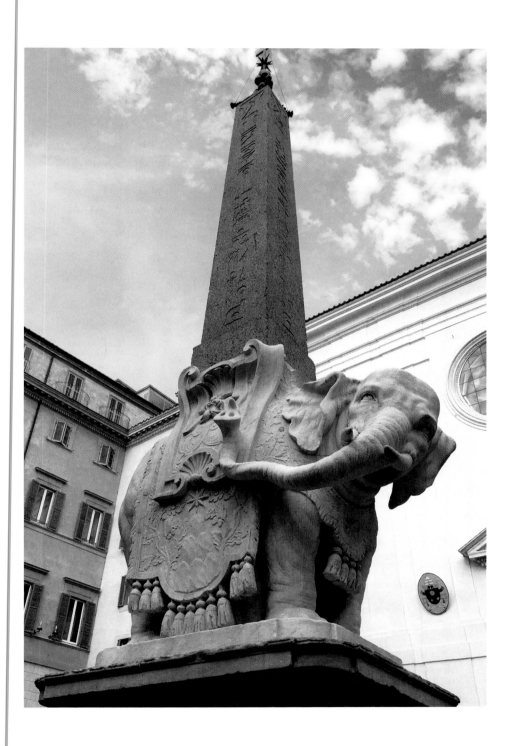

other eminent personages from the pleasure that they too derived from seeing themselves—and yet not themselves—in these portraits', his son wrote. There is indeed more than a touch of the human in the Minerva elephant's lively eyes and sly expression, and a discernible hint of Alexander's likeness there. But while it is not an explicit caricature of the pope, it is certainly a striking metaphor. As good a sculptor as Ferrata was, there isn't such wit or liveliness in any of his other work, which suggests that Bernini must have closely supervised the carving.

A flow of paperwork shows the progress of the work in Piazza della Minerva and the number of skills involved: '25 *scudi* paid to Master Cantalupo the Mason', '250 *scudi* paid to Sr Giovannia Battista Frugone for the marble that he will give to be used to make the aforesaid elephant', '12 *scudi* paid to the said Polidoro, stonecutter', '10 *scudi* paid to Francesco de Banchi and Giovanni Alessandrini, stonecutters, for work on the pedestal of the new obelisk', '25 *scudi* were paid to master Vincenzo Giovannini for the placement and installation of the elephant and obelisk', '10 *scudi* paid to Bernadino Colonna, marble polisher, for work done and to be done'.

Alexander himself paid great attention to the placing of the elephant. He briefly considered siting it on the south side of the square, where it would underline the importance of the road leading to the Jesuit's Roman College and the Corso. But he seems quickly to have come to the more logical choice of lining the elephant up with the axis of the church and thus making it the centrepiece of a much

improved space. Indeed, the entry in Alexander's diary that notes the confirmation of the elephant and obelisk also confirms the rebuilding of the church steps. There are further records of payments for travertine to make the new steps, and for cutting and installing them.

The siting was doubly important as the Minerva obelisk could seem frankly diminutive, even in a square as small as the Piazza della Minerva. In order to give it sufficient impact Bernini not only raised the obelisk on the back of the elephant, but also placed the elephant on a tall plinth. This had the added advantage of providing a great deal of space for the lengthy inscriptions of which Alexander was so fond. Probably written in collaboration with Kircher, they interpret the elephant and obelisk to those sufficiently educated to read Latin. The inscription facing away from the Church reads: 'In the year of Salvation 1667, Alexander VII dedicated to Divine Sapience this ancient Egyptian obelisk, a monument of Egyptian Pallas, torn from the earth and erected in what was formerly the square of Minerva, now that of the Virgin who gave birth to God', neatly placing the pope in a chain of sacred knowledge stretching back to ancient Egypt. The other inscription facing towards the church is more moralizing and commands: 'Let the beholder of the carved images of the wisdom of Egypt carried by the elephant, the strongest of beasts, realise that it takes a robust mind to carry solid wisdom.' Here the identification of the elephant with Alexander is explicit. With poignancy and perhaps a little irony, the ever-ailing pope is compared

to the strongest beast in order to pay tribute to his 'robust mind', which carried such 'solid wisdom'.

Alexander's health declined further in the summer of 1666 and, despite a brief rally in the autumn, by the time winter arrived he was bedridden and struggling to perform his duties. Work on the elephant was nearing its climax and its installation on site began in early February: there are records of payments to the ox drivers who transported material and to the workers who carted away the dirt from the dug up foundation for the monument. But it was not quite soon enough.

Alexander died at 10 o' clock at night on 22 May. Immediately the machinery of papal burial and mourning creaked into operation. The dead pope was loaded onto a crimson litter, and, accompanied by the Cardinal Lord Chamberlain and a torch-lit procession of armour-wearing horse guards, taken from the Quirinal to the Vatican. An autopsy, an embalming and a dressing in papal vestments followed the next day, and the body was put on display in the Chapel of the Blessed Sacrament in Saint Peter's, where the public could come to kiss the dead pope's feet and take what souvenirs they could—usually bits of cloth or hair—under the less-than-watchful eyes of the guards. Meanwhile a giant, temporary catafalque—a sort of stage to display the pope's coffin—was erected in the nave of Saint Peter's. Painted black with gilded decorations and lit by six hundred candles, Alexander's catafalque was surrounded by four obelisks with

Catafalque of Alexander VII in St Peter's

inscriptions and illustrations celebrating the great works of his reign: the continued adornment of Saint Peter's, the new gateway to the Piazza del Popolo, the clearing of the piazza of the Pantheon, the building works at the port of Civita-vecchia, the reconstruction of Santa Maria della Pace, and others. No wonder sharp-tongued Romans cruelly said that Alexander suffered from '*mal de pietra*', stone sickness, refer-ring not just to the kidney stones that helped to kill him, but also to his mania for building—a mania that excited equal amounts of admiration and contempt. As a Venetian

A print issued to show some of Alexander VII's architectural accomplishments

diplomatic report put it, ' the money pressed from the veins and blood of the poor had congealed into hard stone… the buildings multiply, but the inhabitants grow fewer.'

In the weeks before and after Alexander's death, Bernini must have thought back with horror to the violence and chaos of the *sede vacante* that followed the death of his friend and patron Urban VIII twenty-three years earlier. There was a great deal of popular resentment over how much Alexander spent on his building works. On the other hand, Sforza Pallavicino, Alexander's friend and biographer, wrote admiringly how Alexander's projects created employment and opportunity: 'The pope deemed it wrong to support by alms the able-bodied, therefore he erected buildings and joined beauty to usefulness. He knew too how much wide

streets and commodious houses contribute to the delight of the tenants, and how much these two would help bring to Rome large and illustrious numbers of foreigners.'

On 6 June, Ferrata was given his final payment for the work. The elephant would have been unveiled with little ceremony as Rome was once again enduring the uncertainty of a papal vacancy. The monument was finished and on view sometime before 11 June when a newsletter from Rome reported the new addition to the city as 'the uncovering of the elephant holding up the obelisk in the Piazza della Minerva, a work of exquisite sculpture with the inscriptions and arms of the late pontiff' before adding, no doubt to Bernini's fury, that it was all under the direction of 'Father Giuseppe Paglia, the famous Dominican architect'.

Bernini may have had the last laugh, though. A minor, but meaningful change in the design of the elephant involved moving the animal's tail to the side. Guidebooks love to say that this makes it look as if the elephant is about to defecate in the direction of the Dominicans' monastery, but art historians tend to dismiss the story. While it does seem undignified, especially in connection with a papal monument, such scatalogical humour was in fact common in Baroque Rome, and an expression too of the contemporary Italian love of practical jokes. As the historian Peter Burke put it, 'if we were to visit early modern Italy, we might find it difficult to adjust to a sense of humour which is now virtually confined to barracks'. The plays which Bernini wrote and produced for the élite of Rome contained, in his son's words, 'satirical

and facetious remarks' as well as practical jokes, including one in which an actor pretended to set the scenery alight and, as Domenico tells us, 'such was the terror of those witnessing the scene that someone actually died in the rush to escape the anticipated peril.' Compared to which, an about-to-be defecating elephant in a Roman square seems relatively harmless.

Was this a change approved by or even known to the pope? It would have entertained Kircher and his fellow Jesuits, as well as being Bernini's not-so-subtle critique of his Dominican overseer, Paglia. As the Roman satirist Sergardi (who might have invented the story) wrote: 'The elephant turns its back, shouting with raised trunk "This, Dominicans, is what I think of you!"'

The elephant's rear, before recent cleaning

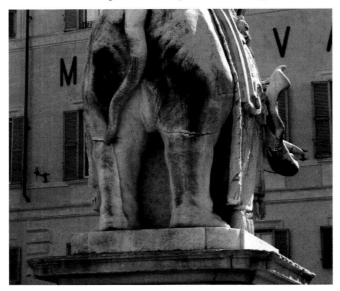

IN THE EVENT, the interregnum between the death of Alexander VII and the election of his successor was brief. The expected backlash against the Chigi began quickly, unleashed first against the dead pope's brother, Mario. 'The very night of the pope's death,' a newsletter reported, 'the Chigi started to experience bitterness, as Don Mario, in walking down the stairs of the Palace to head back home was attacked by the people with unheard-of insults. That night the façade of his palace was defaced with writing. The following morning his servants were mistreated and beaten, the evening before stones were thrown in the windows of the Chigi Palace.'

So it was just as well that this *sede vacante* was a short one. The cardinals gathered in conclave on 2 June and the usual fears, jealousies, horse trading and national rivalries soon became apparent. Cardinal Spada was a popular candidate but perhaps too friendly with the Barberini. What about Cardinal Carpegna? Too close to the Medici. Cardinal d'Elce was a favourite of the late pope's supporters, but the Medici didn't like him. Was Cardinal Buonvisi at sixty years old, just too young? In the end, the sixty-four Cardinals chose Giulio Rospigliosi, who took the regnal name of Clement IX. He had 'too many nephews and is too delicate,' a German cardinal reported to the Holy Roman Emperor Leopold I, 'however people think he may live another two or three years and it is precisely this circumstance, more than anything else, that will contribute to his election.' This was a great relief to Bernini. Like Alexander, Clement was an accomplished poet and, even more to the point, a keen

playwright. Bernini had designed sets for Clement's plays dating back to the days of Urban VIII, when the young cleric first came to the attention of the Barberini: his debut play *Sant'Alessio* was written for the opening of their private theatre. But he was no Alexander. His reign turned out to be a short one, less than two-and-a-half years, and he was unable to conceive or deliver the sort of grand projects that appealed to his predecessor.

As for Bernini, 'unbelievable was the Cavaliere's joy,' his son wrote, 'first, in seeing Rospigliosi elevated to the papal throne, and then, in experiencing the manifestations of the esteem and love with which he was held by the new pope.'

CLEMENT's brief reign was not especially happy. The Church's political power continued to erode. The new pope was bullied by both declining Spain and rising France, and the loss of Candia, the last Venetian stronghold on Crete, to the Turks meant the end of Christian power in the Eastern Mediterranean. So great was the alarm over this defeat that it is reputed to have brought on the pope's death.

But there were some triumphs too. Clement successfully, if only temporarily, soothed divisions in the Catholic Church in France, and the Church's global reach was symbolised by the beatification of the Dominican nun Rose of Lima, who later became the first saint born in the Americas. And although Clement was too frail, and the Church too poor, to support

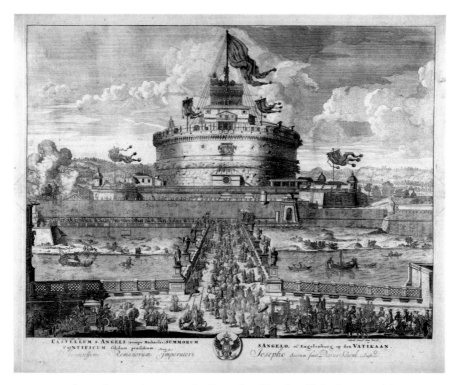

A papal procession crosses the Ponte Sant'Angelo with its 'new angels'
towards the end of the century

patronage on the scale of either Urban VIII or Alexander VII, building work continued on the colonnade of Saint Peter's Square, and Clement made one major intervention in the Roman townscape when he commissioned Bernini to modernise the Ponte Sant'Angelo. This bridge formed the major processional route across the Tiber towards Castel Sant'Angelo and then on to Saint Peter's itself. Bernini conceived ten larger-than-life-size angels, each associated with one of the instruments of Christ's passion. He carved two

241

Bernini, terracotta sketch for one of the angels carved by
Bernini himself for the Ponte Sant'Angelo,1668

of the angels himself and delegated the rest of the work to the usual suspects, including Ferrata, who had just finished carving the Minerva elephant. A new member of the team, though, was Bernini's son Paolo, who sadly inherited close to none of his father's talent. Paolo was paid the same rate as the other more proficient sculptors, but seems to have done little more than assist his father. The pope took a great interest in the Ponte fo angels, visiting Bernini's studio to see the work in progress and also viewing some of the angels on the bridge itself. Clement died in December 1669 and never saw the finished project. It took almost two more years before a report could be issued, in the autumn of 1671, that 'Now that the Cav. Bernini has finally finished his angel, the bridge is being visited by one and all.'

Popes came and went, Bernini carried on through the reigns of two more—another Clement, elected at the age of seventy-nine and not expected to last long, who surprised all by reigning for six years, and his successor, Innocent XI. While Clement X and Innocent XI continued to employ and honour Bernini, his relationship with them had none of the intensity and intimacy he had shared with Clement IX, Urban VIII or above all Alexander VII. It was not for lack of important works to be done. Chief among these was the long-delayed tomb of Alexander VII, finished and unveiled in 1678 after the austere Innocent XI had demanded that the voluptuous, naked figure of the allegory of Truth needed to be clothed. Consequently 'the statue was covered by the Cavaliere, under orders of the same pope,

Bernini, tomb of Alexander VII, 1671-78.
Truth (right) rests her foot on England

with a dress fashioned from metal whose surface he had treated so as to give it the appearance of white marble. This caused Bernini a great deal of trouble,' his son recalled. Such was the price of papal patronage.

Throughout his very long career, Bernini played his parts well and managed to stay on top more or less consistently amidst the violence, intrigue and turbulence of the Eternal City. Great artists needed great patrons to inspire, commission and pay for their work. Bernini's contemporary, the painter Salvator Rosa, tasted the ashes of the artist without patrons, complaining, 'As for commissions, I haven't had any, even from a dog, for a full year... I might as well plant my brushes in the garden.' Bernini by contrast made it his business to keep close to the pope, the greatest patron of all, and he managed to prosper through eight reigns, even when the incumbent was initially hostile, as with Innocent. But his relationship with Alexander seems to have been more in the nature of a genuine friendship.

BERNINI EXPLICITLY believed that his artistic inspiration came directly from God and that creativity was an almost divine practice. 'All that we know comes from God,' he declared, 'and teaching others means taking His place.' Meanwhile, Alexander, the representative of Christ on earth, had a lust for building and a desire for glory that equalled that of any other absolute monarch. The Venetian politician Nicolò Sagredo wrote that: 'The pope has long paid particular attention to beautifying the city and repairing the

roads,' before going on to compare Alexander's commissions as 'an achievement to recall the greatness of ancient Rome'. The comparison to ancient Rome appeared in an English guidebook of 1664 too, which noted that 'the pope's pleasure is not bounded with enlarging and embellishing only of the papal palaces, he shows the same passion for the whole City. And thus it being in his thoughts and design to embellish it in the same manner as those Roman Emperors with much care and heat endeavoured to do.'

For twelve years, the divinely inspired artist and the imperious pope shared centre stage in 'the world's theatre' and during that time they took the ragged remnants of the ancient city and clothed it in Baroque finery for its many roles, as capital of the Catholic Church, fount of Western civilisation and premier tourist destination. In some ways, they were unlikely partners: Alexander, the frail, intellectual descendant of an ennobled Sienese banking family with historic papal connections, and Bernini, the robust, instinctive, grandson of a country cobbler. Together, their union of need and want, resource and talent, aspiration and inspiration created what was known in its own time as *Roma Alessandrina* or sometimes *Roma Moderna,* and what to us, nearly four hundred years later, is Bernini's Rome. Those names tell us that, in 'the age of Bernini', credit often went to the patron; since the late nineteenth century we have given credit to the artist. The relationship between Alexander and Bernini was both complementary and complicated—almost, one might say, as Baroque as the work it produced.

247

Bernini, Tabernacle for the Chapel of the Blessed Sacrament,
Saint Peter's, 1674

Among Bernini's last works was the tabernacle for the Chapel of the Blessed Sacrament at Saint Peter's, which was designed to display the consecrated host to the visiting faithful. It is an exceptionally complex confection, featuring large kneeling angels, monumental candlesticks, an evocation of the famous Tempietto of Bramante and figures of Christ and

the apostles, all whipped up in marble, lapis lazuli and gilt bronze: at the same time an exemplar of religious intensity and an object as exquisite as a Fabergé Easter egg. Only an artist of Bernini's skill could have so masterfully struck a balance between ostentation and sincerity and somehow made so many disparate elements into such an harmonious whole.

It was something of a last hurrah, however, not just for the artist, but for the heroic age of refashioning Rome. There was to be a final burst of urban creativity in the eighteenth century, with the creation of the new Trevi Fountain and the construction of the Spanish Steps, but the vast scale of Bernini's achievement was not repeated. Hardly suprisingly, as Alexander's creation of a new Rome, a *Roma Alessandrina,* had left the papal treasury bare. At the end of his reign, the papal debt was fifty million *scudi* and tax revenues barely two million a year. Small wonder that a contemporary newsletter excoriated Bernini as 'the one who instigates the popes to spend unnecessarily in these calamitous times'. But Alexander and Bernini had succeeded in once again making Rome look and feel like *Caput Mundi,* the head of the world.

Silver giulio of Alexander VII. The disingenuous motto around the table covered with money declares: 'And store of care doth follow riches' store.' (Horace, translated by Spenser)

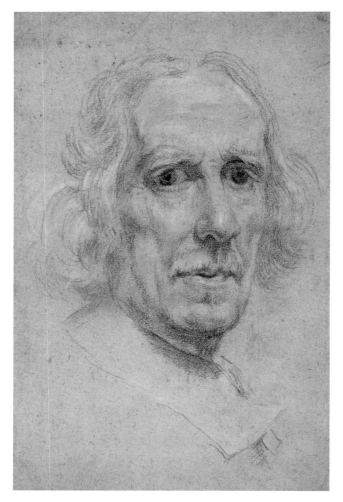

BERNINI, SELF-PORTRAIT, 1674

LIKE MANY successful artists, Bernini's character was a mix of supreme self confidence and insecurity, arrogance and neediness. During his stay in France he confided his worries about posterity to his minder Fréart de Chantelou

who recorded in his diary that, when asked about his works, Bernini 'replied with great modesty that he owed all his reputation to his star which caused him to be famous in his lifetime, that when he died its ascendancy would no longer be active and his reputation would decline or fall very suddenly.' Of course, Bernini's reputation has waxed and waned both before and since his death. But what has remained absolutely fixed has been Bernini's centrality to the fabric of the Eternal City. One small example. The centuries-old tradition of providing souvenirs for visitors testifies to the long and strong grip Rome has had on the Western imagination. The grandest of all souvenirs for eighteenth century visitors was a painting by one of the city's leading artists, Batoni or Mengs or Panini, and the grandest of all those paintings was a huge pair of pictures by Panini, *Roma Antica* and *Roma Moderna,* painted for the departing French ambassador, the Duke de Choiseul, and contrasting the monuments of the ancient and contemporary city. In the painting, Choiseul poses in a huge, imaginary gallery hung with pictures of Rome's principal attractions. What is remarkable is how many of these sights are the works of Bernini, including the Fountain of the Four Rivers, Saint Peter's Square, the equestrian statue of Constantine, the Apollo and Daphne and the youthful self-portrait as David. And, of course, tucked away at the side and almost obscured by a casual curtain, is our friend, the modest little elephant of the Minerva. No artist before or since Bernini has ever so clearly defined the image of a great city.

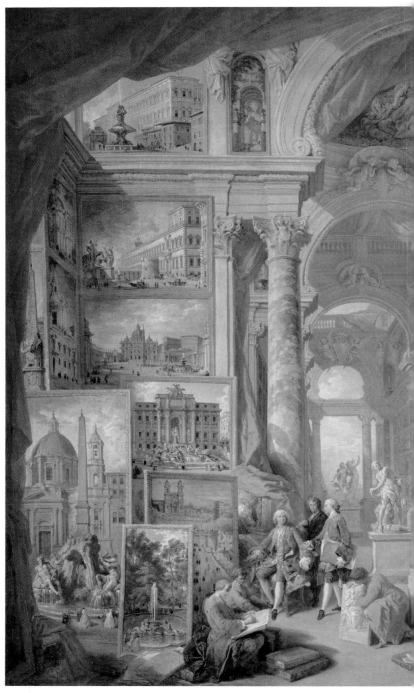

Panini, Roma Moderna, 1757

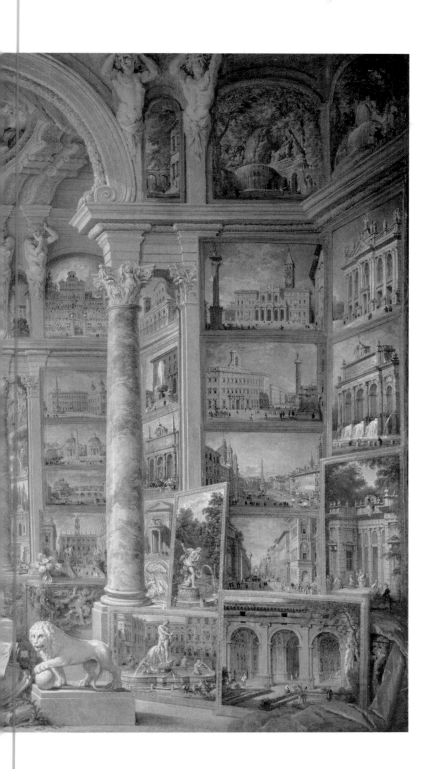

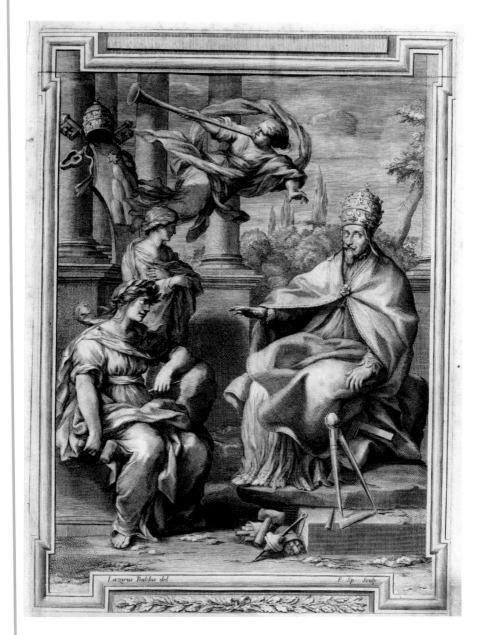

The statue of Alexander VII, refusing to be completed (see p. 199).

Obelisk Walk of Rome

Following Rome's example, obelisks became urban status symbols. When New York was about to acquire its own obelisk for Central Park in the late nineteenth century, the *New York Herald* declared that 'it would be absurd for the people of any great city to hope to be happy without an Egyptian Obelisk. Rome has had them this great while and so has Constantinople. Paris has one. London has one. If New York was without one, all those great sites might point the finger of scorn at us and intimate that we could never rise to any real moral grandeur until we had our obelisk.'

There are thirteen standing obelisks in Rome: more than any other city in the world, more than in Egypt itself. All thirteen can be visited in a day's walking tour. But as this itinerary will take you through some of the most interesting neighbourhoods of Rome, it is perhaps better to break it up into a few parts and take it at a more leisurely pace with plenty of time for cups of coffee, aperitifs, lunch and of course the sort of discursive sightseeing which makes Rome so rewarding. You will do a great deal of walking—the whole route is around 15 kilometres—and develop an increased appreciation of Rome's hilly topography: the legendary 'City of Seven Hills' nickname is a geographical understatement. The speed at which you travel from obelisk to obelisk is going to be very much affected by Rome's often challenging weather, especially in the furnace-like conditions of peak summer days and the occasional monsoon-heavy rains. The city's good but limited underground system won't be much help, and I'm afraid that travelling by car is both

infuriating and also rather misses the point. Rome is alas not a good city for those with limited mobility: all those hills and the beautiful but treacherous cobblestone paving present major challenges. You can follow your route on Falda's map of 1676, reproduced on pp. 272-283.

I. Piazza del Popolo is a good place to start. The square's current layout was fixed in the nineteenth century, but for centuries before it has been the gateway to Rome for visitors from the north of Italy and beyond the Alps. Amongst the most notable of these was Queen Christina of Sweden, whose conversion to Catholicism was a trophy for the Church of Rome and Pope Alexander VII in particular. In order to welcome her Alexander commissioned Bernini to redesign the square's entrance, the Porta del Popolo, and adorn it with a Latin inscription which declares 'May your entrance be a prosperous and happy one.'

Santa Maria del Popolo itself has, even by the high standards of Rome, outstanding treasures for such a small church. Visitors mesmerised by the Caravaggios in the Cerisi chapel may be in danger of overlooking Pinturicchio's murals in the Della Rovere Chapel. Before he became pope, Alexander VII commissioned Bernini to finish work on his family chapel, which had been begun to designs by Raphael. The chapel features two pyramidal tombs to Alexander's Chigi forebears, one of them to the extremely rich papal banker Agostino Chigi, as well as two outstanding Biblical sculptures by Bernini— *Habbakuk* and *Daniel in the Lion's Den.*

As a key entry point to Rome, Piazza del Popolo was an obvious place for Sixtus V to site one of his obelisks as a signpost for visiting pilgrims. This one, sometimes called the Flaminian, was carved in Egypt around 1,300 BCE and brought to Rome by Augustus, who used it to decorate the central reservation of the Circus Maximus racetrack. The usual story of collapse, loss and rediscovery culminated in re-erection in 1589 with a laudatory inscription proclaiming that 'Sixtus V ordered this miserably broken and overturned obelisk to be excavated, transferred and restored and dedicated to the invincible cross.' Piazza del Popolo is home to two cafes with fine terraces: Rosati, the slightly smarter of the two, and Canova, which attracted celebrities and papparazzi in the Dolce Vita era. The famous trident of three streets, Corso, Babuino and Ripetta, fans out from the piazza, but we will turn our back on those to walk up Via Gabriele D'Annunzio to the edge of the Borghese gardens. Ten minutes later you will get to the top of the Salita del Pincio staircase where there is an excellent view across Rome to Saint Peter's.

2. Another few minutes' walk brings you to the small—a little over nine metres tall—obelisk of Monte Pincio, commissioned in the second century CE by the Emperor Hadrian as a monument to his recently deceased lover, the teenage Greek Antinous, whom Hadrian had deified. When Giuseppe Valadier, the architect responsible for the final design of the Piazza del Popolo, took charge of the

layout of the Borghese Gardens, modern Rome's first public park, the obelisk was re-erected not, as the obelisk historian Erik Iversen observed, to mark a significant urban space, but as a mere garden ornament. That was in 1822, during the reign of Pius VI. Today the obelisk stands as the centrepiece of a pantheon of somewhat decrepit statues commemorating largely obscure Italian worthies including a headless Carlo Botta, author of early nineteenth-century histories of Italy and the American Revolution, and a noseless G. B. Niccolini, poet, playwright and patriot. Nearby is the Casina dell' Orologio, a painted wooden chalet dating from the 1920s serving excellent coffee and those dubious-looking but delicious *tramezzini*, little triangular white bread sandwiches. A leisurely ten minute walk passes the Casino Valadier, a restaurant and event space, and the late sixteenth-century Villa Medici, home to the French Academy since 1803. The villa and its gardens, with guided tours in various languages, are well worth visiting.

3. Just after the Villa Medici we reach the top of the Spanish Steps and the small piazza in front of the not overly interesting French church of Santa Trinità dei Monti, the site of a medium sized 14 meter high obelisk. It is not known when or by whom the Santa Trinità obelisk was brought to Rome, but it once formed part of the decorative scheme of the celebrated gardens of the Roman historian Sallust. The obelisk was installed here on the orders of Pius VI in 1788-89. In spite of its spectacular location it is not an

especially successful monument: its overly high plinth has long been criticised. With the obelisk and church at your back the importance of the Spanish Steps is obvious as they provide the link between the low-lying Piazza di Spagna and the top of the steep slope of the Pincian Hill. The steps were made possible by a legacy from the former French Ambassador, Étienne Gueffier, and opened in 1725 with an inscription praising Louis XV of France. Through some long forgotten PR blunder, although paid for and glorifying France, they are forever and universally known as the Spanish Steps. The fine view from the obelisk takes in the Barcaccia or 'boat' fountain designed by Bernini's father Pietro, but perhaps with a great deal of input from his son.

Now we begin a long walk down the Via Sistina, one of the great roads ordered by Sixtus V to improve the circulation of Rome's pilgrims, straight as a gun barrel and site of numerous plaques commemorating the Roman residences of Piranesi, Thorvaldsen, Hans Christian Andersen, Gogol and Rossini. We cross Piazza Barberini, as boring as any Roman square can be but home to two Bernini fountains, the justly celebrated Triton and the charming but overlooked Fountain of the Bees. A further five minutes and we arrive at the crossroads of the Quattro Fontane and the church of San Carlo al Quattro Fontane the masterpiece of Borromini, Bernini's one-time assistant and eventual rival. Turning left on our way out of the church we carry on down Via del Quirinale one side of which is dominated by the long and monotonous Manica Lunge—long sleeve or long wing—of

the Quirinale Palace, a sometime papal residence from the late sixteenth century and now the home of the President of Italy. Opposite the Manica Lunga you will wish to visit the church of Sant'Andrea al Quirinale which Bernini claimed with false modesty was his only successful work.

4. Turn left out of the church and we are almost immediately in the Piazza del Quirinale, at the top of another of Rome's hills and with a spectacular vista across the city to Saint Peter's, a view loved by Alexander VII as he plotted the urban renewal of Rome. The piazza is dominated by the colossal statues of the Dioscuri, the horse-taming mythological twins, Castor and Pollux, originally carved for the Baths of Constantine but flanking the Quirinale obelisk since its installation in 1786 by order of Pius VI. This 14.5 meter obelisk has no hieroglyph inscriptions so its exact origin and date are unknown, but it seems to be one of a pair of obelisks brought to Rome by the Emperor Domitian and at one time erected in the Mausoleum of Augustus. The overly complicated base of the obelisk and Castor and Pollox statues features a large, bowl-like fountain installed in the early nineteenth century. Not one of my favourites. The neighbouring eighteenth century Scuderie or stables of the Quirinal have been restored and host some of Rome's best temporary art exhibitions. There is also a decent café and informal restaurant there.

It's now a relatively long—twenty minutes or so—walk to our next obelisk. This takes us down Via Nazionale, a major

thoroughfare with the Victor Emanuel monument at one end and the Baths of Diocletian at the other. One of the least picturesque streets in Rome, but potentially useful, with its array of mid-market hotels and chain stores, Via Nazionale is also a reminder of the city's major expansion following the unification of Italy and Rome's designation as capital in 1871. In spite of the glories of Ancient, Renaissance and Baroque Rome, it is worth remembering that a great deal of the city is owed to this late nineteenth century growth. A diverting stop along the way is the Victorian church of Saint Paul's Within the Walls: American Episcopalian, the work of G. E. Street, architect of London's Law Courts, and featuring heroic mosaics by Burne-Jones. A few minutes walk further, Santa Maria dei Angeli is Michelangelo's masterly conversion of part of the remnants of Diocletian's baths into a High Renaissance church.

5. We now approach the small and contentious obelisk of the Viale delle Terme, the last to be excavated, the latest to be erected and the least impressively sited. This red granite obelisk, inscribed with the cartouches of the Pharaoh Ramses II, was probably brought to Rome by the Emperor Claudius, and only fully excavated in 1883. Shortly thereafter, Italy, embarking on the cynical quest for African colonies that infected all European states at the time, invaded Ethiopia. The East African empire was no pushover and the Italians were badly defeated at the battle of Dogali. Subsequently this newest obelisk was erected

in front of Rome's main railway station and dedicated to the 'heroes of Dogali.' in 1887. The obelisk has since moved farther away from the railway station and now sits in the middle of a forlorn and ill-kept triangular square. However, it is just across the street from the Palazzo Massimo, part of the National Roman museum, and home to a large collection of Roman murals and the magnificent bronzes saved from Caligula's first century pleasure fleet which was moored at Lake Nemi, about thirty kilometres south of Rome.

6. It is about a ten minute walk to Santa Maria Maggiore, one of Rome's most impressive churches, set on the Esquiline hill. In 1587 Sixtus V decreed an obelisk for this important pilgrimage site and used the slightly smaller near-twin of the Quirinale obelisk. This 13 metre uninscribed shaft of pink Aswan granite is set on a plinth with some of Rome's most elegantly carved Latin inscriptions including one in which the obelisk atones for its past pagan behaviour: 'Overjoyed, I pay homage to the cradle of the ever living God, Christ, having with sadness adorned the sepulchre of dead Augustus.' Bernini's father moved into 24 via Liberiana by the side of the church when he came to Rome to work on the Basilica's Pauline chapel and the young Bernini was raised here. To the right of the Basilica's high altar a modest floor slab marks the Bernini family's tomb.

You may now need to stop at Cottini, a serviceable café across the street, before visiting the early Christian church

of Santa Prassede. The church's tiny chapel of Saint Zeno built for Pope Paschal in the early ninth century has some of the most beautiful mosaics in Rome as well as a questionable relic – supposedly the column at which Christ was scourged. The church also contains the funerary monument of Monsignor Giovanni Batista Santoni with a marble bust carved by the teenage Bernini, one of the earliest examples of his prodigious talent. Santa Prassede is is also tantalizingly close to the neighbourhood's best restaurant, Trattoria Monti, and if you began this walk with an early breakfast, it is nearly time for lunch. Reservation essential.

7. A brisk 20 minute walk and we arrive at Saint John Lateran. In importance second only to Saint Peter's, Saint John Lateran is the mother church of the Catholic world and the seat of the pope in his role as Bishop of Rome. Built on the site of a Roman imperial cavalry barracks, the first church was dedicated here in 324, a mere eleven years after Constantine the Great promulgated the Edict of Milan legalising Christian worship. The neighbouring Lateran Palace was the papal residence before Vatican City. In such a grand context, it's not surprising that the Lateran obelisk is the largest standing obelisk in the world at 32 metres high and weighing around 455 tonnes. Obelisks were almost always made in pairs, and the Lateran may be the only obelisk that was commissioned as a single megalith. It was made sometime in the 15th century BCE during the reign of the Pharaoh Tuthmosis III and 1,800 years

later Constantine intended to bring it to his new capital Constantinople, but instead it was one of Constantine's sons who transported it to Rome and had it erected in the Circus Maximus. Over a thousand years after that, the obelisk was consecrated in 1588 at its current site, as part of Sixtus V's plan. Any visitor to Saint John Lateran and the obelisk should also take time to visit the early Christian octagonal baptistery—the prototype for all other baptisteries—with Roman porphyry columns and a seventeenth century fresco cycle of the life of Constantine.

8. A 20 minute walk from Saint John Lateran leads to what may be Rome's least visited obelisk: that of the Villa Celimontana, tucked in the corner of a pretty park much used by Romans for dog walking and callisthenics and unknown to tourists. The Celimontana obelisk—well proportioned if rather petite—has an unusually checkered history. It was created for Pharaoh Ramses II, taken to Rome at an inderterminate date, and erected in the Temple of Isis in the Campo Marzio; collapsed and broken, it was partially erected on the Capitoline Hill in the late Middle Ages, taken down and then, rather unusually, presented to the rich antiquarian Ciriaco Mattei in 1582 to put in the garden of his new villa on the Cælian Hill. There it remains, now surrounded by a circle of cypresses and park benches which provide a cool refuge on hot Roman days.

This walk will also bring you close to two churches slightly off the beaten path: Santissimi Giovanni e Paolo—multi-

storey bell tower decorated with coloured tiles, Roman-
esque porch, dull eighteenth century interior—and Santo
Stefano Rotondo, dedicated in the fifth century to St Ste-
phen, the first Christian martyr, and appropriately decorated
in the sixteenth century with 34 extraordinarily gruesome
scenes of martyrdom.

There is now a long, say 45 minutes, walk down the hill,
around the Colosseum—avoid queueing tourists, ticket touts
and the usual men dressed as Roman legionnaires and de-
manding money to be photographed—and down the Via dei
Fori Imperiali—a very wide, very straight, very uninterest-
ing example of Mussolini's idea of good urban planning—
on the way to our next obelisk, Montecitorio. A slight de-
tour will bring you to Enoteca Corsi, one of Rome's most
refreshingly basic restaurants, open only at lunchtime: if you
can, get a table in the room which doubles as a wine shop.

9. Originally designed by Bernini as a palace for the
papal Ludovisi family, the Palazzo Montecitorio is
home to the Italian parliament's Chamber of Deputies. In
an effort to beautify the square in front of the palace, Pope
Pius VI ordered the obelisk to be erected with an inscrip-
tion on its base recording the vicissitudes of the then twenty
three hundred year old object: 'Royally raised as a pyramid
marking the time on its dial, long in a dung hill it rested,
broken, disdained and forgotten, now to new splendour and
dignity called...' One of the first obelisks brought to Rome
by Augustus who installed it as the pointer of a giant sun

dial, the Montecitorio is much damaged, rather stolid and does sadly little to relieve the bleakness of the parliament square.

IO. Walk five minutes or so from Montecitorio to the Piazza della Rotonda and the Pantheon. As the most complete surviving Roman building and a supreme example of skilful and harmonious architecture, the Pantheon has for hundreds of years been among the world's most famous buildings. So powerful is it and so overwhelming the throngs of visitors milling around, that it is easy not to notice the slim and pretty pink granite obelisk—twin to the one in the Villa Celimontana—that Pope Clement XI ordered installed as the centrepiece of a new fountain of 1711 as part of the papal efforts begun by Alexander VII to improve the appearance of the square and the setting of the Pantheon. Inevitably the square's cafés are the worst sort of tourist traps but very close by there is an excellent restaurant —Armando al Pantheon— not to mention two reputable *gelaterie*—San Crispino and La Palma—and Rome's most famous and most overcrowded café, the Tazza d'Oro.

II. It is now a two minute walk to the Piazza della Minerva and Bernini's elephant carrying an obelisk in front of Santa Maria sopra Minerva. Do spend some time in the church to see Fra Angelico's tomb and the Carafa Chapel (1488-93) by Botticelli's apprentice Filippino Lippi: the greatest example of Florentine art in

Rome. As you turn left out of the square on your way to Piazza Navona, you may want to visit the shop of Ditta Gammarrelli, papal tailors and sellers of beautiful socks to stylish clergymen.

I2. Ten minutes walking takes you to Piazza Navona. Created on the footprint of the Emperor Domitian's chariot racing stadium, the square owes its grace and grandeur to Innocent X's desire to show off the wealth and power of the Pamphili family. Bernini's Fountain of the Four Rivers with its vertiginously balanced 93 tonne obelisk, is along with the Trevi, Rome's most famous fountain. Unusually the obelisk was crafted and carved to order in Egypt but always intended for Rome, with a hieroglyophic inscription celebrating Domitian's success in 'taking over the kingdom of his father, Vespasianus, from his elder brother, Titus, when his soul had flown to heaven.' The cafés and restaurants of the square are well avoided, but a visit to the church of Sant'Agnese in Agone is worthwhile. The architecture is mostly by Carlo Rainaldi and Borromini with some contributions by Bernini. There is a proficient but relatively uninspired statue of St Agnes being burned to death by Ercole Ferrata, Bernini's assistant who carved the Minerva elephant.

I3. To get from the Piazza Minerva to the square of Saint Peter's takes about half an hour and will take you over the Ponte Sant'Angelo. One of Bernini's last

great commissions was to decorate the bridge with statues of ten angels bearing the instruments of Christ's passion, two executed by Bernini himself (but now replaced by copies), the others by his chief assistants, including yet again Ferrata. Turn left when you've crossed the bridge and Saint Peter's faces you in the distance at the end of the grand and monotonous Via della Conciliazione, another example of Mussolini's town planning, this time celebrating the political reconciliation between the Italian state and the Church agreed by the 1929 Lateran Treaty. Entering Saint Peter's Square to face the Vatican obelisk you are, as Bernini intended, embraced by the curving colonnades with which he framed the square. The tall (25.5 metre) handsome, uninscribed obelisk — created in Egypt, supposed witness to the apostle Peter's crucifixion, never toppled, moved into place by order of Pope Sixtus V in 1586— is a good place to finish our tour.

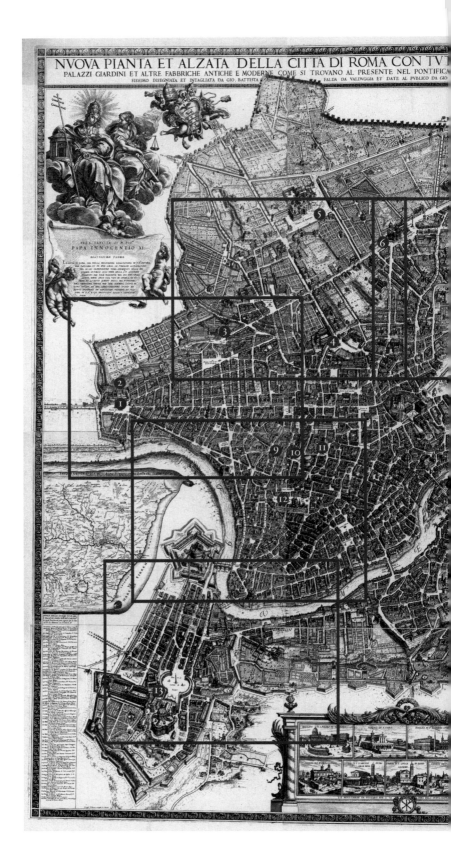

NVOVA PIANTA ET ALZATA DELLA CITTA DI ROMA CON TV

PALAZZI GIARDINI ET ALTRE FABBRICHE ANTICHE E MODERNE COME SI TROVANO AL PRESENTE NEL PONTIFICA

SISSIMO DISEGNIATA ET INTAGLIATA DA GIO. BATTISTA ___ FALDA DA VALVGGIA ET DATE AL PVBLICO DA GIO

ALLA SANTITA DI N. SIG

PAPA INNOCENTIO XI

BEATISSIMO PADRE

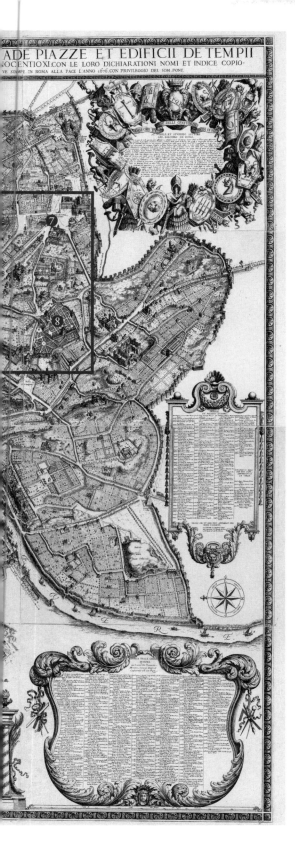

MAP OF ROME, 1676

NUOVA PIANTE ET ALZATA
DELLA CITTÀ DI ROMA
CON TUTTE LE STRADE
PIAZZE ET EDIFICI
Drawn and etched by
Giovanni Battista Falda
Published by Giovanni
Giacomo de Rossi
154 x 153 cm

THE OBELISKS OF ROME
1. Piazza del Popolo
2. Monte Pincio
3. Santa Trinità
4. Piazza del Quirinale
5. Vialle delle Terme
6. Santa Maria Maggiore
7. Saint John Lateran
8. Villa Celimontana
9. Palazzo Montecitorio
10. Piazza della Rotonda
11. Piazza della Minerva
12. Piazza Navona
13. Saint Peter's Square

Sepultura delle
Donne Meretrici

Vestigij della
Naumachia di
Ottauiano Aug:
Napoli

Porta del Popolo
ò Flaminia

Piazza del Popolo.

Pi.
dell
Oca.

STRADA

STRADA DA P.

A GEOGRAFICA DELL' AGRO ROMANO OVERO PARTE DEL' DISTRETTO DI R.

à Capo
le Case

Monte ③ Pincio.

Piazza sotto la SS.ᵗᵃ
Trinità de' Monti.

Pia: di Spagna

li due Ma=
celli

Piazza di
Ceri.

Piazza
delle Mona=
che di
S. Sil=
uestro.
328.

Pia.
Col.
n.

Piazza
di S.
Loren
zo in
Lucina

Monte
d'Oro.

Piazza
Borghese.

Piazza
Nico

Piazza
della
Madalena

⑨

⑩

la Rotonda
177

GIARDINO DI

NEGRONI

MONS.

GIARDINO

Circo di Flora

incinia
rina

Piazza
Barberina
à Ca po
le Case

Monte Pincio

3

Pia: di Spagna

Piazza sotto la SS.ª
Trinità de' Monti

⑥

STRADA S.

GIARD. DE CARD... RELLI

d'Henrico IV.
Colonna
Santa
Maggiore

STRADA DA S. M. MAGGIORE A

Piazza

MAIR

STRADA URBANA

STRADA DI S. LORENZO IN PANISPER NA

STRADA DELLO ZINGARI

STRADA

STRADA DELLA SUBURRA

delle Therma
di Vespain

Velb Sig.
di Tito
Vag. Iei Sde

il Piazza
di S. Pie-
tro in
Vincola

STRADA A BACCINA

MONTE MIGLIO

Torre de
Conti

Ruine del Tempie
di della Pace

Anfiteatro di
Tito, e Vespalia-
no, detto il Coli-
seo

Meta
Sudante

del Tempio
d'Iride e
Serapide.

Arco di Constantino

Acqua
Tito

Vaccino.

GIARDINO

DE GIVSTINIANI.

S. Scala Santa

7

Piazza di S. Giò
in Laterano.

S. GIOVANNI LATERANO.

AL COLISEO A S. GIOVANNI

Piazza della
Naui & cella

Voltia dell'

8

Piaz. di S. Gio
C. Paoolo.

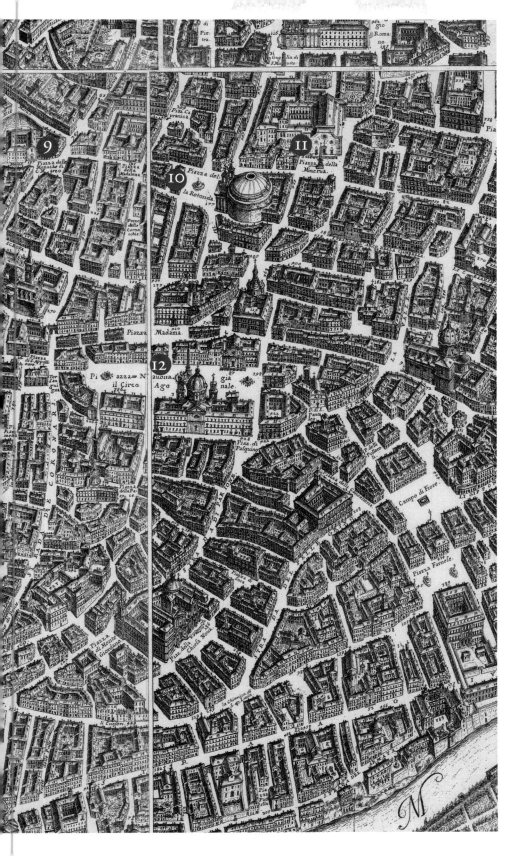

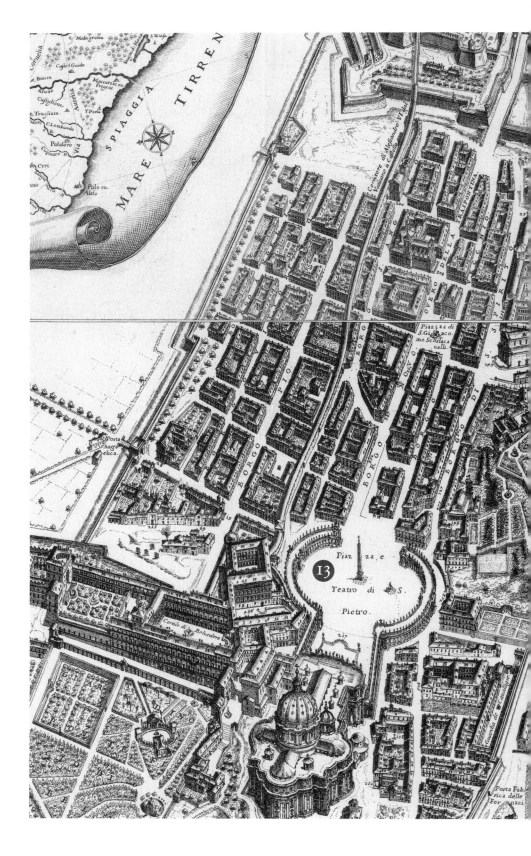

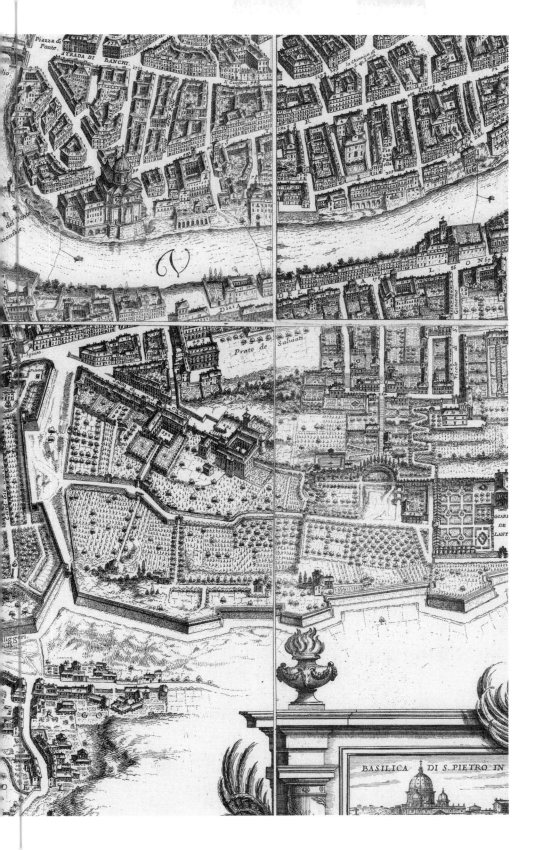

Piazza di
Ponte.
STRADA DI
BANCHI. 17

la chiauica di
S. Saluad.

Il Cuefoni 444

Pia
ella
A

del ponte
omide

V

DI.A

L 8 ON 8

O L A
A

G S Giacomo di S.

S. Spirito

Prato de Saluati

Vicolo di S.

GIARI
DE
LANT

liggiri

BASILICA DI S. PIETRO IN

Timeline of events

1629 Bernini becomes Architect of Saint Peter's basilica

1635 Bernini's affair with Costanza Bonarelli

1639 Bernini's marriage to Caterina Tezio

1644 Election of Pope Innocent X (Pamphili)

1646 Bernini's tower for St Peter's demolished

1648 Peace of Westphalia ends the Thirty Years' War

1648-51 *Fountain of the Four Rivers* Piazza Navona

1655 Election of Pope Alexander VII (Chigi)
Christina of Sweden arrives in Rome
Porta del Popolo

1656-67 *Colonnades* Saint Peter's Square

1658-65 *Sant' Andrea al Quirinale*

1663-66 *Scala Regia*

1665 Bernini's visit to France

1666-67 *Elephant and Obelisk*

1667 Death of Alexander VII, election of Clement IX
(Rospigliosi)

1669 Angels for the Ponte Sant'Angelo

1670 Election of Clement X (Altieri)

1672-78 *Tomb of Alexander VII*

1673 Death of Caterina Bernini

1676 Election of Innocent XI (Odescalchi)

1679 *Salvator Mundi*

1680 Bernini dies on 28 November

Acknowledgements

The foundations of modern Bernini scholarship were solidly laid in 1955 by Rudolf Wittkower with the publication of *Bernini: Sculptor of the Roman Baroque*. At around the same time, his slightly younger contemporary John Pope-Hennessy was putting Bernini in context with his superb three volume *Introduction to Italian Sculpture*. It would be impossible to write anything about Bernini today without reference to the work of these titans of a heroic age of art history. More recently the late Irving Lavin illuminated all parts of Bernini's many talents. Among today's scholars no one has done more to promote Bernini studies than Francesco Mormando as author of the only English language biography of Bernini and through his magnificent editing of Domenico Bernini's life of his father. Just as the above are indispensable to any work on Bernini, there are two scholars in particular who have elucidated the architecture and town planning of Baroque Rome: Dorothy Metzger Habel and the late Richard Krautheimer. I am grateful to them both.

Many thanks to the staffs of the following libraries: The British School at Rome, The British Library, The Warburg Institute and The London Library. The staff of The Royal

Collection were immensely helpful in allowing me to study the Bernini drawings kept at Windsor Castle.

John Goodall cheerfully read and commented on an early draft of this book. Mark Roberts of the British Institute in Florence was a ready source of papal information and cheerfully translated some more challenging Latin for me. Many thanks too, to Thomas Leo True who undertook archival research in Rome. Duncan Robinson who was my supervisor at Cambridge has been a constant inspiration. Bruce Boucher helped point me in the right direction when I started to research Bernini. It was very helpful when Tom Richards invited me to speak about Bernini to his students at the Florence Academy of Art. Princess Georgiana Corsini generously let me view her modello of the elephant.

Continuing thanks to Camilla Eadie, peerless assistant and arranger, and to Peter Schnabl. Throughout the whole process of bringing this book to press, Alexander Fyjis-Walker has been a diligent and exemplary publisher. Caroline Michel at Peters Fraser and Dunlop is the best of literary agents and I am indebted to her for introducing me to the expert and entertaining editorial skills of Tim Binding.

Throughout all my work, my daughters Flo and Connie are unfailing bringers of joy.

This book is dedicated to Melissa, sublime companion.

Bibliography

Adshead, S. D. 'The Decoration and Furnishing of the City: No. 3.
 Obelisks', *The Town Planning Review*, Vol. 2, No. 3, 1911
Avery, Charles. *Bernini: Genius of the Baroque* (London, 1997)
Ayres, Philip. *A Short Account of the Death of Pope Alexander the VII*
 (London, 1667)
Bacchi, Andrea and Coliva, Anna (eds). *Bernini* (Rome, 2017)
Bacchi, Andrea; Hess, Catherine and Montagu, Jennifer (eds). *Bernini and
 the Birth of Baroque Portrait Sculpture* (Los Angeles, 2008)
Bacon, Edmund N. *Design of Cities* (New York, 1976)
Baines, John and Malek, Jaromir. *Atlas of Ancient Egypt* (New York, 1980)
Baldinucci, Filippo. *The Life of Bernini* (University Park, Pennsylvania,
 1966)
Barber, A. B. *Pilgrim's Rome* (London, 2012)
Bargrave, John. *Pope Alexander the Seventh and The College of Cardinals*
 (London, 1867)
Basilica of Santa Maria sopra Minerva (Rome, 1992)
Bazin, Germain. *Baroque and Rococo* (London, 1964)
Beddard, Robert A. 'Pope Clement X's Inauguration of the Holy Year
 of 1675', *Archivum Historicum Pontificiae*, Vol. 38, 2000
Bedini, Silvio A. 'The Papal Pachyderms', *Proceedings of the American
 Philosophical Society*, Vol. 125, No. 2, 1981
Bellori, Giovan Pietro and Wohl, Alice Sedgwick; Wohl, Helmut and
 Montanari, Tomaso (eds and trans). *The Lives of the Modern Painters,
 Sculptors and Architects* (Cambridge, 2009)
Bernardini, Maria Grazia. *Bernini: The Sculptures* (Rome, 2016)
Bernheimer, Richard. 'Theatrum Mundi', *The Art Bulletin*, Vol. 38,
 No. 4, 1956
Bernini, Domenico and Mormando, Franco (trans and ed). *The Life of
 Gian Lorenzo Bernini* (University Park, Pennsylvania, 2011)
Bernstock, Judith. 'Bernini's Tomb of Alexander VII', *Saggi e Memorie di
 Storia dell'Arte*, No. 16, 1988

288

Bevilacqua, Mario and Fagiolo, Marcello. *Piante di Roma: Dal Rinascimento ai Catasti* (Rome, 2012)

Black, Christopher F. *Early Modern Italy: A social history* (London, 2001)

Blanning, Tim. *The Pursuit of Glory: Europe 1648-1815* (London, 2007)

Blondin, Jill E. 'Power Made Visible: Pope Sixtus IV as *Urbis Restaurator* in Quattrocento Rome', *The Catholic Historical Review*, Vol. XCI, No. 1, 2005

Blunt, Anthony. *Borromini* (Cambridge, Massachusetts, 1979)

Blunt, Anthony. *Guide to Baroque Rome: The Churches* (London, 2013)

Boucher, Bruce. *Italian Baroque Sculpture* (London, 1998)

Brauen, Fred. 'Athanasius Kircher (1602-1680)', *Journal of the History of Ideas*, Vol. 43, No. 1, 1982

Bricault, Laurent; Meyboom, Paul G. P. and Versluys, Miguel John (eds). *Nile Into Tiber: Egypt in the Roman World*, (Leiden, 2007)

Burke, Peter. 'The Crisis in the Arts of the Seventeenth Century: A Crisis of Representation?', *The Journal of Interdisciplinary History*, Vol. 40, No. 2, 2009

Burke, Peter. *The Fabrication of Louis XIV* (New Haven, 1992)

Burke, Peter. *The historical anthropology of early modern Italy* (Cambridge, 1987)

Carandini, Andrea and Carafa, Paolo (eds); Halavais, Andrew Campbell (trans). *The Atlas of Ancient Rome* (2 vols, Princeton, 2017)

Carsten, F. L. *The New Cambridge Modern History Volume V: The Ascendancy of France 1648-88* (Cambridge, 1961)

Chaney, Edward and Wilks, Timothy. *The Jacobean Grand Tour: Early Stuart Travellers in Europe* (London, 2014)

Claridge, Amanda. *Rome: An Oxford Archæological Guide* (Oxford, 2010)

Coarelli, Filippo. *Rome and Environs: An Archæological Guide* (Berkeley, 2007)

Colonna, Francesco. *Hypnerotomachia Poliphili: The Strife of Love in a Dream* (London, 1592)

Cooke, H. L. 'Three Unknown Drawings by G. L. Bernini', *The Burlington Magazine*, Vol. 97, No. 631, 1955

Cooper, J. P. (ed). *The New Cambridge Modern History Volume IV: The Decline of Spain and The Thirty Years' War 1609-48/59* (Cambridge, 1970)

Croxton, Derek. *Westphalia: The Last Christian Peace* (New York, 2013)

Curran, Brian; Grafton, Anthony and Decembrio, Angelo. 'A Fifteenth-Century Site Report on the Vatican Obelisk', *Journal of the Warburg and Courtauld Institutes*, Vol. 58, 1995

Curran, Brian. *The Egyptian Renaissance: The Afterlife of Ancient Egypt in Early Modern Italy* (Chicago, 2007)

Curran, Brian A.; Grafton, Anthony; Long, Pamela O. and Weiss, Benjamin. *Obelisk: A History* (Cambridge, Massachusetts, 2009)

Curzietti, Jacopo. 'Gian Lorenzo Bernini e l'elefante della Minerva. Una documentazione inedita', *Studi di Storia dell'Arte*, Vol. 18, 2007

Dannenfeldt, Karl H. 'Egypt and Egyptian Antiquities in the Renaissance', *Studies in the Renaissance*, Vol. 6, 1959

Davidson, Peter (ed). *The Celebrated Museum of the Roman College of the Society of Jesus* (Stonyhurst, 2015)

Debenedetti, Elisa. 'Middle-Class Rome: From the Baroque City to the European Capital', *Source: Studies in the History of Art*, Vol. 66, 2005

Delaforce, Angela; Montagu, Jennifer; Gomes, Paulo Varela and Soromenho, Miguel. 'A Fountain by Gianlorenzo Bernini and Ercole Ferrata in Portugal', *The Burlington Magazine*, Vol. 140, No. 1149, 1998

Delbeke, Maarten. *The Art of Religion: Sforza Pallavicino and Art Theory in Bernini's Rome* (London, 2012)

Della Dora, Veronica. 'Alexander the Great's Mountain', *Geographical Review*, Vol. 95, No. 4, 2005

Dibner, Bern. *Moving the Obelisks: A chapter in engineering history in which the Vatican obelisk in Rome in 1586 was moved by muscle power, and a study of more recent moves* (Norwalk, Connecticut, 1991)

D'Onofrio, Cesare. *Gli Obelischi di Roma*, (Rome, 1965)

Duffy, Eamon. *Saints and Sinners: A History of The Popes* (New Haven, 2014)

Duggan, Christopher. *A Concise History of Italy* (Cambridge, 1994)

Erdkamp, Paul (ed). *The Cambridge Companion to Ancient Rome* (Cambridge, 2013)

Erwee, Michael. *The Churches of Rome 1527-1870* (2 vols, London, 2014, 2015)

Fahrner, Robert and Kleb, William. 'The Theatrical Activity of Gianlorenzo Bernini', *Educational Theatre Journal*, Vol. 25, No. 1, 1973

Fehl, Philipp. 'Hermeticism and Art: Emblem and Allegory in the Work of Bernini', *Artibus et Historiæ*, Vol. 7, No. 14, 1986

Findlen, Paula (ed). *Athanasius Kircher: The Last Man Who Knew Everything* (London, 2004)

Frankfurter, David. *Religion in Ancient Egypt: Assimilation and Resistance* (Princeton, 1998)

Fréart de Chantelou, Paul (Blunt, Anthony ed). *Diary of the Cavaliere Bernini's Visit to France* Princeton, 1985)

Giedion, Sigfried. *Space, Time and Architecture: the growth of a new tradition* (Cambridge, Massachusetts, 2008)

Gigli, Girolamo. *Diario di Roma* (Rome, 1994)

Gnoli, Domenico. 'Disegni del Bernini per L'Obelisco della Minerva in Roma', *Archivio Storico Dell'Arte*, Anno 1, 1888

Godwin, Joscelyn. *Athanasius Kircher's Theatre of the World* (London, 2015)

Gould, Cecil. *Bernini in France: An Episode in Seventeenth-Century History* (Princeton, 1982).

Grafton, Anthony. 'Obelisks and Empires of the Mind', *The American Scholar*, Vol. 71, No. 1, 2002

Greengrass, Mark. *Christendom Destroyed: Europe 1517-1648* (London, 2014)

Habel, Dorothy Metzger. *The Urban Development of Rome in the Age of Alexander VII* (Cambridge, 2002)

Habel, Dorothy Metzger. *When All of Rome Was Under Construction: The Building Process in Baroque Rome* (University Park, Pennsylvania, 2013)

Hare, Augustus. *Walks in Rome* (2 vols, London, 1872)

Hart, Vaughan and Hicks, Peter (eds and trans). *Palladio's Rome* (New Haven, 2006)

Haskell, Francis. *Patrons and Painters: A Study in the Relations Between Italian Art and Society in the Age of the Baroque* (New Haven, 1980)

Heckscher, William S. 'Bernini's Elephant and Obelisk', *The Art Bulletin*, Vol. 29, No. 3, 1947

Hibbard, Howard. *Bernini* (London, 1990)

Hopkins, Andrew. *Italian Architecture from Michelangelo to Borromini* (London, 2002)

Hsia, R. Po-Chia. *The World of Catholic Renewal 1540-1770* (Cambridge, 2005)

Iversen, Erik. *Obelisks in Exile, Volume One: The Obelisks of Rome* (Copenhagen, 1968)

Ivins Jr., William M. 'The Aldine Hypnerotomachia Poliphili of 1499', *The Metropolitan Museum of Art Bulletin*, Vol. 18, Nos 11 and 12, 1923

Jones, Howard; Kessler, Martin; Lahnemann, Henrike and Ostermann, Christina (eds). *Martin Luther: Sermon on Indulgences and Grace* (Oxford, 2018)

Karmon, David. *The Ruin of the Eternal City: Antiquity & Preservation in Renaissance Rome* (Oxford, 2011)

Kemp, Barry J. *Ancient Egypt: Anatomy of a Civilization* (London, 2006)

Koortbojian, Michael. 'Disegni for the Tomb of Alexander VII', *Journal of the Warburg and Courtauld Institutes*, Vol. 54, 1991

Krautheimer, Richard and Jones, Roger B. S. 'The Diary of Alexander VII: Notes on Art, Artists and Buildings', *Römisches Jahrbuch für Kunstgeschichte*, 15, 1975

Krautheimer, Richard. *The Rome of Alexander VII, 1655-1667* (Princeton, 1985)

Kuntz, Margaret A. 'Questions of Identity: Alexander VII, Carlo Rainaldi, amd the Temporary Façade at Palazzo Farnese for Queen Christina of Sweden',

Memoirs of the American Academy in Rome, Vol. 58, 2013

Labrot, Gérard. *L'Image de Rome: Une Arme Pour la Contre-Réforme 1534–1677* (Paris, 1987)

Langdon, Anthony. *A Guide to Baroque Rome: The Palaces* (London, 2015)

Lansford, Tyler. *The Latin Inscriptions of Rome: A Walking Guide* (Baltimore, 2009)

La Regina, Adriano. *Archæological Guide to Rome* (Milan, 2007)

Lassels, Richard. *The Voyage of Italy* (London, 1686)

Lavin, Irving (ed). *Gianlorenzo Bernini: New Aspects of His Life and Thought* (University Park, Pennsylvania 1985)

Lavin, Irving. 'On the Unity of the Arts and the Early Baroque Opera House', *Perspecta*, Vol. 26, 1990

Lavin, Irving. *Visible Spirit: The Art of Gianlorenzo Bernini* (2 vols, London, 2007, 2009)

Lingo, Estelle. *Mochi's Edge and Bernini's Baroque* (London, 2017)

Lloyd, Joan Barclay. 'Saint Catherine of Siena's Tomb and Its Place in Santa Maria sopra Minerva, Rome: Narration, Translation and Veneration', *Papers of the British School at Rome*, Vol. 83, 2015

Lloyd, Karen J. 'Bernini and the Vacant See', *The Burlington Magazine*, Vol. 150, No. 1269, 2008

Lo Sardo, Eugenio (ed). *The She-Wolf and the Sphinx: Rome and Egypt from History to Myth* (Milan, 2008)

Magnuson, Torquil. *Rome in the Age of Bernini* (2 vols, Stockholm, 1982, 1986)

Maier, Jessica. *Rome Measured and Imagined: Early Modern Maps of the Eternal City* (Chicago, 2015)

Marciari, John. *Art of Renaissance Rome: Artists and Patrons in the Eternal City* (London, 2017)

Marder, Tod A. 'Bernini and Alexander VII: Criticism and Praise of the Pantheon in the Seventeenth Century', *The Art Bulletin*, Vol. 71, No. 4, 1989

Marino, John A. (ed). *Early Modern Italy* (Oxford, 2002)

Martin, Geoffrey R. 'The Role of Culture in Global Structural Transformation: Opera and the Baroque Crisis in Seventeenth-Century Europe', *International Political Science Review*, Vol. 18, No. 2, 1997

McPhee, Sarah. *Bernini and the Bell Towers: Architecture and Politics at the Vatican* (New Haven, 2002)

McPhee, Sarah. *Bernini's Beloved: A Portrait of Costanza Piccolomini* (New Haven, 2012)

McPhee, Sarah. 'Bernini's Books', *The Burlington Magazine*, Vol. 142, No. 1168, 2000

Minozzi, Marina and Uliva, Michela. *Le Sculture di Bernini* (Rome)

Moffitt, John F. 'Bernini's "Cathedra Petri" and the "Constitutum Constantini"', *Source: Notes in the History of Art*, Vol. 26, No. 2, 2007

Montagu, Jennifer. *Roman Baroque Sculpture: the Industry of Art* (New Haven, 1992)

Mormando, Franco. *Bernini: His Life and His Rome* (Chicago, 2011)

Mutnjakovic, Andrija. *The Architectonics of Pope Sixtus V* (Zagreb, 2010)

Napier, David A. 'Bernini's Anthropology: A "Key" to the Piazza San Pietro', *RES: Anthropology and Æsthetics*, No. 16, 1988

Nash, Ernest. *Pictorial Dictionary of Ancient Rome* (London, 1968)

Norberg-Schulz, Christian. 'Genius Loci of Rome', *Architectural Design*, Vol. 49, No. 3/4, 1979

Norberg-Schulz, Christian. *Meaning in Western Architecture* (London, 1980)

Nussdorfer, Laurie. 'The Vacant See: Ritual and Protest in Early Modern Rome', *The Sixteenth Century Journal*, Vol. 18, No. 2, 1987

Panofsky, Erwin. *Three Essays on Style* (Cambridge, Massachusetts, 1995)

Pastor, Ludwig von. *The History of the Popes, Volume XXXI* (London, 1940)

Pestilli, Livio. 'On Bernini's Reputed Unpopularity in Late Baroque Rome', *Artibus et Historiæ*, Vol. 32, No. 63, 2011

Petersson, Robert T. *Bernini and the Excesses of Art* (Florence, 2002)

Pierce, James Smith. 'Visual and Auditory Space in Baroque Rome', *The Journal of Æsthetics and Art Criticism*, Vol. 18, No. 1, 1959

Pinto, John A. *City of the Soul: Rome and the Romantics* (New York, 2016)

Pope-Hennessy, John. *Italian High Renaissance & Baroque Sculpture* (London, 1996)

Popham, A. E. 'Bernini's Drawings of Elephants', *The Burlington Magazine*, Vol. 97, No. 633, 1955

Poseq, Avigdor W. G. 'On Physiognomic Communication in Bernini', *Artibus et Historiæ*, Vol. 27, No. 54, 2006

Poseq, Avigdor W. G. 'The Physiognomy of Bernini's Elephant', *Source: Notes in the History of Art*, Vol. 22, No. 3, 2003

Ricasoli, Corinna. '"Momento Mori" in Baroque Rome', *Studies: An Irish Quarterly Review*, Vol. 104, No. 416, 2015/2016

Rice, Louise. 'Bernini and the Pantheon Bronze', *Sankt Peter in Rom: 1506-2006* (Munich, 2008)

Rietbergen, Peter. 'Founding a University Library: Pope Alexander VII (1655-1667) and the Alessandrina', *The Journal of Library History*, Vol. 22, No. 2, 1987

Rietbergen, Peter. *Power and Religion in Baroque Rome: Barberini Cultural*

Policies (Leiden, 2006)

Ripa, Cesare. and Pierce Tempest (trans) *Iconologia or Moral Emblems* (London, 1709)

Roberts, Mark. *Upon this Rock: brief lives of the popes with notes historical, art-historical, architectural, theological, sepulchral and liturgical* (Florence, 2017)

Robertson, Clare. *Rome 1600: The City and the Visual Arts Under Clement VIII* (New Haven, 2015)

Roden, Marie-Louise. *Politics and Culture in the Age of Christina* (Stockholm, 1997)

Roma/ Santa Maria del Popolo (Rome, 1998)

Romer, John. *A History of Ancient Egypt, Volume 2: From the Great Pyramid to the Fall of the Middle Kingdom* (London, 2016)

Roosen, William. 'Early Modern Diplomatic Ceremonial: A Systems Approach', *The Journal of Modern History*, Vol. 52, No. 3, 1980

Roullet, Anne. *The Egyptian and Egyptianizing Monuments of Ancient Rome*, (Leiden, 1972)

Rowland, Ingrid D. *The Ecstatic Journey: Athanasius Kircher in Baroque Rome* (Chicago, 2000)

Scott, John Beldon. 'S. Ivo alla Sapienza and Borromini's Symbolic Language', *Journal of the Society of Architectural Historians*, Vol. 41, No. 4, 1982

Scullard, H. H. *The Elephant in the Greek and Roman World* (London, 1974)

Sella, Domenico. *Italy in the Seventeenth Century* (London, 1997)

Signorotto, Gianvittorio and Visceglia, Maria Antonietta (eds). *Court and Politics in Papal Rome 1492-1700* (Cambridge, 2002)

Slatkes, Leonard J. 'Rembrandt's Elephant', *Simiolus: Netherlands Quarterly for the History of Art*, Vol. 11, No. 1, 1980

Spear, Richard E. 'Scrambling for Scudi: Notes on Painters' Earnings in Early Baroque Rome', *The Art Bulletin*, Vol. 85, No. 2, 2003

Stendhal. *Promenades dans Rome* (Paris, 1829)

Sturgis, Matthew. *When in Rome: 2000 Years of Roman Sightseeing* (London, 2011)

Sweet, Rosemary. *Cities and the Grand Tour: The British in Italy, c. 1690-1820* (Cambridge, 2015)

Swetnam-Burland, Molly. *Egypt in Italy: Visions of Egypt in Roman Imperial Culture* (Cambridge, 2015)

Taylor, Rabun; Rinne, Katherine W. and Kostof, Spiro. *Rome: An Urban History from Antiquity to the Present* (Cambridge, 2016)

Tschudi, Victor Plahte. *Baroque Antiquity: Archæological Imagination in Early*

Modern Europe (Cambridge, 2017)

Varriano, John. 'Alexander VII, Bernini and the Baroque Papal Medal', *Source: Studies in the History of Art*, Vol. 21, 1987

Weston-Lewis, Aidan. *Effigies & Ecstasies: Roman Baroque Sculpture and Design in the Age of Bernini* (Edinburgh, 1998)

Wittkower, Rudolf. 'A Counter-Project to Bernini's "Piazza di San Pietro"', *Journal of the Warburg and Courtauld Institutes*, Vol. 3, No. 1/2, 1939-1940

Wittkower, Rudolf. *Art and Architecture in Italy 1600-1750* (3 vols, New Haven, 1999)

Wittkower, Rudolf. *Gian Lorenzo Bernini: The Sculptor of the Roman Baroque* (London, 1955 and London, 1997)

Wolk-Simon, Linda (ed). *The Holy Name: Art of the Gesù* (Philadelphia, 2018)

Wortham, Robert A. 'Urban Networks, Deregulated Religious Markets, Cultural Continuity and the Diffusion of the Isis Cult', *Method & Theory in the Study of Religion*, Vol. 18, No. 2, 2006

Zietsman, J. C. 'Crossing the Roman Frontier', *Acta Classica*, Vol. 52, 2009

Zucker, Paul. 'Space and Movement in High Baroque City Planning', *Journal of the Society of Architectural Historians*, Vol. 14, No. 1, 1955

List of illustrations

(photograph UTSA College of Architecture)

pp. 116-117 Filippo Lauri and Filippo Gagliardi, Carnival of 1656, Carousel at Palazzo Barberini in honour of Christina of Sweden, 1656/1659, oil on canvas, 231 x 340 cm, Museo di Roma, Rome (Wikimedia)

p. 119 Giovanni Battista Falda, Piazza Santi Apostoli, 1665-67, etching, 18.8 x 29.2 cm, Rijksmuseum, Amsterdam

p. 123 Anon, Monument in Rome for the Corsican Guard Affair, etching, 1707, illustration to François-Séraphin Régnier-Desmarais, *Histoire des démeslez de la Cour de France avec la Cour de Rome, au sujet de l'affaire des Corses,* 1707

p. 125 Gian Lorenzo Bernini, Louvre, East Façade (Study For The First Project), 1664, pen & brown ink on laid paper, 16.3 x 27.8 cm, Courtauld Institute of Art, London

p. 127 Gian Lorenzo Bernini, Bust of Louis XIV, 1665, marble, height 80 cm, Château de Versailles, Versailles

p. 129 Giovanni Battista Gaulli (Il Baciccio), Gian Lorenzo Bernini, detail, *c.* 1670-1680, oil on canvas, 99 x 74.5 cm, Scottish National Gallery, Edinburgh

p. 129 Anon, after Gian Lorenzo Bernini, Alexander VII, *c.* 1657-70, red chalk on paper, 25.5 x 19.6 cm, Royal Collection, Windsor

p. 131 Attributed to Agostino Ciampelli, Crossing of St Peter's, with earlier drawing of the full-size wooden model of the Baldacchino used as part of the design process pasted down over later image of the basilica, 1628-31, Morgan Library, New York

p. 133 Gian Lorenzo Bernini, Putti on Baldacchino, Saint Peter's, Rome (photograph Ruud Teggelaar)

p. 135 Dominique Barrière, Façade of Santa Maria della Pace, with visit by Alexander VII, 1657-67, (detail), etching, 31.6 x 39.3 cm, British Museum, London

p. 136 Jacob van Swanenburgh, Saint Peter's Square, 1628, oil on panel, 57.5 x 109 cm, Statens Museum for Kunst, Copenhagen

p. 137 Gaspare Morone, medal showing Colonnade of Saint Peter's, 1666, bronze, diameter 4.1 cm, Metropolitan Museum of Art, New York

p. 139 Lievin Cruyl, St Peter's Basilica, 1666, etching, 26 x 38.5 cm, Cleveland Museum of Art, Cleveland, OH

p. 141 François Spierre after Gian Lorenzo Bernini, Cathedra Petri, 1666 or after, engraving, 84 x 55.6 cm, Metropolitan Museum of Art, New York

p. 142 Gian Lorenzo Bernini, Sketch for the Cathedra Petri, 1658, terracotta, height 58.4 cm, Detroit Institute of Arts

10.2 cm, Germanisches National-
museum, Nürnberg, (Wikimedia)

p. 185 Anon, frontispiece to Atha-
nasius Kircher and Giorgio de
Sepi, *Romani Collegii Societatis Jesu
Musæum Celeberrimum*, Amsterdam,
1678

p. 188 After Giacomo Lauro, Circus
of Caracalla (now known as Circus
of Maxentius), 1612-28, etching,
17.7 x 23.6 cm, Bibliothèque
nationale de France/Gallica

p. 189 Anon, Systema Ideale etc.
illustration to Athanasius Kirch-
er, *Mundus Subterraneus*, 1665,
Norman B. Leventhal Map &
Education Center at the Boston
Public Library

pp. 190-91 Jan Lutma, Two views of
the Fountain of the Four Rivers,
1652, etchings, each 70.3 x 49.5
cm, Rijksmuseum, Amsterdam

p. 193 Cornelis Bloemaert after Gio-
vanni Angelo Canini, frontispiece
to Athanasius Kircher, *Obeliscus
Pamphilius*, 1659

p. 197 Melchiorre Cafà, Bust of Pope
Alexander VII, 1667, bronze, height
99.7 cm, Metropolitan Museum of
Art, New York

p. 199 Giovanni Battista Bonacina
after Pietro da Cortona, Allegory
of the Liberation of Rome from
the Plague, engraving, 60.5 x 41
cm, Biblioteca Casanatense,
Rome

p. 201 Gian Lorenzo Bernini and
studio, Design for tomb of Alexan-
der VII, *c.* 1662-66, pen and bistre

wash over black chalk, 44 x 30.7
cm, Royal Collection, Windsor

p. 203 Francois Spierre after Pietro
da Cortona, frontispiece to Chris-
tophorus Lozanus's thesis, 1666,
engraving printed in red ink, 37 x
27.3 cm, British Museum, London

p. 204 Gian Lorenzo Bernini, sketch
for tomb of Alexander VII, 1669-
79, terracotta, height 30.3 cm,
V&A, London

p. 205 Anon., Iconographia Septi
Isaici, illustration to Athanasius
Kircher, *Obelisci Ægyptiaci*, Rome,
1666

p. 206 Anon., Obeliscus Ægyptiacus
etc., illustration to Athanasius
Kircher, *Obelisci Ægyptiaci*, Rome,
1666

pp. 209-11 Anon., Progetti 1-6,
illustrations to Domenico Gnoli,
'Disegni del Gian Lorenzo Bernini
per l'obelisco della Minerva in
Roma', *Archivio storico dell'Arte* 1,
1888, p. 398-403

p. 212 Gian Lorenzo Bernini, Design
for elephant and obelisk, 1630, pen
and ink with brown wash over
black chalk, 27.3 x 11.6 cm, Royal
Collection, Windsor

p. 215 Raphael and studio, Hanno,
1516, pen and brownish black ink
over traces of black chalk, with
white highlights on greyish brown
paper, 27.9 x 28.5 cm, Kupferstich-
kabinett, Berlin (Wikimedia)

pp. 216-17 Anon., Hansken the
Elephant, *c.* 1650, engraving, 29.5 x
38.3 cm, Rijksmuseum, Amsterdam

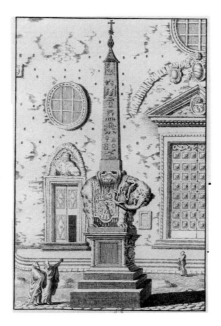

Index

Entries in *italics* indicate images

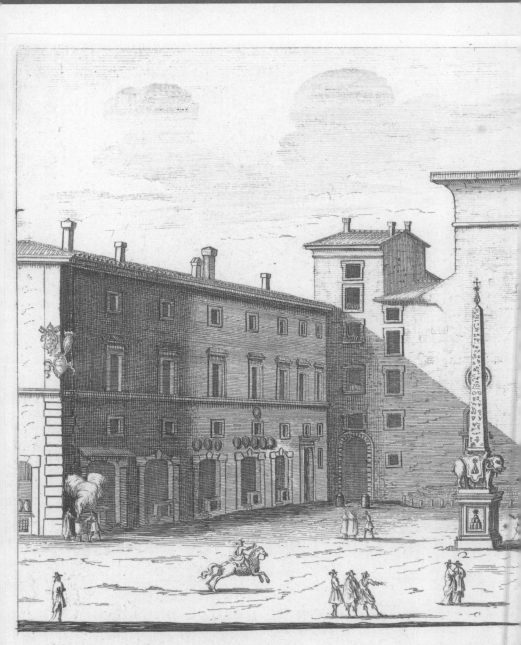

i Chiefa di S. Maria della Minerua. **PIAZZA DI SANT**

Gio.Batta Falda dif.et fec. Per Gio.Iacor